Retro Cameras

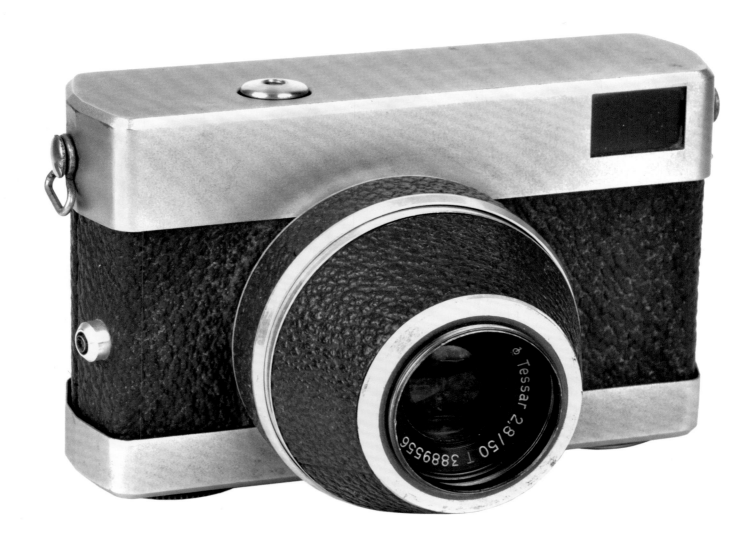

Retro Cameras

The Collector's Guide to Vintage Film Photography

John Wade

With over 550 illustrations

Thames & Hudson

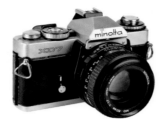

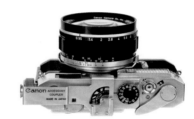

First published in the United Kingdom in 2018
by Thames & Hudson Ltd, 181A High Holborn,
London WC1V 7QX

Reprinted 2019

Retro Cameras © 2018 Thames & Hudson Ltd,
London

Text © 2018 John Wade

Photographs © 2018 John Wade
unless otherwise stated

British Library Cataloguing-in-Publication Data

A catalogue record for this book is available from
the British Library

ISBN 978-0-500-54490-7

Printed in China by C&C Offset Printing Co. Ltd.

To find out about all our publications,
please visit **www.thamesandhudson.com**.
There you can subscribe to our e-newsletter,
browse or download our current catalogue,
and buy any titles that are in print.

Contents

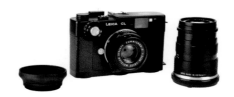

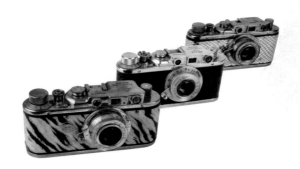

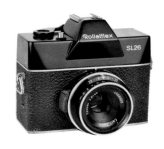

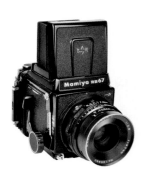

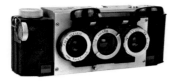

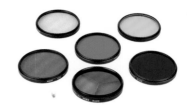

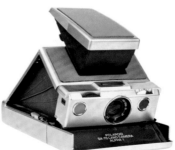

Introduction

There were two types of camera buyer in the days before digital: photographers and collectors.

Photographers bought cameras, obviously, to take pictures. Collectors bought cameras because they were interested in their place in the history of photography, or simply because they considered them to be beautiful objects in their own right – objects to be admired and polished, but rarely to be used.

As the digital age dawned, photographers began to make the move to the new cameras, even though initially many agreed that this new-fangled method of photography would never catch on. In a remarkably short time, however, digital cameras became more sophisticated. They soon dominated the market and finally superseded film cameras completely for both amateur and professional photographers.

Cameras from the era of the last days of film photography were left in a kind of limbo. Photographers saw these cameras as primitive compared to the latest digital models and collectors considered them to be too modern to be of historic interest. No one wanted them.

But then a new generation began buying film cameras. They were photographers who had grown up in the digital age or in the last days of film photography when cameras had developed super-sophisticated fully-auto metering systems and advanced auto-focus functions. Interestingly, these new buyers ignored the fully automatic models from the end of the film era and were attracted more to manual single-lens reflexes (SLRs), or those that had some fairly basic form of automation. Autofocus too was shunned. They sought basic camera craft and found it with early manual SLRs such as Prakticas, Zeniths (or Zenits) and Pentaxes.

Once hooked, many of this new generation of photographers moved on to the better-specified SLRs of the late 1960s, 1970s and early 1980s – the big five names were Canon, Minolta, Nikon, Olympus and Pentax. Others went back and took an interest in the rangefinder cameras of the 1950s or earlier, with names such as Leica and Contax. Some took the leap into medium-format photography with cameras from manufacturers that included Hasselblad, Mamiya and Bronica.

Early digital cameras such as these from Fujifilm, Sony and Samsung offered low resolution at high prices.

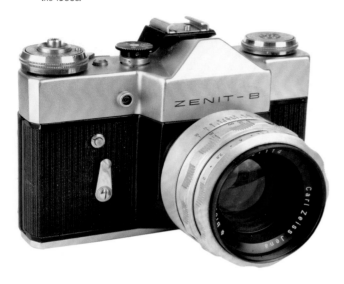

Many retro photographers begin with manual SLRs such as this Zenit-B, which was made in the 1960s.

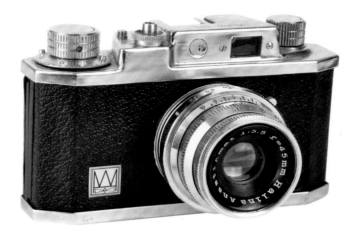

The Halina 35X does not have exposure automation or a rangefinder, but provides an easy entry into basic 35 mm film photography.

At about the same time, instant film for Polaroid cameras was made again by independent manufacturers and a renewed interest in instant photography began. The really ambitious film photographers diversified into specialized equipment with cameras for panoramic, stereo and subminiature photography. Retro accessories also became popular.

There was a new challenge for born-again film users. Brought up in the era of auto-everything cameras, many had no real knowledge of what the camera was actually doing to adapt its workings to their picture-taking needs. They soon discovered that it all came down to two factors: the way shutter speeds were juggled with apertures and, without the advantages of autofocus, they had to learn the correct way to focus a lens. It was time to go back to basics. This is what this book is all about.

After discussing some of the often forgotten basics, each section deals with a type of camera and how to use it, aiming at the photographer contemplating using a manual or semi-automatic film camera for the first time. The cameras listed are all practical propositions for a retro photographer with a reasonable budget. Each one has been carefully chosen as a typical example of a camera from its era. A comprehensive glossary at the end of the book gives definitions of terms that might be unfamiliar to photographers in the digital age.

An author's note: most retro cameras were made with a choice of lenses, either fixed or interchangeable. The specifications quoted throughout this book refer only to the actual cameras and lenses described and illustrated in each section.

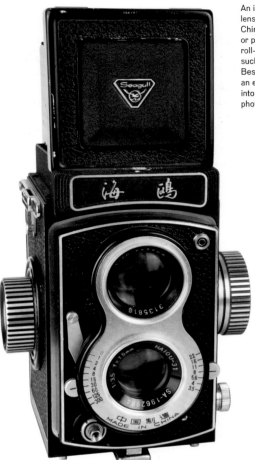

An inexpensive twin-lens reflex such as the Chinese Seagull (left), or perhaps an older 120 roll-film folding camera such as the Voigtländer Bessa 66, can provide an economical way into medium-format photography.

Russian cameras such as this Fed 2 from the 1950s can provide an introduction to 35 mm rangefinder photography.

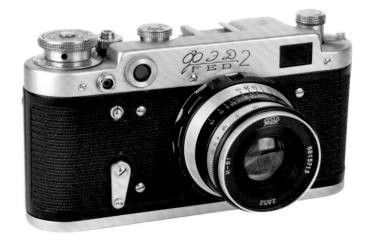

Value and Rarity

The price of a retro or classic camera is not always easy to determine. Often it depends on a camera's rarity or how interesting it is to collectors. There are, however, anomalies to consider.

For example, most Leica cameras are of great interest to collectors because of their place in history and the quality of their engineering. This makes them expensive. Most models, though, were made by the thousand and, for those who know where to look, they can still be found in abundance. Equally, the first Kodak Instamatic is a significant photographic landmark. Unlike the Leica, however, collectors see it as no more than a worthless snapshot camera. This means it can be bought very cheaply. So here are two cameras, both landmark examples, which are easy to find, but are at very different ends of the price spectrum.

The increase in the use of retro cameras by the new generation of film users, as opposed to cameras bought by collectors for their historic interest, is another factor that must be considered when valuing a camera.

For these reasons, it is impractical to give accurate prices here for every camera described, particularly since such prices will inevitably fluctuate during the shelf life of the book. Instead, a five-star value rating has been devised, which you will find on the relevant page for each camera. Here's how to read it:

✳︎✳︎✳︎✳︎✳︎ Cheap
✳︎✳︎✳︎✳︎✳︎ Inexpensive
✳︎✳︎✳︎✳︎✳︎ Moderately priced
✳︎✳︎✳︎✳︎✳︎ Relatively expensive
✳︎✳︎✳︎✳︎✳︎ Very expensive

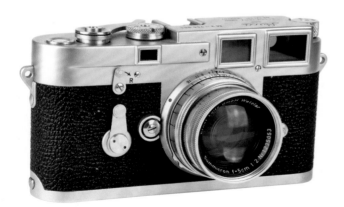

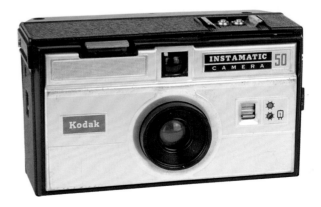

The Leica M3 and Kodak Instamatic 50: two landmark cameras from opposite ends of the price range.

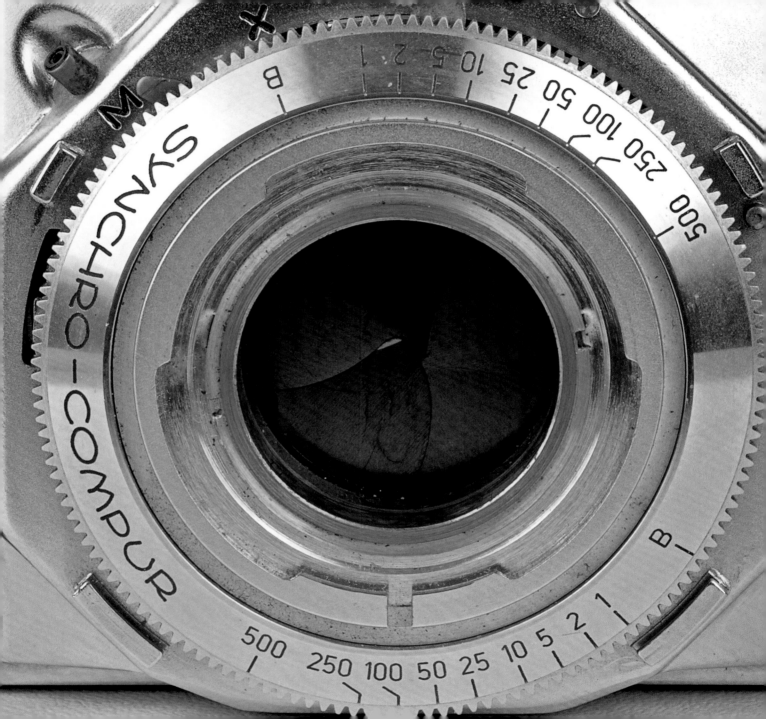

The Basics

Back to Basics

To get good results when using a retro camera, you need to understand the functions of shutter speeds, apertures and focusing. Each does its own job and is interrelated.

For a picture to look natural – not too dark and not too light – it needs to be correctly exposed. This means controlling how much light is transmitted through the lens and onto the film. Shutter speeds and apertures are used for this purpose. The aperture controls the amount of light let through the lens, while the shutter controls the length of time that set amount of light is allowed to reach the film.

The most common types of shutter are leaf and focal plane. With the former, an iris opens and closes to allow light to reach the film for a specific amount of time. With the latter, two blinds are used, one following the other across the focal plane, with the timed exposure controlled by the speed of the blinds and width of the gap between them. Shutter speeds are measured in seconds and fractions of a second.

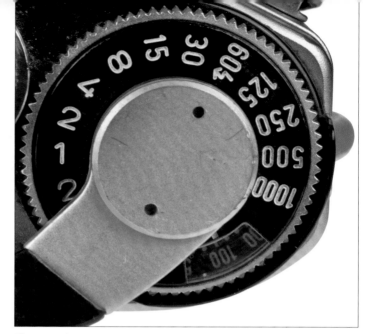

Shutter speeds are usually set on a camera's top plate dial. (Canon AE-1 shutter-priority camera)

The focal-plane shutter in the body of an Olympus OM-1 camera.

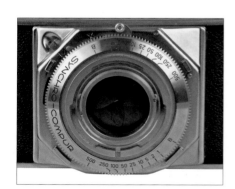

Leaf shutter in the body of a Voigtländer Prominent camera.

Apertures are usually set on a ring around the lens. (Pentax ME Super aperture-priority camera)

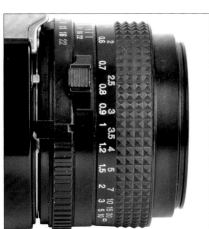

Focusing is normally carried out with a collar surrounding the lens barrel. (Minolta XD-7 camera)

The difference between apertures of f/16 and f/1.4 when set on a Nikkor lens.

The aperture traditionally takes the form of an iris that opens and closes to control the amount of light allowed through the lens. Apertures are measured in f-stops: the higher the f-stop number, the smaller the aperture.

Each setting on the aperture or shutter-speed scale is half or double its neighbour, making it possible to set a range of different combinations that, in effect, give the same exposure. For example, a shutter speed of 1/125 second at an aperture of f/11 gives the same exposure as 1/250 second at f/8 because, as the shutter speed is halved, the amount of light through the aperture is doubled. Likewise, 1/125 second at f/11 is equivalent to 1/60 second at f/16 and so on.

Shutter speeds control the way you capture movement. A fast speed will freeze movement, while a slow speed will blur it. If you want a moving subject to appear sharp, then the faster it is moving, the faster the required shutter speed. If you want to be more creative, and blur the action of a moving subject, then go for a slower shutter speed. Using the right shutter speed also helps compensate for shake when hand-holding a camera.

Apertures control depth of field. This is the area of acceptable sharpness in an image either side of the spot where you actually focus the lens. Small apertures provide a deep depth of field, which means everything from the foreground to infinity can be kept in focus. Wide apertures reduce depth of field so that you can isolate a sharp subject against a blurred background.

Focusing is the third function. Whether you are doing this manually, with estimated distances set on a scale around the lens, or with the aid of a rangefinder built into the camera, the principle is the same: focus the lens on the most important part of the subject.

A fast shutter speed stops the action. (Canon F-1 35 mm SLR, 1/500 second at f/5.6)

A small aperture and a wide-angle lens contribute to maximum depth of field. (Canon F-1 35 mm SLR, 20 mm focal length at f/16)

A slow shutter speed can be used to blur movement as you move the camera to follow the subject. (Canon AE-1 35 mm SLR, 1/15 second at f/16)

Keep in mind, however, that the closer you get to the subject, the shallower the depth of field. If you are shooting a wide-open landscape, where the nearest subject is a reasonable distance from the camera, a medium-sized aperture of around f/5.6 or smaller will be sufficient to keep everything in focus. If you move in closer to the main subject, then the background will start to fall out of focus. You need a small aperture to maintain focus, which means you require a slower shutter speed to compensate for this.

This is not as complicated as it sounds. Basic retro camera use is about practising until setting the correct shutter speed/aperture/focus distance for any subject becomes second nature. It means prioritizing the most important aspect of your photograph and then compromising to make sure you have selected the best settings for that subject. Mastering shutter speeds, apertures and focusing in this way is at the heart of retro camera usage.

A long focal length and wide aperture result in a very narrow depth of field. (Canon F-1 35 mm SLR, 200 mm macro lens at f/4)

Formats and Focal Lengths

The most popular retro camera format is 35 mm, which uses film in cassettes. As each exposure is made, the film is drawn out of the cassette one frame at a time and wound onto a take-up spool. At the end of the roll, it is wound back again into its cassette.

The second most popular is the 120 size roll film. This is rolled onto spindles and attached to backing paper with some extra at each end to protect the film from light during loading and unloading. The backing paper has numbers on it, which can be seen through a red window on the back of the camera, to indicate how far each frame needs to be wound between exposures.

The standard full-frame 35 mm format is 24 × 36 mm.

The third most popular film that is still available today is the 127 size, which is smaller than 120, but is used in the same way.

Large-format sheet film, which comes in individual sheets that must be pre-loaded into a film holder, is occasionally of interest to the retro photographer.

Each film type offers different image formats according to the camera. The smaller the format, the more images you can shoot on a single roll or sheet of film. Here are the most popular formats:

35 mm full frame (36 exposures):	24 × 36 mm
35 mm half-frame (72 exposures):	18 × 24 mm
35 mm panoramic (21 exposures):	24 × 58 mm
35 mm panoramic (12 exposures):	24 × 105 mm
120 (8 exposures):	6 × 9 cm
120 (10 exposures):	6 × 7 cm
120 (12 exposures):	6 × 6 cm
120 (16 exposures):	4.5 × 6 cm
127 (8 exposures):	4 × 6.5 cm
127 (12 exposures):	4 × 4 cm
127 (16 exposures):	3 × 4 cm
Minox film (up to 36 exposures):	8 × 11 mm
Sheet film (1 exposure)	10 × 12.7 cm

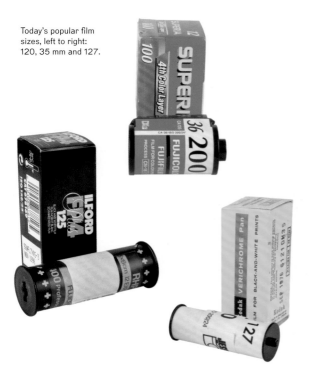

Today's popular film sizes, left to right: 120, 35 mm and 127.

The 120 size offers a variety of formats, including 6 × 9 cm, 6 × 7 cm, 6 × 6 cm and 4.5 × 6 cm.

Lenses are identified by their focal lengths: the distance between the centre of a lens and its sharply defined image when the subject is at infinity. The lens that is usually sold with a camera is a standard lens, which gives a natural view, similar to that seen with the human eye. Lenses with longer focal lengths are telephotos, designed to magnify and bring subjects that are far away closer to the camera. Lenses with shorter focal lengths are wide angles, which open up the image to include more details of the subject each side, as well as top and bottom of the viewfinder image, and therefore of the picture.

The way focal lengths are designated varies according to the format of the image on the film. The focal length of a standard lens is approximately equal to the diagonal measurement across the format it serves. For a standard 35 mm image of 24 × 36 mm, this is a little over 43 mm, which most camera manufacturers round up to 50 mm.

With a medium-format image, measuring 6 × 6 cm, you end up with a standard lens of around 85 mm. When used with their appropriate format, both lenses will give approximately the same view of the subject. But if you put a 50 mm standard lens from a 35 mm camera onto a medium-format camera then it becomes a wide-angle lens. Likewise, if you put an 85 mm standard lens from a medium-format camera on a 35 mm one, it will turn into a medium telephoto.

Different focal lengths are used primarily to manage magnification, or the size you require the subject to appear on film. They can also be used to control perspective: this is the apparent distance between foreground objects and those in the background. A standard focal length records perspective much as you see it with your eyes. If you switch to longer focal lengths then the background appears to advance on the foreground, bunching everything up. Go for a wider-than-standard focal length and the background appears to recede, separating itself more from the foreground.

Focal lengths also play a role in controlling depth of field. Wide-angle lenses give a deep depth of field that is useful for landscapes where you want focus from the foreground all the way into the distance. Telephoto lenses reduce depth of field, making them useful for isolating a subject such as a portrait against a blurred background.

Finally, be aware that long focal lengths exaggerate camera shake. So the longer the focal length in use, the faster the shutter speed required to keep everything shake-free.

A standard lens offers
a field of view similar to
that seen with the human
eye. (90 mm lens on
6 × 7 cm format)

Minox colour negative
film is still available
for sub-miniature
photography.

Sheet film used to come in many sizes, but 4 × 5 inch is the format that has survived.

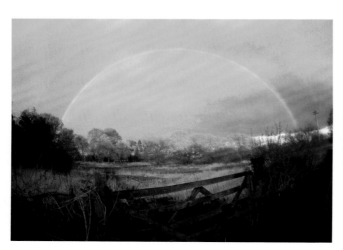

A super-wide-angle lens was needed here to capture the full diameter of a rainbow on a standard 35 mm frame. (16 mm lens on a 35 mm SLR)

A telephoto lens can be used to record details of distant subjects. Here you can see the effects of using a 28 mm lens (above left) and a 400 mm lens (above right) on a 35 mm format from the same camera position.

These photographs show how focal length affects magnification. The same subject is recorded from the same distance on a 35 mm camera with the following focal lengths: top, left to right, 28 mm, 50 mm and 105 mm, and above, left to right, 200 mm, 400 mm and 800 mm.

How focal lengths affect perspective. The pictures were shot at wide, standard and telephoto focal lengths, progressively moving the camera further from the subject as the focal length was increased.

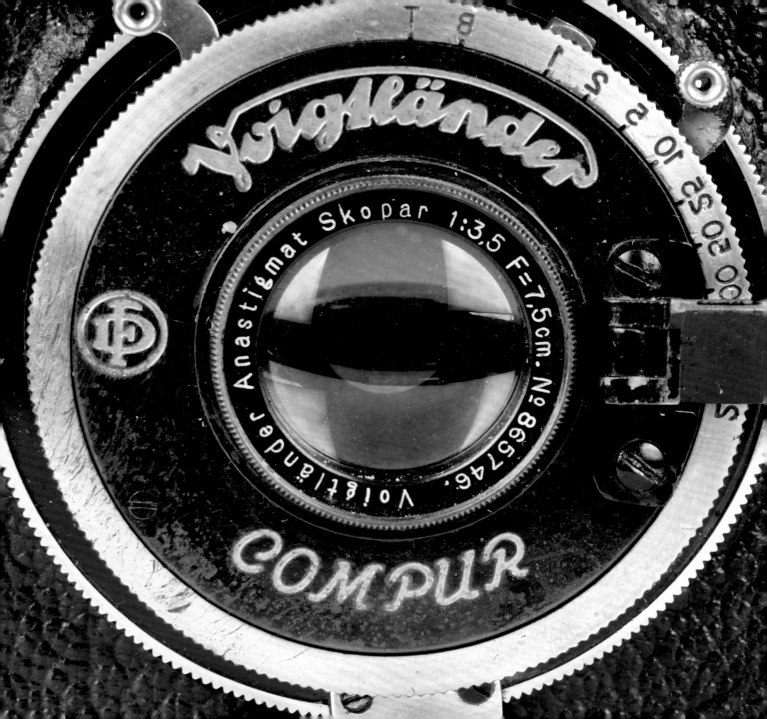

The
Cameras

35 mm Single-Lens Reflexes

The single-lens reflex (SLR) design is older than photography itself. It dates back to the camera obscura, which was a device used by artists in pre-photographic times to help with composition and perspective. One design was a box with a lens on the front and the image was reflected via a mirror to a screen on top. This, in short, is the basic design of the SLR.

Thomas Sutton was credited with the invention of the photographic SLR. He patented the design in 1861, at a time when photographic images were made on glass plates. Later cameras were designed for different sizes of roll film and, in 1936, the first 35 mm SLR reached the market. It was made by Ihagee in Germany and called the Kine Exakta.

The SLR design places a mirror at an angle between the lens and the film to reflect the image up to a screen above. Once focused, the mirror is moved out of the light path, so that the image from the lens can reach the film. In early 35 mm SLRs, with the image reflected onto a screen on the top of the body, the camera was held at waist level and the photographer looked down at the viewfinder, which showed an image that was laterally reversed. In 1948 a camera called the Contax S became the first 35 mm SLR to use an eye-level viewfinder, incorporating a pentaprism that corrected the reversed image.

Subsequently, the eye-level 35 mm SLR became the most popular style of camera for professional and amateur photographers alike.

Early 35 mm SLRs were mostly made in Germany. Board of Trade restrictions following the Second World War prevented them from being imported into the UK until the late 1950s and, in the aftermath of the war, they were not always popular elsewhere in the world either. Nevertheless, they are worth seeking out today. Japanese SLRs are the better choice for cameras made after 1960.

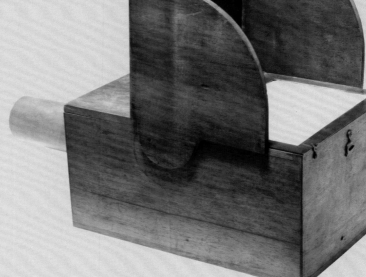

The camera obscura, from the days before photography, heralded the design of the single-lens reflex.

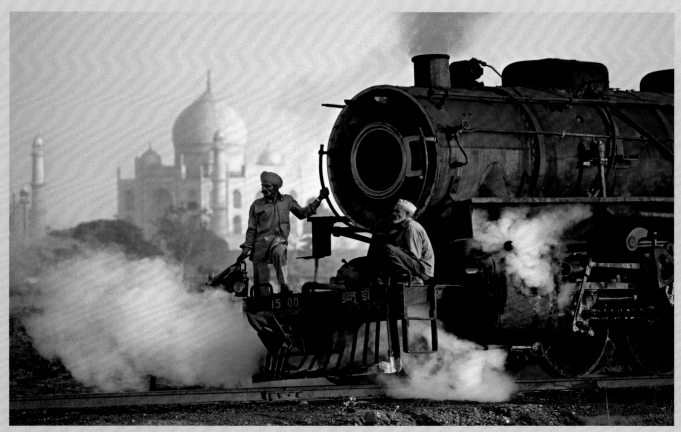

Steve McCurry, *Taj and Train*, Agra, India, 1983
© Steve McCurry/Magnum Photos

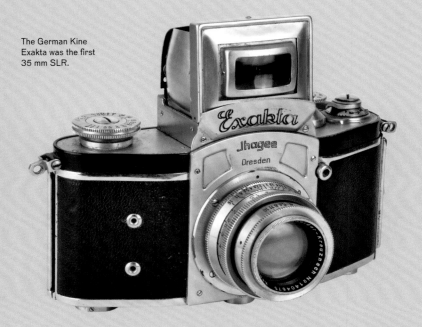

The German Kine Exakta was the first 35 mm SLR.

BUYERS' TIPS

Choose between totally manual cameras (inexpensive today) and those with some form of metering (more expensive).

If the camera has a meter, check that it works.

Run through the shutter speeds to make sure that the camera isn't stuck on one speed.

Look through the lens and avoid cloudy elements, signs of fungus or heavy scratches. A few light scratches on the front element won't affect the picture quality too much.

Go for Japanese SLRs made after 1960. The top makes are Canon, Minolta, Nikon, Olympus and Pentax, but consider also Ricoh, Konica, Fujica and Topcon.

Top German names from before the Second World War, and into the 1950s, include Zeiss Ikon, Ihagee, Exakta and Voigtländer.

Beware of ex-professional cameras that might have had more use than normal.

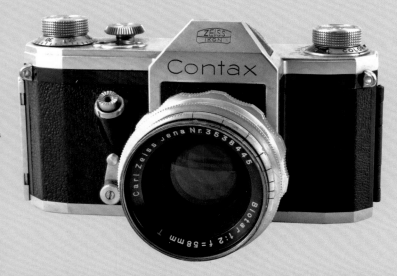

The Contax S was the first 35 mm SLR with an eye-level pentaprism viewfinder, which set the style for many years to come.

The Cameras ⚡ 35 mm Single-Lens Reflexes

Shooting Guide

A 35 mm SLR is probably the easiest of all retro cameras to use, primarily because of its focusing system. It is comprised of a mirror behind the lens that reflects the image, sometimes via other mirrors, but more commonly using a pentaprism, into the viewfinder. At the moment of exposure, the mirror moves away to allow the lens's light to reach the film. After exposure, the mirror usually returns automatically, although with older cameras that might not happen until the film is wound.

So, prior to exposure, the view you see through the viewfinder is precisely that seen by the lens, without any of the parallax problems encountered in a non-reflex camera.

On the simplest early SLRs the viewfinder might be completely plain. Later, more sophisticated cameras are more likely to show exposure information around the periphery. The most useful addition to any SLR viewfinder is a rangefinder, which is found on most SLRs from the 1960s onwards. It will nearly always be a split-image type.

On the majority of cameras, shutter speeds are set on a dial on the top plate, apertures on a scale around the lens barrel and focusing is carried out by turning a large ring around the lens. Exceptions to these include shutter speeds sometimes set on a ring around the lens and focusing occasionally controlled by a knob on the body, but such features are the exception rather than the rule.

When choosing a camera to use, consider the five basic types of exposure control found on 35 mm SLRs and decide which is best for the type of pictures you most enjoy shooting. They are as follows:

Fully manual: shutter speeds and apertures are set manually without any metering to help.

Match-needle: an in-built meter controls the position of a needle in the viewfinder as shutter speeds are adjusted against apertures. When the needle settles on a central spot, then the correct exposure has been attained.

Shutter-priority: the photographer selects a shutter speed and then the camera's meter selects and automatically sets the aperture needed for correct exposure.

Aperture-priority: the photographer selects an aperture and then the camera's meter selects and automatically sets the shutter speed needed for correct exposure.

Programmed automation: the camera's meter selects and sets the best combination of shutter speed and aperture for correct exposure.

Different cameras might offer just one of these options, or a combination of any or all of them.

The heart of a 35 mm SLR: the reflex mirror in a Canon AE-1, which transfers the image from the lens to the viewfinder.

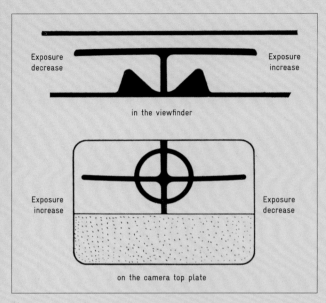

Exposure decrease

Exposure increase

in the viewfinder

Exposure increase

Exposure decrease

on the camera top plate

Above you can see how match-needle metering is shown in the viewfinder and on the top plate of a Topcon RE Super 35 mm SLR. (As shown in the camera's instruction book.)

- The most comfortable way to hold a 35 mm SLR is in the right hand with the index finger on the shutter release and the thumb hooked behind the film-wind lever, supporting the base on the palm of the left hand, with that hand's fingers on the focusing ring.

- Keep your elbows tight into your body to reduce camera shake.

- When composing a picture, it's easy to look only at the subject in the centre and not notice surrounding detail. Hold the camera still and look carefully at all four corners of the viewfinder. If you see too much space around your subject, move closer or fit a longer lens.

- Look carefully at horizontal lines in the viewfinder to ensure that you are holding the camera straight.

- To ensure you are using the slowest practical speed for hand-holding, select a shutter speed that is at least the reciprocal of the focal length of the lens in use (50 mm lens = 1/50 second shutter speed, 250 mm lens = 1/250 second shutter speed, etc.).

- If you rely on automation, check that the camera has not automatically set a shutter speed that is too low for hand-holding the camera.

This shows how a split-image rangefinder helps to focus a 35 mm SLR. When it is out of focus (far left) the image is split, but when it is in focus (near left) the image is aligned.

A 35 mm SLR viewfinder gives you an accurate preview of the picture, so you can move in close to the subject without including any extraneous detail. (Canon AE-1 with 100 mm macro lens)

From a 35 mm transparency taken with a Canon F-1 35 mm SLR, 28–85 mm zoom lens set at 28 mm focal length.

Keep the camera straight to avoid sloping horizons; even a slight tilt can spoil the picture.

Canon F-1

The Canon F-1 series of cameras was made for professional use, although at the time of the launch most professionals favoured Nikon. What you get with the F-1 is a camera with a professional specification, but it is unlikely to have had heavy professional use.

The original model, launched in 1971, was a basic match-needle metering model. It was updated in 1976 as the F-1n and again in 1981 as the New F-1. This is the model you should go for. Confusingly, all three are marked 'F-1'. The New F-1 can be identified, however, because it has a film-speed setting that goes to 6400 ASA (equivalent to today's ISO speeds), an accessory shoe on top of the pentaprism, a film-type reminder on the camera back and a shutter release and speed dial slightly elevated above the

film-wind lever. Standard 50 mm Canon lenses include f/1.2, f/1.4 and f/1.8.

The basic F-1 is a sturdy camera with match-needle Cadmium Sulphide (CdS) metering, powered by a 1.3-volt battery, which also powers the electronic focal-plane shutter. Shutter speeds of 1/60 second and below are electronically controlled; 1/125 second and above are mechanical. This means the camera can be used even when the battery fails.

Speed and aperture indicators are shown in the viewfinder, which also incorporates a split-image rangefinder. Exposures of plus or minus two stops are set on a ring surrounding the rewind crank. This is where film speeds are also set.

If you replace the standard viewfinder with the AE version, one that many buyers go for as the norm, and set the speed dial

to 'A', then the camera is converted to aperture-priority. Add the AE power winder or motor drive to the base of the camera, set the lens to its 'A' setting and the camera is set up for shutter-priority automation as well. Both winders feature twin-shutter release buttons incorporated into the handle, one for horizontal pictures, the other for vertical. Continuous or single-film advance is adjusted by a ring around the horizontal release.

The camera also features an aperture stop-down button to preview depth of field, interchangeable focusing screens, databack and bulk film-back facilities, and it accepts Canon's huge range of FD bayonet-fit lenses. Equipped with the AE finder, the AE power winder and a Canon FD 28–85 mm f/4 macro zoom, the user has a formidable and versatile kit to cover a vast range of subjects.

Top view of the Canon F-1 with the viewfinder removed to show the focusing screen.

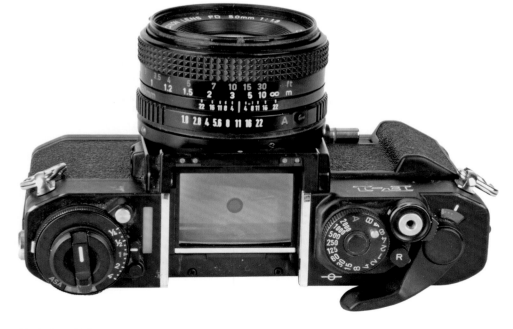

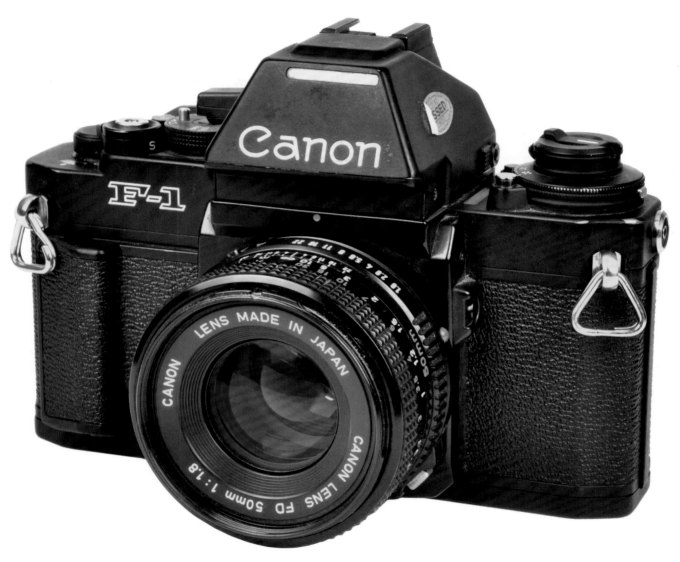

The New F-1 with a 50 mm
f/1.8 Canon lens.

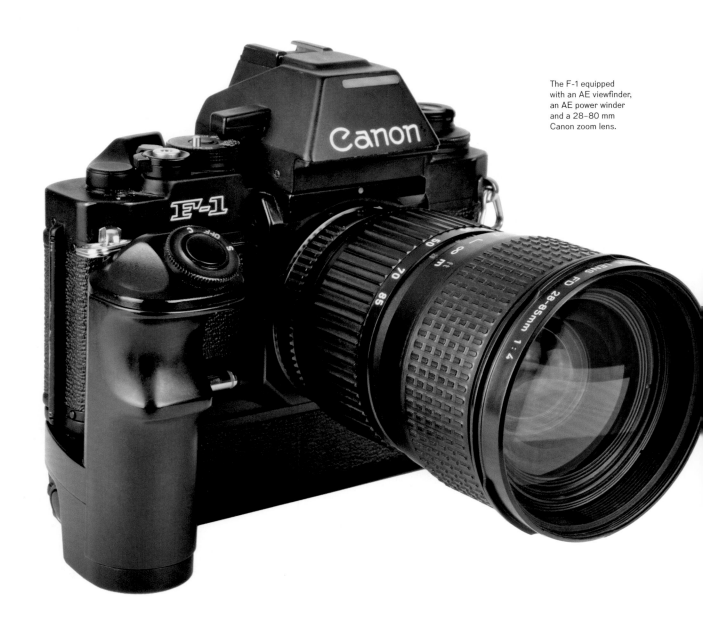

The F-1 equipped
with an AE viewfinder,
an AE power winder
and a 28–80 mm
Canon zoom lens.

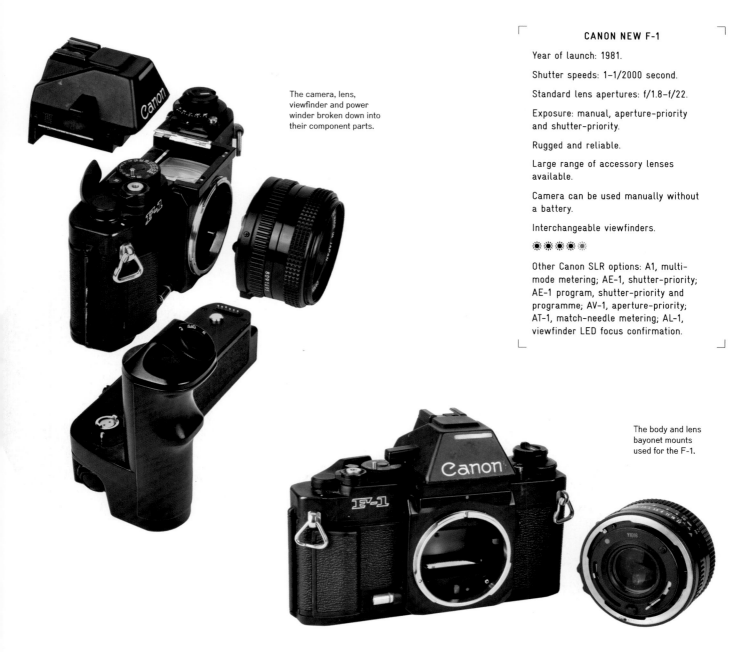

The camera, lens, viewfinder and power winder broken down into their component parts.

CANON NEW F-1

Year of launch: 1981.

Shutter speeds: 1–1/2000 second.

Standard lens apertures: f/1.8–f/22.

Exposure: manual, aperture-priority and shutter-priority.

Rugged and reliable.

Large range of accessory lenses available.

Camera can be used manually without a battery.

Interchangeable viewfinders.

✳ ✳ ✳ ✳ ✳

Other Canon SLR options: A1, multi-mode metering; AE-1, shutter-priority; AE-1 program, shutter-priority and programme; AV-1, aperture-priority; AT-1, match-needle metering; AL-1, viewfinder LED focus confirmation.

The body and lens bayonet mounts used for the F-1.

Olympus OM-1

In the 1970s there was a trend to build 35 mm SLRs that were smaller, lighter and quieter than their predecessors. The Olympus OM-1 was the first of this new breed.

The camera is manual with apertures and shutter speeds set on rings around the lens. This makes eye-level match-needle metering with the through-the-lens system easier than with cameras where the speed is set on the top plate. The control that sits in the place of the speed dial is to set film speeds between 25 and 1600 ASA. The shutter is a focal-plane type. Despite its size, the OM-1 is a true system camera that stands at the centre of an arsenal of versatile lenses and accessories more usually associated with larger cameras.

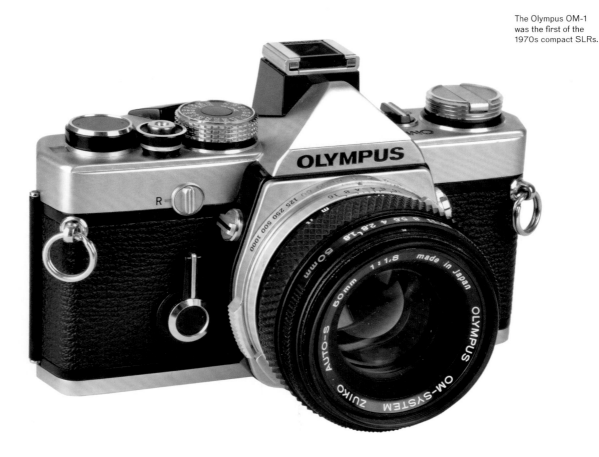

The Olympus OM-1 was the first of the 1970s compact SLRs.

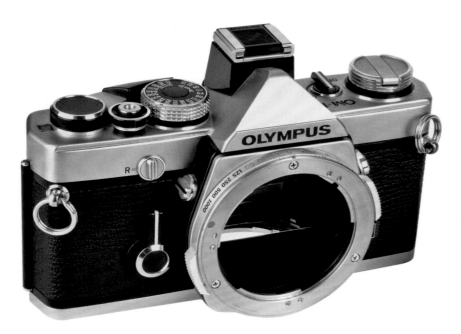

The body and lens bayonet mounts used by the Olympus OM-1 and the top plate (bottom).

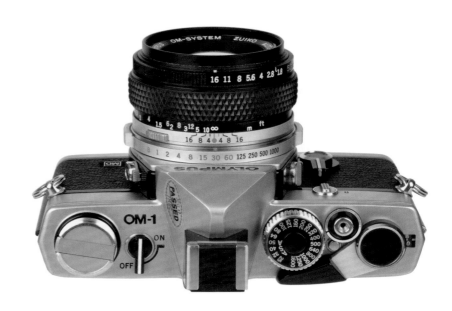

Minolta XD-7

The Minolta XD-7, known as the XD11 in the US, was the first multi-mode SLR from Japan, where it was known as the XD.

A lever next to the shutter-speed dial selects the modes. Setting the lever to 'M' allows speeds and apertures to be set manually with a recommended exposure shown in the viewfinder. Setting the lever to 'A' converts the camera to aperture-priority. Setting the lever to 'S', with the lens at its smallest aperture, converts the camera to shutter-priority.

If the chosen speed means over- or under-exposure, because the lens has run out of apertures for the correct exposure, the automation overrides the setting and sets a faster or slower speed.

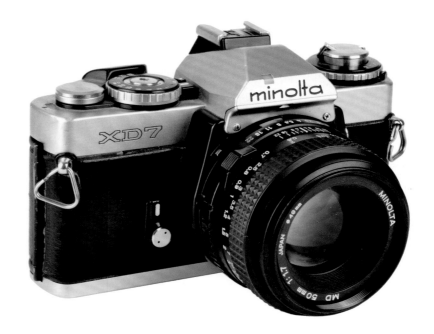

MINOLTA XD-7

Year of launch: 1978.

Shutter speeds: 1–1/1000 second.

Standard lens apertures: f/1.7–f/22.

Exposure: manual, aperture-priority and shutter-priority.

Electronic shutter with 1/100 second manual speed means the camera can still be used if the battery fails.

☀☀☀☀☀

Other Minolta SLR options: X-700, aperture-priority and program; XG2, auto and full-manual modes; XG-M with auto exposure and capability to fit a faster motor drive.

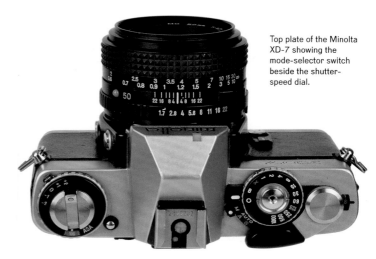

Top plate of the Minolta XD-7 showing the mode-selector switch beside the shutter-speed dial.

Pentax ME Super

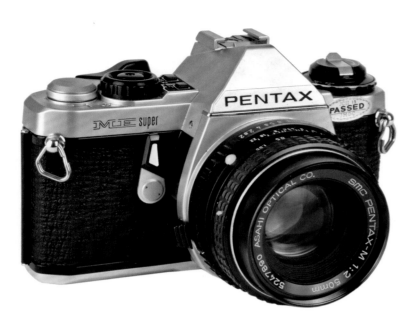

In 1976 the Pentax ME, an example of the then-current craze for compact SLRs, was introduced. It featured aperture-priority automation and had no shutter-speed dial. Today, the ME Super, which appeared four years later, is more popular.

This camera is also an aperture-priority model, but with the addition of manual shutter-speed control via two small black buttons set into the top plate. These are used to increase or decrease the shutter speeds, which are indicated on a scale in the viewfinder.

The camera is interesting because of its early use of electronic controls, but cannot be used if the battery fails.

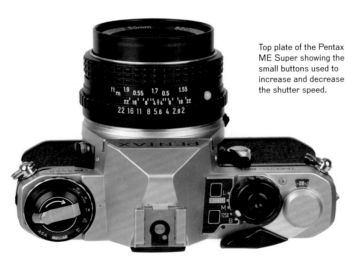

Top plate of the Pentax ME Super showing the small buttons used to increase and decrease the shutter speed.

PENTAX ME SUPER

Year of launch: 1980.

Shutter speeds: 4–1/2000 second.

Standard lens apertures: f/2–f/22.

Exposure: manual and aperture-priority.

Convenient push-button shutter-speed controls.

☀ ☀ ☀ ☀ ☀

Other Pentax SLR options: K1000, manual and mechanical with match-needle through-the-lens metering; Pentax K2, manual and aperture-priority metering.

Nikon F

The quality and reliability of the Nikon F makes it a worthy contender for use today, even though it was launched in the late 1950s. Do be aware, however, that throughout the 1960s it was considered the standard professional workhorse, so any you buy today could have had a lot of use.

The basic camera is totally manual, with no in-built metering and no way to measure exposures. But if you add the Photomic head, in place of the standard viewfinder, then you have a CdS meter linked to the shutter-speed dial with a coupling to the aperture setting that offers match-needle metering in the head's own viewfinder.

The bayonet lens mount is compatible with lenses that share a mount – and even with today's Nikon lenses. With a choice of viewfinders, a focusing screen, motor drives and other accessories, the camera is part of a system that is as usable today as the day it was launched.

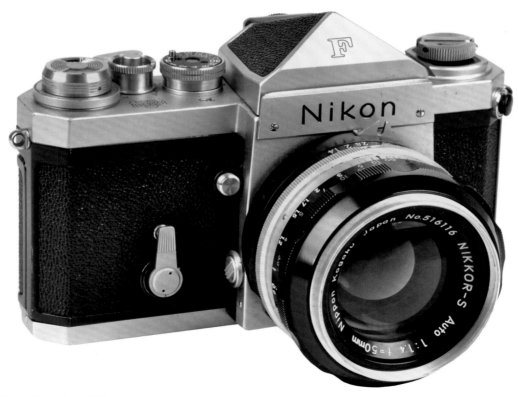

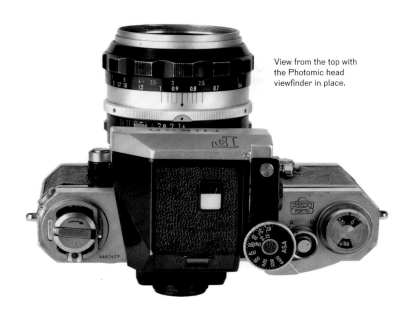

View from the top with
the Photomic head
viewfinder in place.

NIKON F

Year of launch: 1959.

Shutter speeds: 1–1/1000 second.

Standard lens apertures: f/1.4–f/16.

Exposure: manual.

Professional reliability.

Superb lens quality.

Photomic head option for match-needle
metering.

✻ ✻ ✻ ✻ ✻

Other Nikon SLR options: F2, F2 Photomic,
F3, F4 and FA.

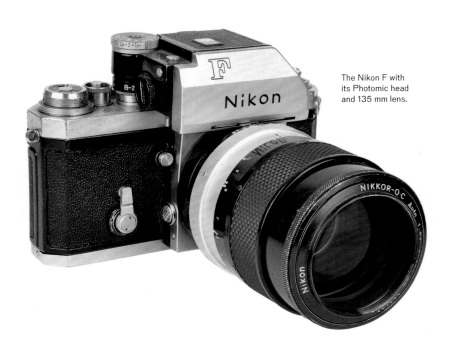

The Nikon F with
its Photomic head
and 135 mm lens.

Zeiss Ikon Contarex

The Contarex is often referred to as the Bullseye because of the large, round Selenium meter cell that sits above the lens. Coupled to the shutter speeds and apertures, this gives match-needle metering in the viewfinder and in a small window on the camera's top plate. The viewfinder incorporates a split-image rangefinder.

There is a wide choice of lenses, ranging from a 16 mm f/2.8 fish-eye through to a 1000 mm f/5.6 catadioptric mirror lens. An interchangeable film-back with a dark slide to protect the film is also available. This means the film can be changed mid-roll without the need to rewind.

Operational note: to remove the film-back, the dark slide must be pulled out, the film advanced and then the dark slide re-inserted. The back will not detach unless this sequence is adhered to.

ZEISS IKON CONTAREX

Year of launch: 1958.

Shutter speeds: 1–1/1000 second.

Standard lens apertures: f/1.4–f/22.

Exposure: match-needle.

Very heavy camera.

Interchangeable film-backs.

☀ ☀ ☀ ☀ ☀

Other Zeiss Ikon SLR options: Contaflex cameras that are smaller and lighter, and have leaf shutters.

The interchangeable back fitted to the Zeiss Ikon Contarex with the dark slide partially removed.

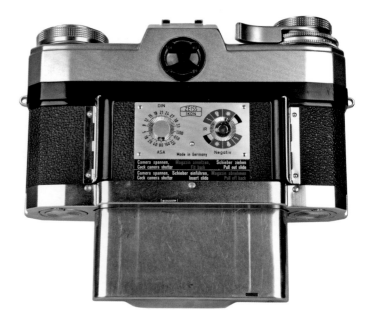

The Zeiss Ikon Contarex
is also known as the
Bullseye because of
the Selenium meter
cell above the lens.

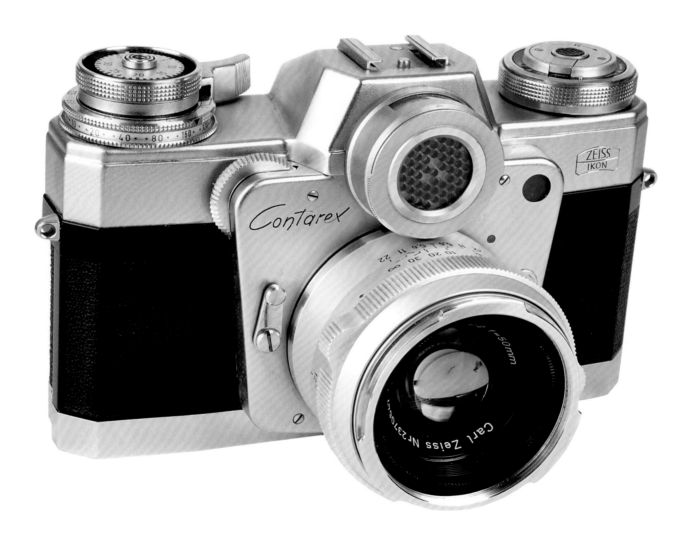

Topcon RE Super

This camera offers the best of both worlds: it is usable today, but was also a collectable landmark when it was launched. It was the first SLR with through-the-lens metering.

If you remove the lens, then you can see how it works. Transparent lines etched into the reflex mirror allow light to pass to a CdS meter cell at the rear, while still reflecting an image into the viewfinder. The result is match-needle metering with indicators in the viewfinder and on the camera's top plate.

Topcon cameras of this era are large and heavy compared to later SLRs, but they are known for their high quality.

Topcon RE Super with a pentaprism viewfinder fitted and a waist-level viewfinder.

TOPCON RE SUPER

Year of launch: 1963.

Shutter speeds: 1–1/1000 second.

Standard lens apertures: f/1.4–f/16.

Exposure: match-needle.

Eye-level and waist-level viewfinders.

Part of a comprehensive system that includes focusing screens, extension tubes and a range of lenses.

☼ ☼ ☼ ☼ ☼

Other Topcon SLR options with through-the-lens metering: RE-2, RE-200, RE-300 and Super DM.

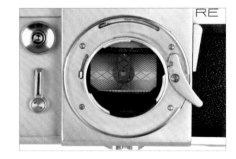

With the lens removed, the special mirror that both transmits and reflects light is revealed.

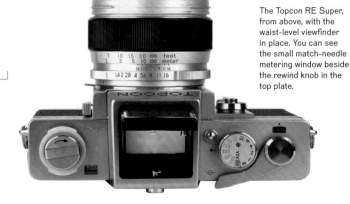

The Topcon RE Super, from above, with the waist-level viewfinder in place. You can see the small match-needle metering window beside the rewind knob in the top plate.

Praktina FX

This extremely robust camera came from what was then East Germany. It is part of a huge system for which you can find more than 100 lenses made by top names, including Carl Zeiss, Meyer-Optik, Angénieux, Isco, Kilfitt, Schneider and Steinheil.

Alongside the reflex viewfinder, the Praktina FX features a direct vision type, which is useful when manual lenses are stopped down to the shooting aperture, thus darkening the viewfinder image.

The camera's accessories include four types of viewfinder, replaceable focusing screens, clockwork and electric motor drives, a stereo attachment and a huge film-back that holds 17 metres (56 feet) of film.

PRAKTINA FX

Year of launch: 1956.

Shutter speeds: 1/10–1/1000 second.

Standard lens apertures: f/2–f/22.

Exposure: manual.

Takes a range of prestigious lenses.

Can be adapted for 450 exposures.

☀ ☀ ☀ ☀ ☀

Another Praktina SLR option: the FX was upgraded to the IIA in 1958.

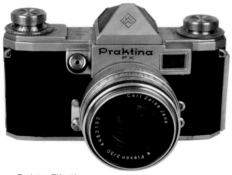

Praktina FX with an eye-level pentaprism viewfinder fitted, plus its three accessory viewfinders (left to right): metered pentaprism, high magnification and waist-level.

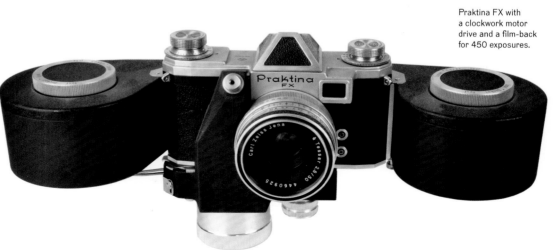

Praktina FX with a clockwork motor drive and a film-back for 450 exposures.

Canon Pellix

The Canon Pellix was set apart from its contemporaries – and the majority of 35 mm SLRs made since – because it uses a stationary pellicle mirror.

It is semi-silvered so it does not move out of the light path at the moment of exposure. Instead, 70 per cent of the light transmits through the mirror to the film, while 30 per cent is reflected into the viewfinder.

This results in less vibration, but a dimmer than usual viewfinder image, which can be compensated for by using a Canon f/1.4 or a super-fast f/1.2 standard lens. To prevent stray light reaching the film, a ring around the rewind crank winds a blind across the viewfinder.

Match-needle metering is through the lens, but only in stop-down mode, making the viewfinder even dimmer while exposure is measured.

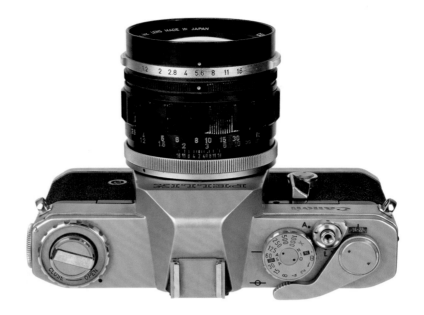

Canon Pellix with its super-fast 58 mm f/1.2 Canon FL lens.

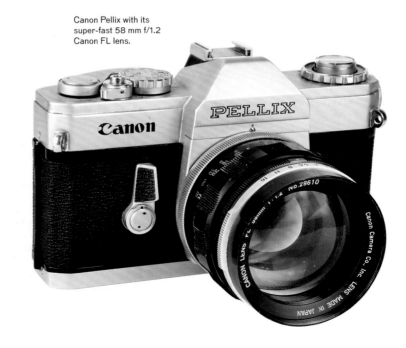

CANON PELLIX

Year of launch: 1965.

Shutter speeds: 1–1/1000 second.

Standard lens apertures: f/1.2–f/16.

Exposure: match-needle.

Static reflex mirror.

Another Canon Pellix option: Pellix QL with an easier to use quick-load system.

Wrayflex II

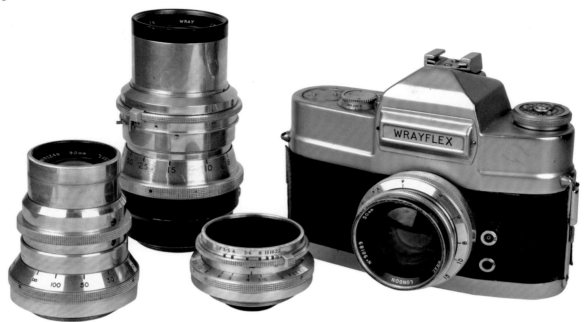

Wrayflex II with its standard 50 mm lens fitted. The 35 mm wide-angle, 90 mm portrait and 135 mm telephoto lenses were made by Wray specifically for the Wrayflex camera range.

In 1951 the Wray Optical Company introduced the Wrayflex, the UK's only attempt at producing a 35 mm SLR. The first two models were marred by having a viewfinder mirror system that produced a dim and laterally reversed image. But in 1959 this was corrected by the introduction of the Wrayflex II, which incorporated a pentaprism.

The camera wasn't very popular and less than 350 were made. Nevertheless, the Wrayflex II is a good, mechanical, fully manual camera for which the following lenses were made: two 50 mm standard, a 35 mm wide-angle, a 90 mm portrait and a 135 mm telephoto. It isn't the best 35 mm SLR of its time, but it does represent an interesting piece of British history.

WRAYFLEX II

Year of launch: 1959.

Shutter speeds: 1/2–1/1000 second.

Standard lens apertures: f/2–f/22.

Exposure: manual.

Only a small range of purpose-made lenses and a few accessories.

☀ ☀ ☀ ☀ ☀

Other Wray SLR options: Wrayflex I with 40-plus exposures per roll of 35 mm; Wrayflex Ia with the usual 36 exposures. The mirror-reflex system means there are dim viewfinders on both.

Voigtländer Bessamatic

This is a camera for those who appreciate brilliant, although slightly quirky, engineering. It has a ten-lens range, which covers 35 mm to 350 mm, and is best known as the first camera to use a zoom lens: the 36–82 mm f/2.8 Zoomar.

The camera features a leaf shutter in the body behind the lens with shutter speeds set on a body-mounted ring. Apertures are set by rotating a knob on the top plate, which turns the aperture ring on the lens.

Thereafter, the two are linked so that changing the shutter speed re-adjusts the aperture to maintain the same overall exposure. At the same time, two pointers move across the lens's focusing scale to indicate depth of field at the chosen aperture. Match-needle metering is courtesy of a Selenium cell mounted above the lens.

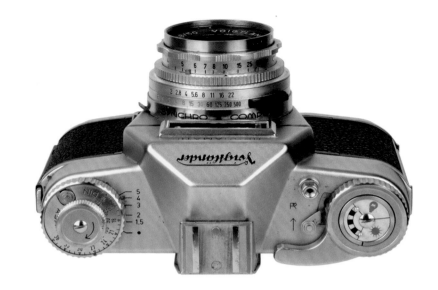

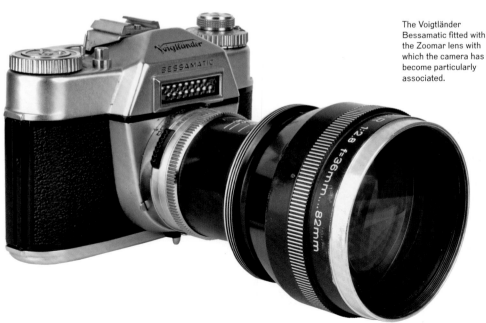

The Voigtländer Bessamatic fitted with the Zoomar lens with which the camera has become particularly associated.

VOIGTLÄNDER BESSAMATIC

Year of launch: 1959.

Shutter speeds: 1/2–1/500 second.

Standard lens apertures: f/2.8–f/22.

Exposure: match-needle.

Linked shutter speeds and apertures.

☀ ☀ ☀ ☀ ☀

Other Voigtländer Bessamatic options:
Bessamatic Deluxe, Bessamatic m
and Bessamatic CS.

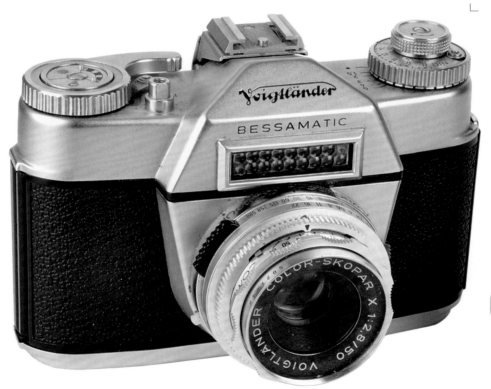

The Voigtländer
Bessamatic with
a standard 50 mm
f/2.8 Color-Skopar
lens fitted and a
35 mm f/3.5 Skoparex
wide-angle lens.

Petri Flex V

If you are looking for a Japanese SLR with no frills, just the basic controls, then the Petri Flex V (also known as the Petri Penta) is the one to go for.

There is no in-built metering, but Petri made a small, barrel-shaped exposure meter that sits in the accessory shoe and complements the camera well.

The shutter release lies at an angle on the front of the body and is more comfortable to use than traditionally placed releases on the top plate. Focus is aided by a microprism in the viewfinder.

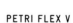

The Petri Flex V with a 55 mm f/2 standard lens and a Petri meter.

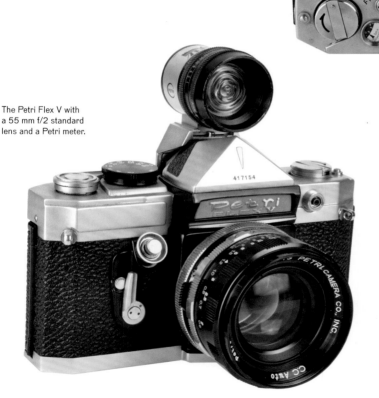

PETRI FLEX V

Year of launch: 1961.

Shutter speeds: 1/2–1/500 second.

Standard lens apertures: f/2–f/22.

Exposure: manual.

☀ ☀ ☀ ☀ ☀

Other Petri options: Petri Flex 7, external CdS meter; Petri FT, in-built through-the-lens metering.

Exakta Varex IIb

Made by Ihagee, a German company, the Exakta Varex IIb has three features that set it apart from the crowd: a left-handed shutter release on the front of the body, which links to apertures in the lens to activate automatic stop-down prior to exposure; an in-built film cutter to allow the removal of film part-way through a roll (in a darkroom or changing bag, of course); and a clockwork mechanism that offers focal-plane shutter speeds of up to 12 full seconds.

The camera is fully manual with no in-built metering. It offers a choice of eye-level or waist-level viewfinders, which incorporate their own focusing screens, and accepts a wide range of Exakta lenses and accessories.

EXAKTA VAREX IIB

Year of launch: 1963.

Shutter speeds: 12–1/1000 second.

Standard lens apertures: f/2.8–f/22.

Exposure: manual.

Left-hand film-wind and shutter release.

☀ ☀ ☀ ☀ ☀

Other Ihagee options: Exa cameras, stripped down and less expensive, but share the Exakta lens mount.

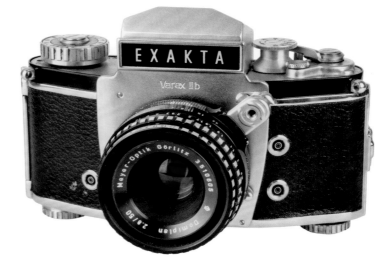

Exakta Varex IIb with a 50 mm f/2.8 Domiplan standard lens and an eye-level pentaprism viewfinder.

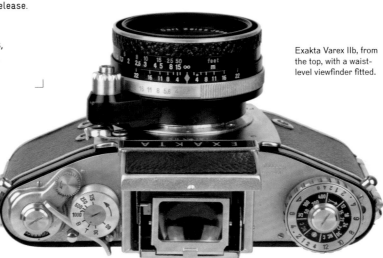

Exakta Varex IIb, from the top, with a waist-level viewfinder fitted.

Mecaflex

The Mecaflex, which was made in 1953, is considered to be a very desirable collector's item today, but it accepts 35 mm film in standard cassettes and so is still a usable camera. It was designed by Heinz Kilfitt, known for his high-precision lenses, and was first manufactured by Metz in Germany and then later by Seroa in France. Measuring just 10 × 6 × 6.5 cm (4 × 2¼ × 2½ inches), it is the only 35 mm SLR made to shoot 50 24 × 24 mm square pictures on a standard 36-exposure length of film.

The camera is usually found in a satin chrome finish with a black leather covering. The top plate, which appears at first to be devoid of any of the usual controls, hinges up to reveal the waist-level viewfinder with the magnifier, shutter release, film-wind lever and rewind knob all hidden beneath.

The magnifier over the focusing screen is made to be used with the camera held at waist level, when a magnified view of the whole screen is easily viewed. A square aperture can also be opened in the front of the now vertical top plate, which couples with an opening in the back of the focusing hood to form a direct vision, eye-level viewfinder. A rare clip-on eye-level viewfinder was made.

The 40 mm f/3.5 Kilar is the standard lens most often found with the camera. It is interchangeable on a unique bayonet mount for which a 105 mm f/4 Tele-Kilar was also made. The camera is occasionally found with a 40 mm f/3.5 Macro-Kilar. Lenses made for the German versions of the Mecaflex do not always mate easily with the bodies of the French-made cameras, and vice versa.

Collectors are particularly attracted to the camera's early form of automatic aperture stop-down by means of an ingenious series of mechanical linkages between body and lens. With the film wound and the reflex mirror lowered, the aperture is first adjusted to its widest setting. At this point, a small lever beneath the lens moves slightly to one side, allowing a pin to spring out from the body and block its return. Now, when the f-stop required for taking the picture is set on the control ring around the lens, the actual aperture remains wide open for easier focusing. First pressure on the shutter release then retracts the pin, allowing the lever to move back, causing the aperture setting to spring to its preset aperture, just before the mirror flips up and the shutter fires.

View from the top, showing the large square magnifier that covers the focusing screen.

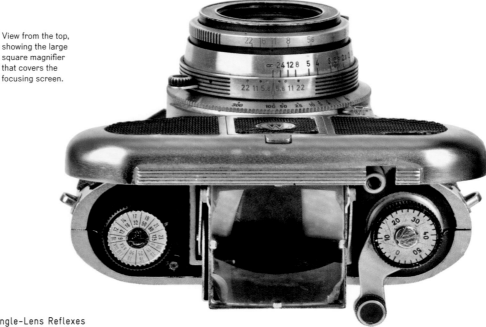

The camera with the
top plate folded up,
ready for action.

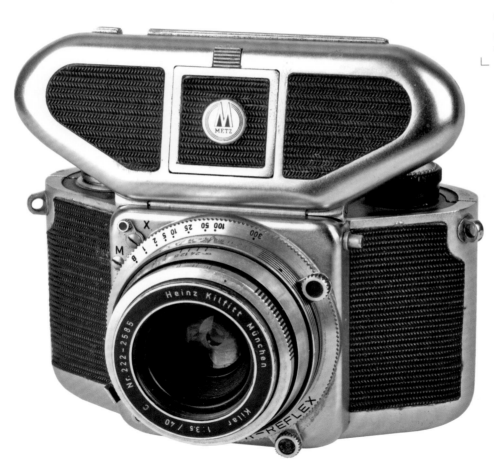

Year of launch: 1953.

Shutter speeds: 1–1/300 second.

Standard lens apertures: f/3.5–f/22.

Exposure: manual.

Mechanically interesting.

Very small body.

The only 24 × 24 mm format 35 mm SLR.

☀ ☀ ☀ ☀ ☀

Other Mecaflex options: limited edition
with brown lizard-skin covering.

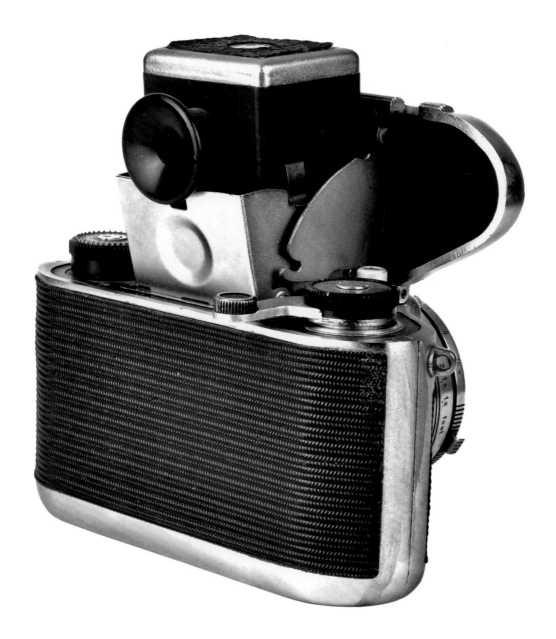

The very rare eye-level viewfinder fits over the focusing screen.

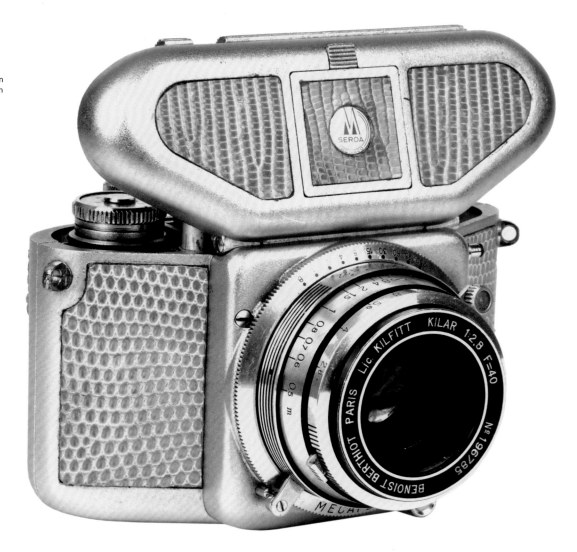

The limited-edition
lizard-skin version
of the Mecaflex.

35 mm Rangefinder Cameras

A rangefinder is a device for measuring distance. Camera lenses need to be accurately focused and an in-built rangefinder is an aid to focusing.

In some cameras the rangefinder is viewed in a separate window to the viewfinder. In others, the rangefinder is incorporated into the viewfinder, so that picture composition and accurate focusing can be carried out simultaneously. A rangefinder might work independently of the camera's focusing control with its reading then transferred manually to the lens's focusing scale. With most rangefinder cameras, however, the rangefinder is coupled to the camera's focusing control, so that it operates as the lens is focused.

The two most common varieties of coupled rangefinder are the coincident image and the split-image types. In the former, two images are overlaid in the rangefinder or viewfinder eye-piece, usually one in the centre of the other and differentiated by subtle colouration. As the lens is focused, the two images move together and, when they exactly coincide, the subject is in focus. In the latter, parts of the image are shown separately, but adjacent, with one slightly offset in relation to the other. The two images come together as the lens is focused until they make a single, uniform image.

Most rangefinders work by the use of two mirrors, one stationary, the other made to swivel and coupled to the lens's focusing mechanism. In this way, two images are overlaid in the rangefinder eye-piece.

Some cameras use prisms in place of mirrors to separate the images. In this design, two glass wedges are placed together, thin end against thick. As the lens is focused, one of the wedges rotates about its axis and so two images are again formed in the rangefinder eye-piece and brought together for accurate focus.

Kodak was the first company to incorporate a coupled rangefinder in a camera's focusing mechanism with the No.3A Autographic Kodak Special in 1916. This was a typical folding design of the day with a drop-down bed and a lens panel that pulled out on bellows.

The rangefinder was fitted below the lens and was used by the photographer standing at 90 degrees to the subject. This revealed a split image, with the parts brought into unison as the focusing knob was turned on the opposite side of the body.

It wasn't until 1932 that rangefinders began to appear in 35 mm cameras and in that year they were incorporated into three models: the Leica II, the Contax I and the Krauss Peggy II.

The majority of 35 mm rangefinder cameras died away as 35 mm SLRs became more popular, starting in the 1960s. With just a few exceptions, rangefinder cameras are divided into two eras: from 1932 until the outbreak of the Second World War in 1939, and post war from 1945 until the early 1960s. The best examples for use today date from the 1950s.

Made by Zeiss Ikon, the 1934 Super Nettel (left) and the 1950 Contessa (below) both use twin-prism-type rangefinders.

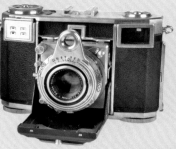

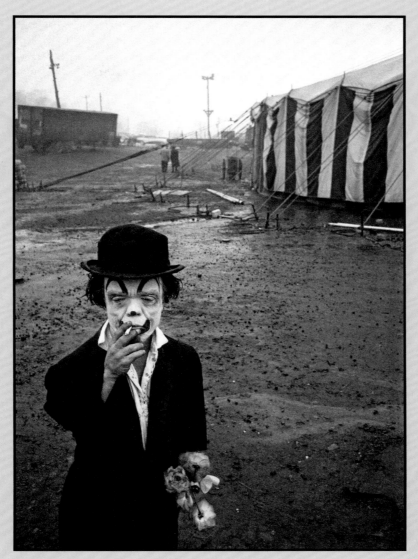

Bruce Davidson, *The Dwarf, Jimmy Armstrong*, Palisades, USA, 1958
© Bruce Davidson/Magnum Photos

The No.3A Autographic Kodak Special was the first camera with a coupled rangefinder.

BUYERS' TIPS

Check smoothness and ease of focusing, as some older cameras can stiffen up.

Check the rangefinder works as the focus is adjusted.

Check the accuracy of the rangefinder by setting the lens at infinity and seeing that distant subjects coincide or line up.

The longer the base of the rangefinder (the distance between the windows), the more accurate it will be.

The best pre-war rangefinder cameras to look at come from Germany: Leicas from Leitz and Contaxes from Zeiss Ikon.

Some of the better post-war German rangefinder cameras were made by Voigtländer. Nikon, Canon and Minolta made the best Japanese cameras.

The Leica II, the Peggy II and the Contax I were the first three 35 mm coupled rangefinder cameras.

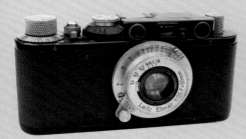

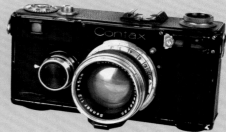

The Cameras ⚡ 35 mm Rangefinder Cameras

Shooting Guide

When using a 35 mm rangefinder camera for the first time it is important to remember that, unlike SLR cameras, the lens and the viewfinder are two separate entities. Sometimes the viewfinder lies directly above the lens and sometimes above and to one side. Either way, the viewfinder image will always be slightly different to the view seen by the camera lens. This is known as parallax.

This difference needs to be taken into account when composing the picture. At middle-to-long distances, when shooting landscapes, it is negligible, but as you move closer to the subject, the difference becomes more pronounced. Some rangefinder cameras have marks in the viewfinder to indicate the differences at close distances. The problem can be overcome by using special reflex attachments for rangefinder cameras.

As with SLR cameras, many rangefinder models accept interchangeable lenses, each of which should have its own dedicated viewfinder according to the focal length of the lens. This means you can use a rangefinder camera with standard, wide-angle and telephoto lenses.

Unlike a reflex camera, the viewfinder in a rangefinder camera shows a clear, sharp image even when the lens is not correctly focused. So a picture may be blurred on film even if it looks sharp in the viewfinder.

Non-reflex cameras favour coincident image rangefinders over split-image types. On most cameras, the rangefinder is coupled to the focusing control, so that when the rangefinder tells you the image is in focus, the lens is automatically set to the correct distance.

Early rangefinder cameras had no form of exposure measurement. If you use one of these, you will need a separate meter to measure exposure. Some rangefinder cameras have non-coupled meters built in and you can use these to take a reading and then transfer it manually to the camera's shutter speed and aperture controls. Through-the-lens, match-needle metering can be found on some rangefinder cameras.

Rangefinder cameras use either focal-plane shutters or leaf shutters. The combination of a near-silent shutter and the lack of mirror noise inherent in a SLR make rangefinder cameras particularly useful to those interested in candid or other forms of unobtrusive photography.

The two square windows on a Contax II are for the rangefinder. The window on the right is also the viewfinder, offset above and to the side of the camera lens.

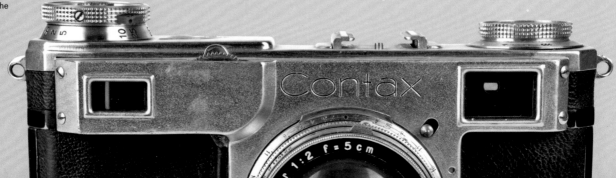

The solid line shows how the viewfinder sees the subject, while the broken line shows (according to the model of camera) how the same subject might record on film.

The combination of a quiet shutter and a small body makes a 35 mm rangefinder camera perfect for candid photography. (Leica CL with 90 mm lens)

A coincident image rangefinder helps to focus a rangefinder camera. When out of focus (near right) the centre of the image is out of alignment, but when in focus (far right) the two images are aligned. The overall image looks sharp at all times.

- The best way to hold a 35 mm rangefinder camera is at eye-level, in a right-handed grip, with the index finger hovering over the shutter release and the left hand operating the focus control, coupled to the rangefinder.

- Use a camera with an in-built meter for faster operation.

- At close distance there will be a difference between the viewfinder image and what appears on film, so you should allow for that.

- If in doubt, leave plenty of space around the subject as seen in the viewfinder.

- Remember that the viewfinder image is always sharp even when the lens is not focused.

- If accessory lenses are to be used, check that the appropriate viewfinders to go with each focal length are available.

Inaccurate viewfinder framing at close distances can be overcome by use of a reflex accessory. This one was made by Sperling, shown here on a Fed 2 rangefinder camera.

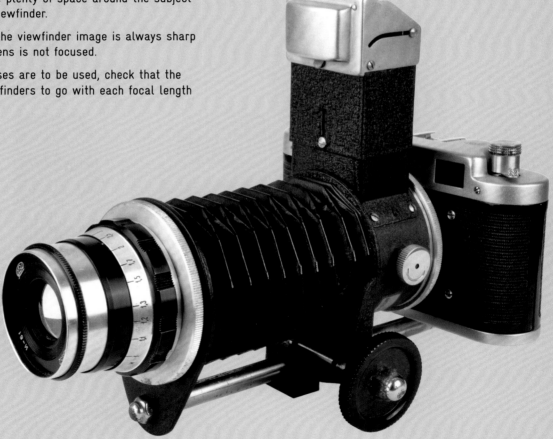

Voigtländer Prominent

Launched when 35 mm rangefinder cameras were at their peak, the Voigtländer Prominent has interchangeable lenses, viewfinders, close-up attachments, filters and other accessories that put it at the heart of a system capable of tackling just about any subject. Even the approaching popularity of SLRs was anticipated with a device that converted it from rangefinder to reflex use.

For today's user, the camera is heavier than most, but it is beautifully engineered and a joy to use. Focusing is controlled by a knob on top of the body, with a focusing scale around its edge and a depth-of-field scale below. As the knob is turned, a standard lens moves back and forth to focus, coupled to the rangefinder in the viewfinder. Early models have a knob to wind the film, while later models use a lever.

Six lenses are available: three 50 mm standards (f/1.5 Nokton, f/2 Ultron and f/3.5 Color-Skopar); a 35 mm f/3.5 Skoparon wide-angle; a 100 mm f/4.5 Dynaron medium-telephoto; and a 150 mm f/4.5 Super-Dynaron. Standard lenses attach to the body via an inner bayonet mount; others use an outer mount and have a different form of focusing. A universal lens hood and a range of filters and close-up lenses individually fit all the lenses. Several accessory viewfinders are available: the best is the Turnit 3. Fitted into the camera's accessory shoe, and with its own parallax adjustment from 3 feet to infinity, it uses a series of masks combined with an ingenious optical system to cover all available focal lengths. The Prominent system also comprises macro stands, a copying stand and a flashgun built into the camera's ever-ready case. With X and M synchronization and a leaf shutter, flash can be used at any shutter speed. A mirror box reflex housing with its own 100 mm f/5.5 Telomar lens bayonets onto the body, converting it into an SLR with options for eye-level or right-angle viewing.

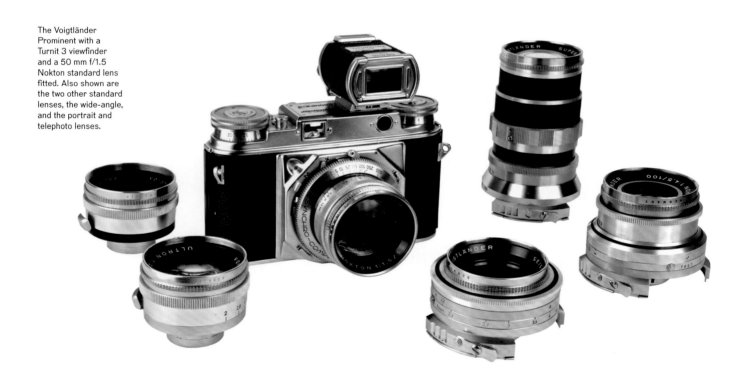

The Voigtländer Prominent with a Turnit 3 viewfinder and a 50 mm f/1.5 Nokton standard lens fitted. Also shown are the two other standard lenses, the wide-angle, and the portrait and telephoto lenses.

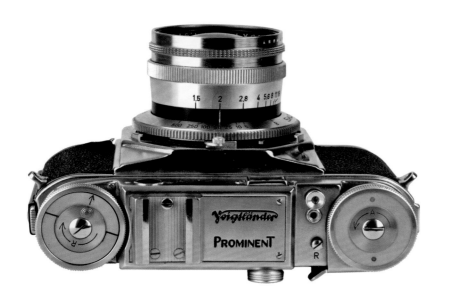

VOIGTLÄNDER PROMINENT

Year of launch: 1951.

Shutter speeds: 1–1/500 second.

Standard lens apertures: f/2–f/16.

Exposure: manual.

Rangefinder: coincident.

Vast range of accessories.

Converts to SLR use.

✴ ✴ ✴ ✴ ✴

Another Voigtländer option: Prominent II with a larger, improved viewfinder containing bright lines for 35 mm, 50 mm, 100 mm and 150 mm lenses.

The filters and lens hood are all made to fit every lens. The two masks adapt the hood for the 100 mm and 150 mm lenses.

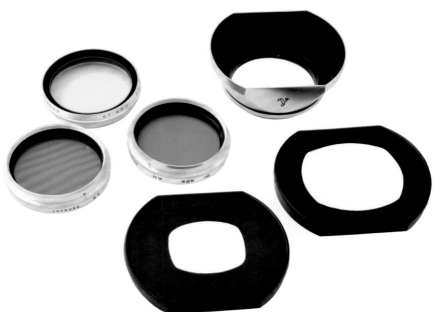

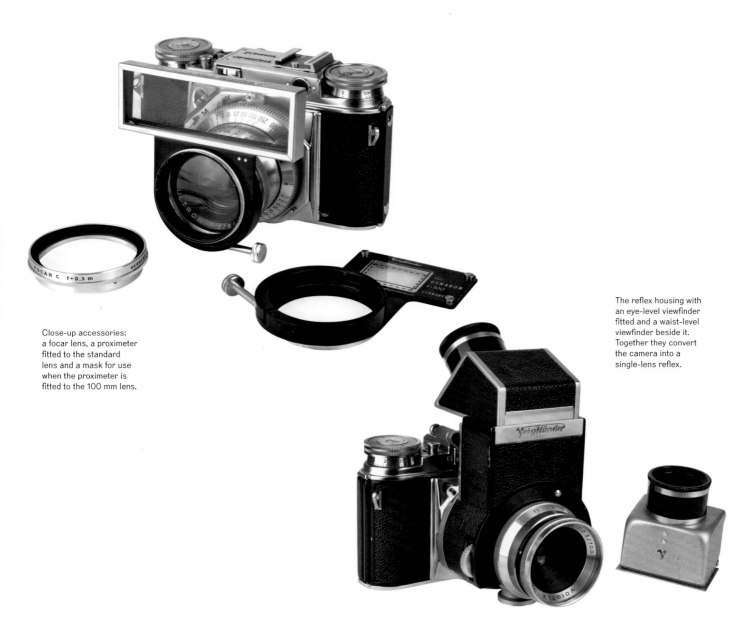

Close-up accessories:
a focar lens, a proximeter
fitted to the standard
lens and a mask for use
when the proximeter is
fitted to the 100 mm lens.

The reflex housing with
an eye-level viewfinder
fitted and a waist-level
viewfinder beside it.
Together they convert
the camera into a
single-lens reflex.

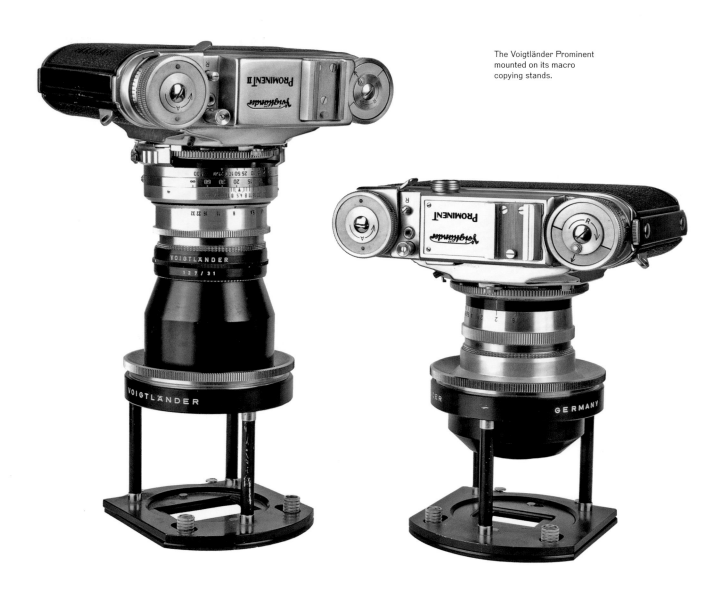

The Voigtländer Prominent
mounted on its macro
copying stands.

Leica M3

When it was launched, the Leica M3 represented a total rethink by Leitz who, until then, had produced cameras that were little more than upgrades to the original Leica I from 1925.

The M3 takes bayonet-fit lenses in place of the screw-fit lenses on previous Leica models. The long-base rangefinder offers greater than usual focusing accuracy and the viewfinder, which incorporates the rangefinder, also features bright frames for 50 mm, 90 mm and 135 mm lenses. The guides automatically appear when each lens is fitted.

The film-wind is a lever. Early cameras require two strokes, although one stroke on later models. A huge range of Leitz lenses and accessories is available for the camera, including the Visoflex, which converts it for reflex use.

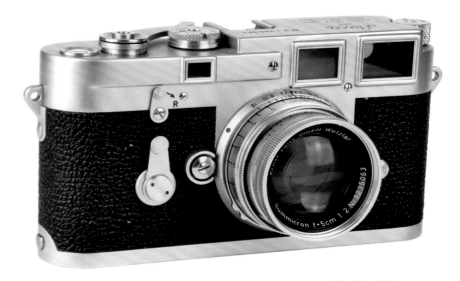

The Leica M3 is considered by some to be one of the best 35 mm cameras ever made.

Top view of the Leica M3 with the lens extended to its shooting position.

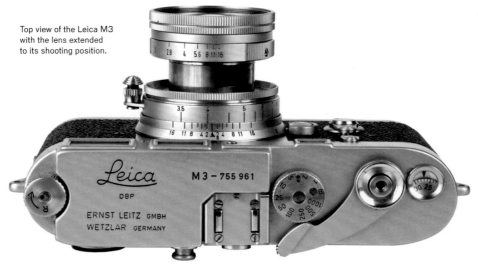

LEICA M3

Year of launch: 1954.

Shutter speeds: 1–1/1000 second.

Standard lens apertures: f/2–f/16.

Exposure: manual.

Rangefinder: coincident.

Vast range of quality Leitz lenses and accessories.

Visoflex reflex accessory useful for close-up work.

☀☀☀☀☀

Other Leica options: M2, a stripped-down version of the M3; other Leica film cameras include the M4, M5, M6 and M7.

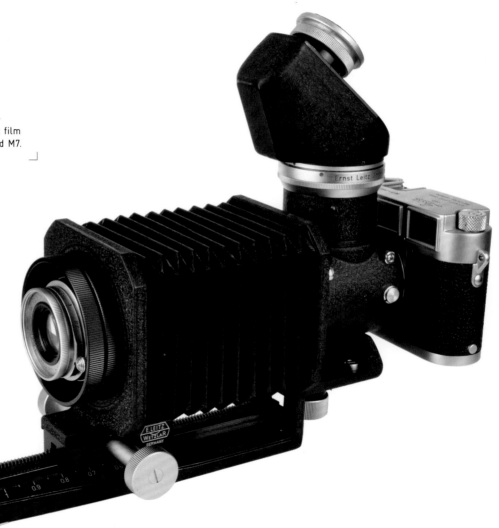

Adapted for close-up photography, the Leica M3 with a Visoflex reflex attachment, an eye-level viewfinder and bellows.

Canon 7

The standard lens of the Canon 7 sets it apart from any other 35 mm rangefinder camera. The focal length is the standard 50 mm, but the widest aperture is a massive f/0.95. It has become known as the Dream Lens.

For use today, the lens is indispensable for low-light photography, although the image is a little soft at the widest aperture. The camera can, of course, also take Canon's more conventional range of lenses.

To accommodate the extra-fine focusing required by the Dream Lens at its widest apertures, the Canon 7 uses a longer than usual rangefinder base, as well as an extra-large Selenium cell that feeds a meter coupled to the shutter control.

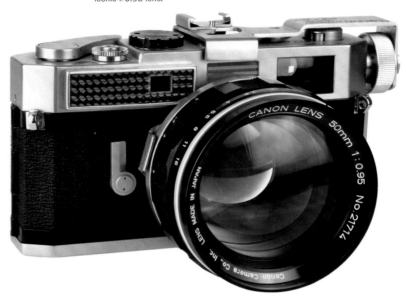

The Canon 7 with its iconic f/0.95 lens.

CANON 7

Year of launch: 1961.

Shutter speeds: 1–1/1000 second.

Standard lens apertures: f/0.95–f/16.

Exposure: meter-assisted manual.

Rangefinder: coincident.

Huge maximum aperture.

Extra-long-base rangefinder for greater accuracy.

☀ ☀ ☀ ☀ ☀

Other Canon 7 options: Canon 7s, with CdS exposure meter; Canon 7z, which is very rare, with a small cosmetic change to the rangefinder.

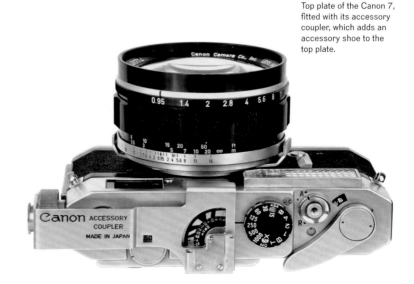

Top plate of the Canon 7, fitted with its accessory coupler, which adds an accessory shoe to the top plate.

Contax IIIa

Before the Second World War, Zeiss Ikon made the Contax I, II and III in Dresden, Germany. After the war, production shifted to Stuttgart, where the Contax II and III were re-launched as the improved IIa and IIIa.

The Contax IIIa is the best of the five cameras. It has a coupled rangefinder in the viewfinder window with focusing controlled by a small wheel that protrudes from the lens panel to fall conveniently under the middle finger as the index finger rests on the shutter release.

A Selenium cell meter on the top plate displays readings to be set manually on the camera.

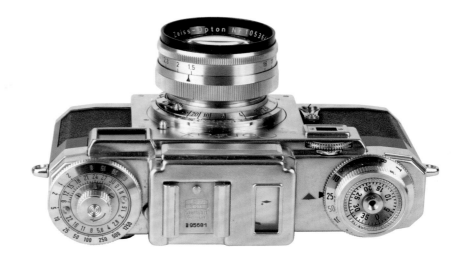

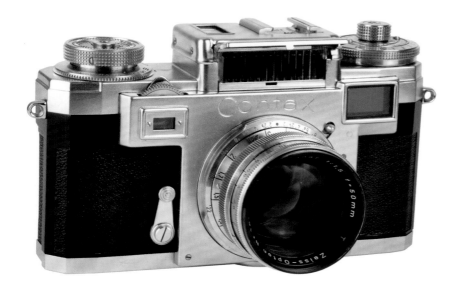

The Contax IIIa with its
meter cell cover open.

CONTAX IIIA

Year of launch: 1951.

Shutter speeds: 1–1/1250 second.

Standard lens apertures: f/1.5–f/16.

Exposure: meter-assisted manual.

Rangefinder: coincident.

Takes wide range of Zeiss lenses.

Easy-to-use focusing control.

☀ ☀ ☀ ☀ ☀

Other Contax options: Contax IIa, a similar camera, but without an exposure meter; also pre-war Contax I, II and III.

Voigtländer Vitomatic IIa

Voigtländer could always be relied upon to produce good-quality cameras and the Vitomatic IIa is no exception, especially when paired with its f/2 Ultron lens.

An in-built Selenium cell meter offers match-needle metering in the viewfinder and in a window on the top plate. X and M flash synchronization means a flashgun can be used at any shutter speed.

The rangefinder, situated in the viewfinder, has quite a short base, so focusing must be carefully checked, especially when shooting at wider apertures that induce shallow depth of field.

The lens is fixed, so it cannot be changed. A proximeter is available for parallax-corrected close focusing.

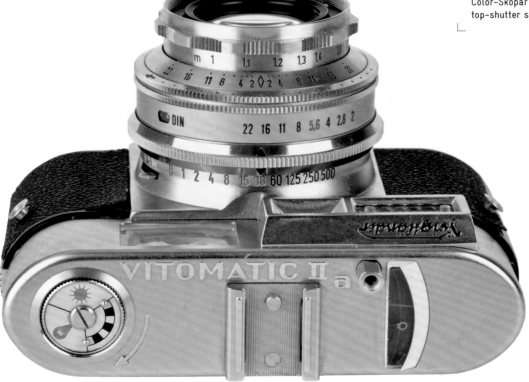

Top view of the Voigtländer Vitomatic IIa, showing the match-needle exposure read-out window.

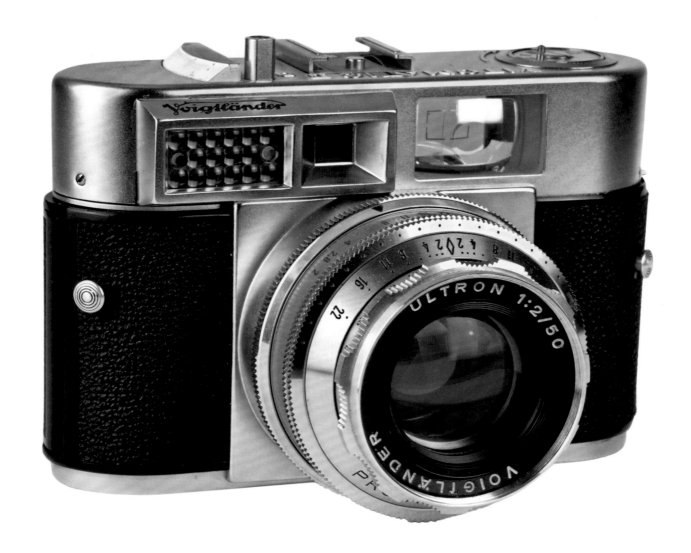

Minolta-35 Model II

Leica had already built a good reputation in the 35 mm rangefinder camera market by the time the Minolta-35 Model II was launched. The Minolta, however, offered a similar specification at a lower price. The same remains true today.

The Minolta places the rangefinder in the viewfinder window, coupling it to the lens. Minolta Rokkor lenses are available but, since it has the same screw mount as the Leica, the huge range of Leica screw-fit lenses can also be used.

Shutter speeds are set by two controls: high speeds on the camera's top plate and slow speeds on a separate control on the front, next to the lens.

Early versions of the Model II, identified by the letters C.K.S. on the top plate, use a 24 × 34 mm film format, while later versions use the conventional 24 × 36 mm format.

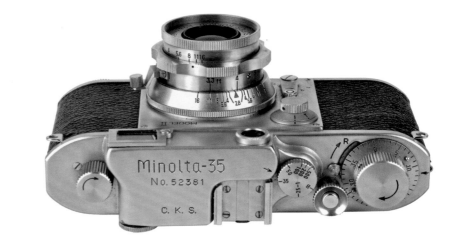

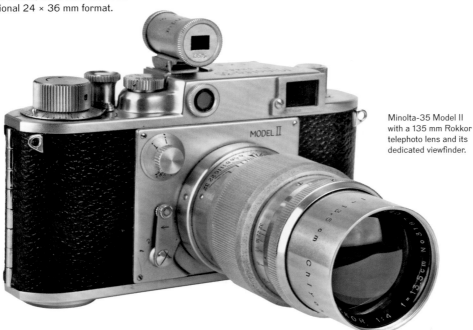

Minolta-35 Model II with a 135 mm Rokkor telephoto lens and its dedicated viewfinder.

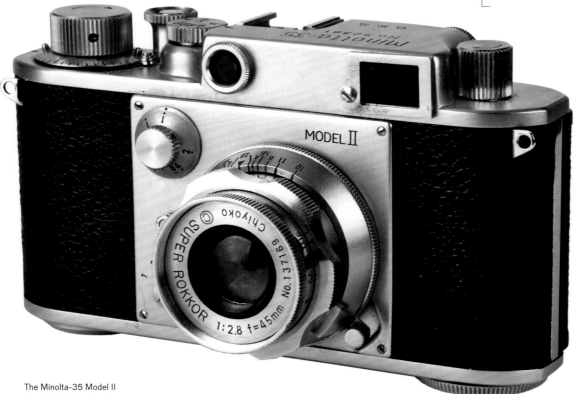

Year of launch: 1953.

Shutter speeds: 1/2–1/500 second.

Standard lens apertures: f/2.8–f/16.

Exposure: manual.

Rangefinder: coincident.

Accepts Leica screw-fit lenses.

✸ ✸ ✸ ✸ ✸

Other Minolta-35 options: Model I,
early versions of the Model I with
a 24 × 32 mm film format are more
collectable and therefore more expensive.

The Minolta-35 Model II
is a viable alternative to
Leica cameras.

Leica CL

The body of the Leica CL was made by Minolta in Japan, while two lenses were made for it by Leitz in Germany: a standard 40 mm f/2 Summicron-C and a telephoto 90 mm f/4 Elmar. Bright frames in the viewfinder give the view for each.

The camera is small, light and easy to use, with a rangefinder in the viewfinder coupled to the focusing. Through-the-lens, match-needle metering is supplied by a Cadmium Sulphide (CdS) cell that swings up behind the lens as the film is advanced, dropping back before the shutter fires. The camera's compatibility with the majority of lenses made by Leitz for its M series of cameras makes the CL particularly versatile.

LEICA CL

Year of launch: 1973.

Shutter speeds: 1/2–1/1000 second.

Standard lens apertures: f/2–f/16.

Exposure: match–needle.

Rangefinder: coincident.

Accepts the majority of Leica M–mount lenses.

✸✸✸✸✸

Another similar option: Minolta CLE, Minolta's version of the camera, with Rokkor lenses and aperture–priority exposure.

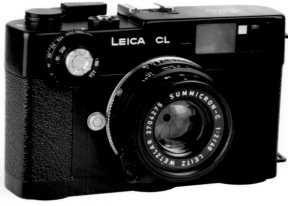

The Leica CL with a 40 mm f/2 Summicron-C fitted, collapsible rubber lens hood and a 90 mm f/4 Elmar.

Konica I

The Japanese company Konishiroku goes back a long way in photographic history and made some excellent cameras.

The Konica I dates back to the late 1940s, but is still a good, usable camera with its coupled rangefinder in the viewfinder. The standard lens is fixed, so it cannot be changed. Before shooting, it must be extended from the body on a short metal tube.

A small button on the back is first pressed to advance the film and then the film is wound by a knob on the top plate. The camera has no double-exposure prevention.

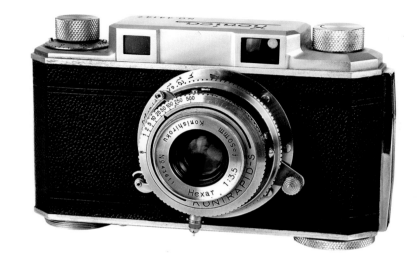

The Konica I with its fixed lens retracted.

KONICA I

Year of launch: 1948.

Shutter speeds: 1/2–1/500 second.

Standard lens apertures: f/3.5–f/22.

Exposure: manual.

Rangefinder: coincident.

Non-interchangeable lens.

✸✸✸✸✸

Other Konica options: variations of the Konica II and III, made with different specifications up to the 1960s.

Kiev-IIa

After the Second World War, the Kiev Arsenal factory in the Ukraine obtained materials and tooling owned by the German Zeiss Ikon factory and began manufacturing its own cameras. Inevitably, they were copies of the German models. The Kiev-IIa is a Contax II in all but name.

The standard lens is a Russian Jupiter, but it shares a mount with Contax cameras and can use German Zeiss lenses. They are focused by a thumbwheel protruding from the top of the body and coupled to a rangefinder in the viewfinder.

Although admittedly not made to the precise standards of its Zeiss counterpart, at a fraction of the cost of a Contax, the Kiev-IIa is a camera worth seeking out and using today.

The Kiev-IIa is a Ukrainian post-war copy of a pre-war German camera (below and opposite, below).

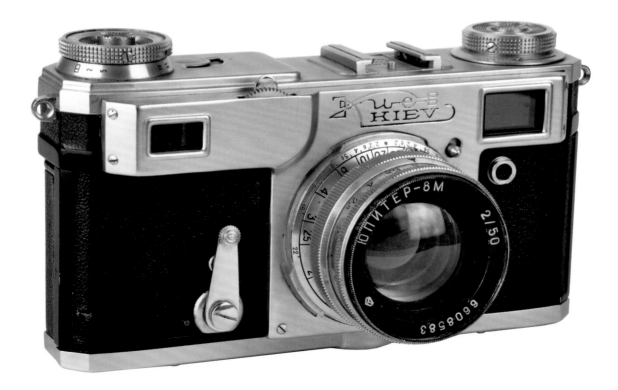

Spot the difference between the Kiev-IIa (below left) and the Contax II (right).

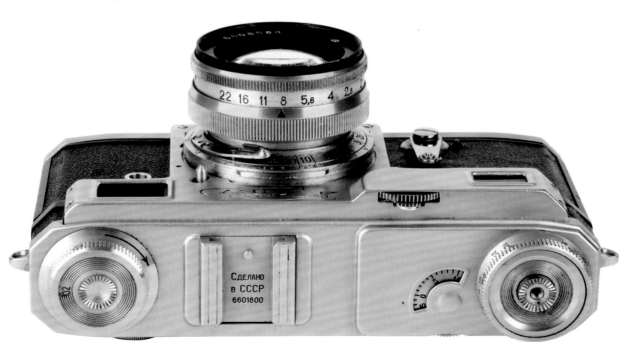

Argus C3

It was originally made just before the Second World War, but variations of the Argus C3 were still being made as late as the 1960s. Over the years it has earned the nickname of The Brick.

The rangefinder is in a window separate to the viewfinder. Focus is achieved by turning a wheel protruding above the camera body and engraved with distances. It is linked via a second gear wheel to the rotating lens. The shutter is tensioned by a lever beside the lens.

The camera is finished in an attractive art deco-style design with twin sockets for a bulb flashgun on the side and a film-speed indicator incorporated into the back.

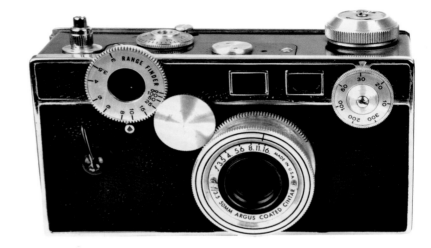

ARGUS C3

Year of launch: 1939.

Shutter speeds: 1/10–1/300 second.

Standard lens apertures: f/3.5–f/16.

Exposure: manual.

Rangefinder: split image.

☀ ☀ ☀ ☀ ☀

Another Argus C3 option: C3 Matchmatic, which was made in 1958 with a two-tone tan and black finish.

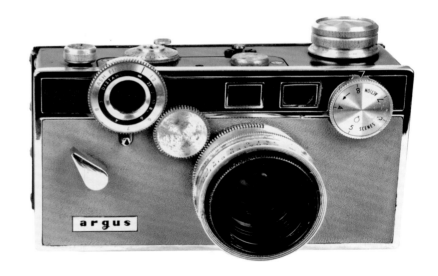

The standard black Argus C3 (top) with its Matchmatic version (above).

Mamiya Magazine 35

At first sight, the Mamiya Magazine 35 looks fairly conventional. The rangefinder is in the viewfinder and coupled to the focusing, which is controlled by a lever attached to a ring around the lens.

What makes it different is the way film is loaded. It isn't loaded into the camera, but into a magazine that can be separated from the body without fogging the film. In this way, one body can be used with two or more magazines pre-loaded to give the photographer the opportunity to change from one type of film to another mid-way through a roll.

The Mamiya Magazine 35 with its magazine removed.

MAMIYA MAGAZINE 35

Year of launch: 1957.

Shutter speeds: 1–1/500 second.

Standard lens apertures: f/2.8–f/22.

Exposure: manual.

Rangefinder: coincident.

Non-interchangeable lens.

Magazine loading for easy film swap mid-roll.

❊ ❊ ❊ ❊ ❊

Other magazine camera options: Adox 300, Kodak Extra (rare and collectable and therefore expensive).

Olympus XA

Rangefinder cameras fell out of favour in the 1960s, but Olympus continued the tradition with the launch of the XA in the late 1970s.

It is a palm-sized camera with a cover that slides to one side to reveal the standard Zuico lens coupled to a rangefinder in the viewfinder. Focusing is carried out by a lever that moves laterally beneath the lens. A thumbwheel on the back winds the film. Setting f-stops on a sliding bar beside the lens activates aperture-priority exposure with no manual control.

Although the electronic shutter offers speeds down to ten full seconds, there is no facility for attaching a tripod to steady the camera at such slow speeds.

OLYMPUS XA

Year of launch: 1979.

Shutter speeds: 10–1/500 second.

Standard lens apertures: f/2.8–f/22.

Exposure: aperture-priority.

Rangefinder: coincident.

Dedicated electronic flash available.

☀ ☀ ☼ ☼ ☼

Other Olympus XA options: XA 1, XA 2, XA 3 and XA 4 in various colours with fixed-focus or zone-focusing lenses in place of the original XA's rangefinder.

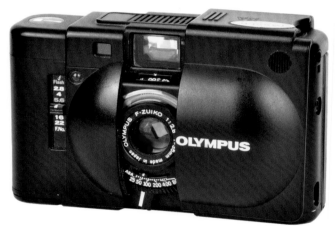

The Olympus XA, along with the Leica M series, is one of the last 35 mm coupled rangefinder cameras.

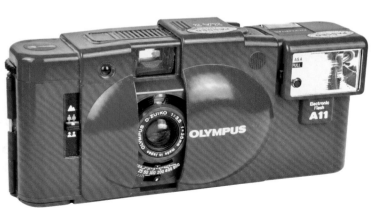

The Olympus XA 2 in red with its dedicated A11 flashgun.

Voigtländer Vitessa

The Vitessa lens sits behind twin barn doors on the front of the body. As the shutter button is pressed, the doors spring open, the lens moves forward on bellows and a rod extends from the top of the camera.

As the rod is pushed down the shutter is tensioned and the film wound. Operating the shutter button with the right hand and the film-wind rod with the left allows very rapid exposures.

The coupled rangefinder is in the viewfinder: the eye-piece can be moved diagonally for parallax correction. Focusing is controlled by a thumbwheel on the back of the body.

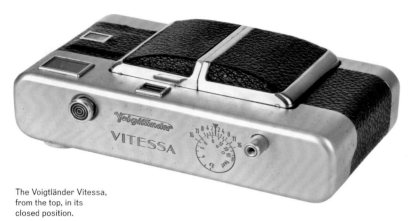

The Voigtländer Vitessa, from the top, in its closed position.

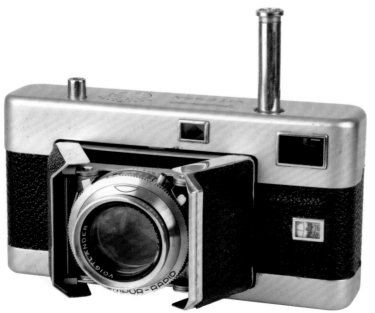

The Voigtländer Vitessa is open and ready for action with the f/2 Ultron lens revealed and its rod extended.

VOIGTLÄNDER VITESSA

Year of launch: 1952.

Shutter speeds: 1–1/500 second.

Standard lens apertures: f/2.8–f/16.

Exposure: manual.

Rangefinder: coincident.

Fast shoot and wind capability.

☀ ☀ ☀ ☀ ☀

Other Voigtländer Vitessa options: Vitessa L, uncoupled exposure meter; Vitessa T, a rigid lens in place of bellows and barn doors.

Leica fakes and copies

Leica cameras have been copied and faked more than any other marque. The workmanship on many does not equal the quality of a real Leica, but some are every bit as good as the original. All are usable by today's retro photographer.

Leica copies and fakes came about because Leitz did not register patents for Leica cameras in Russia or China. In addition, after the Second World War governments in countries where German patents had been registered made those patents available to the public free of charge.

Russian Fed cameras were first produced just two years after the German Leica II was launched in 1932. The Fed continued to be made into the 1950s, so there are still a great many to be found on the second-hand market. In pre-war Russia, Zorki cameras began with a design heavily influenced by the Fed.

Throughout the 1950s the business of copying Leica cameras spread worldwide. The many manufacturers and cameras from this era are too numerous to mention in detail, but two manufacturers are worth singling out. Both made high-quality cameras which, even if not direct copies, were heavily influenced by Leica designs, and are definitely worth using today. They are Canon from Japan and Reid from the UK.

All of these copies look and mostly behave as Leicas do, but they bear the names of their non-Leica manufacturers. Watch out, however, for copies that are also fakes. These cameras, most of which began life as Feds or Zorkis, actually display the Leica name on the top plate with Leica's own Elmar name on the lens. Such cameras are perfectly usable, but they are not the real thing.

One way to tell the difference is to check the serial number on the top plate. The fakes are usually based on Leica II cameras, which had no slow shutter speeds. When the Leica III was launched, a slow speed dial was added to the front beside the lens. Leica III serial numbers start at 107601, so if the serial number is above this, but the camera lacks a slow speed dial, then it's probably a fake.

This equally goes for a strange batch of Leica fakes that still proliferate today. Be assured that if the 'Leica' you bought relatively inexpensively has gold fittings, snakeskin, garish-coloured or even a gold lamé covering, it might still be usable, but it's definitely a fake.

A genuine German Leica II (below left) with a Russian Fed 1 copy (below right).

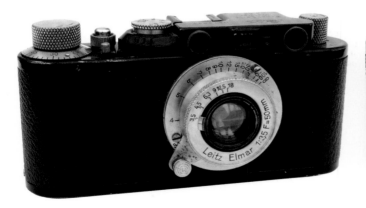
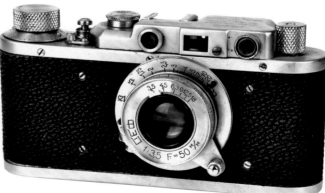

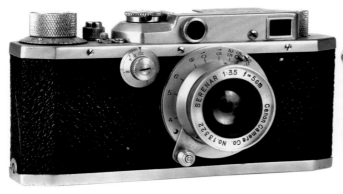

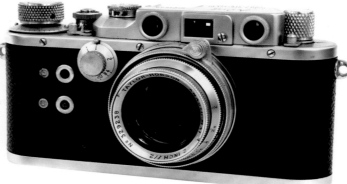

The Canon S-II (above left) and Reid III (above right) are influenced by the Leica III series.

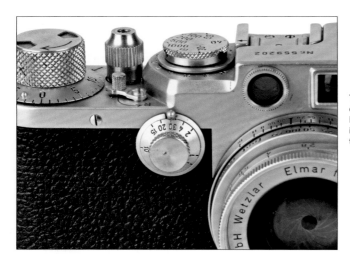

The slow speed dial on the front of a genuine Leica IIIf helps to identify it as part of the Leica III series.

FED 1

Year of launch: 1934.

Shutter speeds: 1/20–1/500 second.

Standard lens apertures: f/3.5–f/18.

Exposure: manual.

Rangefinder: coincident.

Low-cost equivalent of the Leica II.

Accepts Leica screw-fit lenses.

☀☀☀☀☀

Other Fed options: Fed C with added 1/1000 second shutter speed and standard f/2 lens; Fed 2, Fed 3 and Fed 4, variations were made as late as the 1970s.

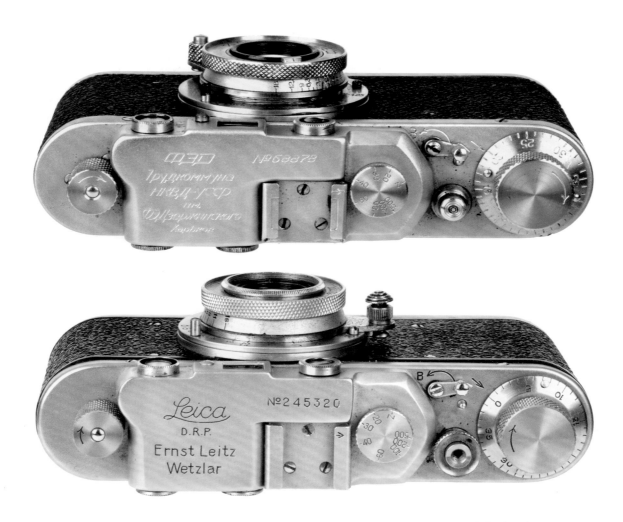

Top plate of a Fed (above) that displays its genuine name in Cyrillic script, and a fake that bears a counterfeit Leica name and an incorrect serial number.

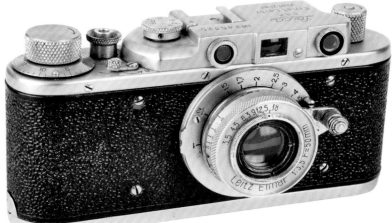

A Leica fake, which probably started life as a Fed or Zorki. It has Leica and Elmar names on the body and lens.

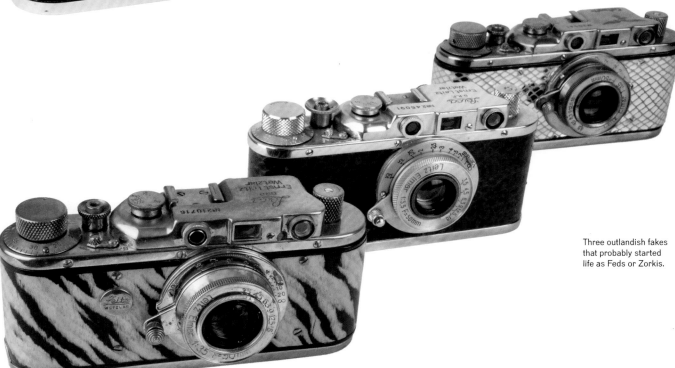

Three outlandish fakes that probably started life as Feds or Zorkis.

35 mm Viewfinder Cameras

Every camera needs a viewfinder of some kind. Non-reflex cameras are equipped with separate viewfinders, which usually stand above and often to the side of the lens. Although some incorporate rangefinders to aid focusing, a rangefinder needn't be a prerequisite for every non-reflex camera. Some offer a bare minimum of exposure and/or focusing information around the viewfinder perimeter, while others are devoid of any extraneous detail. Either way, if the camera is neither a reflex nor a rangefinder model, then it is simply a viewfinder camera.

Thirty-five millimetre film originated in the film industry, where it became known as the standard gauge. Its serious introduction into still photography was thanks to Oskar Barnack, who joined the German Leitz company in 1911 as Director of Research. He soon began work on a 35 mm cine camera, along with a device intended to test small batches of movie film. It became apparent, however, that what he had actually created was a miniature still camera.

A 35 mm movie-frame size measured 18 × 24 mm, with the film running vertically through the camera. However, Barnack ran film through his prototype still camera horizontally, doubling one of the frame dimensions to 24 × 36 mm. This was in 1913, one year before the outbreak of the First World War. After the war Barnack returned to his project and modified that first prototype. He persuaded Ernst Leitz, head of the company, to build a batch of cameras to test the market.

Scientists and photographers were sceptical, but Ernst Leitz took a risk. With a name derived from the words LEItz CAmera, the result was the first Leica and the birth of the now traditional 24 × 36 mm format for 35 mm cameras. This was in 1925 and, although there had been cameras capable of accepting 35 mm a decade or more before, it is the Leica that is generally considered to be the first viable 35 mm viewfinder camera.

These are not, however, workable examples of this camera type. The first model is a sought-after collectable today, but not the best camera for working photography, and when the second Leica model was introduced, a rangefinder was incorporated, remaining in all Leica cameras from that point on.

Viewfinder cameras should not be considered inferior to rangefinder cameras, especially since any viewfinder camera with an accessory shoe can be equipped with a separate accessory rangefinder.

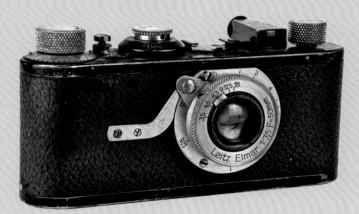

The Leica I is considered to be the first truly viable 35 mm viewfinder camera.

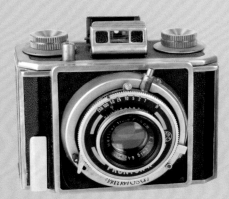

Viewfinder cameras like the Mimosa I (left) and Tenax (below) are collectable, though not very practical for the retro photographer.

┌─ ─┐
 BUYERS' TIPS

Check the size of the viewfinder: some are too small to be practical.

Ensure that the viewfinder is clear without signs of mistiness.

Search out well-known manufacturers where the budgets for particular models didn't extend to a rangefinder.

Look for first versions of cameras where later models went on to be a higher spec.

Consider simple models where the makers didn't find a rangefinder necessary.

Non-reflex, non-rangefinder camera manufacturers include prestigious names such as Voigtländer, Kodak, Rollei, Diax, Olympus, Minox, Minolta and Zeiss Ikon.

└─ ─┘

The Akarette I, with standard and medium telephoto lenses and twin viewfinders that switch between the views for each, crosses the divide between usable and collectable.

Shooting Guide

Using a 35 mm viewfinder camera is similar to using a 35 mm rangefinder camera, with the obvious difference that it does not contain a rangefinder. Before raising the camera to the eye, therefore, it is necessary to ascertain the distance between the camera and the principal subject and then set that manually on the lens.

The best way to measure the distance is with an accessory rangefinder that fits into the camera's accessory shoe. Most of these are coincident image types. If this isn't possible, then an approximate camera-to-subject distance can be determined by imagining yourself lying down head to toe between the camera position and the subject. If you know your own height, then it's easy to work out an approximate distance. Setting the smallest practical aperture increases depth of field and helps cover inaccuracies in your estimations.

Another method is to set the lens at what is called the hyperfocal distance. This is tied in with the lens's focal length and your chosen aperture. The easiest way to do it, if your camera has a depth-of-field scale, is to set infinity on the lens-focusing ring against your chosen aperture on the depth-of-field scale. Then look at the opposite end of the scale to see what distance is set against the same aperture. Everything between those two distances will be in focus.

One problem with some early viewfinder cameras is the small size of the viewfinder. Using an auxiliary viewfinder in the camera's accessory shoe can help. Eye-level accessory viewfinders are the most common, but a few waist-level types can also be found.

- Since the lens cannot be focused while the camera is held to the eye, the best way to hold a viewfinder camera is with a gentle but firm grip on each side with the right index finger on the shutter release.

- Invest in a separate rangefinder.

- If using an auxiliary viewfinder, make sure it matches the focal length of your standard lens.

- If using interchangeable lenses, make sure you have the appropriate viewfinders for them.

- Familiarize yourself with the depth-of-field scale.

- Remember to allow for parallax, particularly if you are using longer focal-length lenses.

Depth-of-field scale (in red) on a Voigtländer Vito B lens.

From a 35 mm
transparency taken with
a Rollei B35 and fixed
40 mm standard lens.

A French rangefinder
on a Memox 35 mm
viewfinder camera.

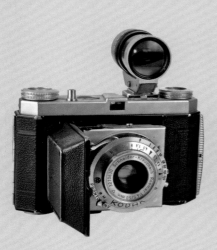

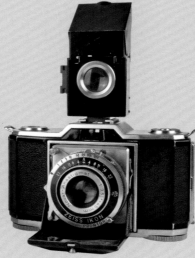

Compensating for small
camera viewfinders:
an auxiliary eye-level
viewfinder adjustable
for different lens focal
lengths on a Retinette
and a waist-level
viewfinder on a Zeiss
Ikon Ikonta.

Adox 300

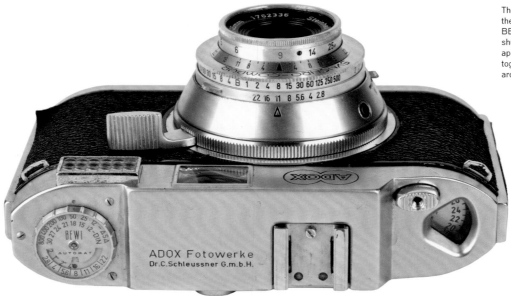

The Adox 300, from the top, showing the BEWI meter and how shutter speeds and apertures are locked together on controls around the lens.

The Adox 300 offered the rare opportunity in a 35 mm camera of allowing film to be safely changed mid-way through a roll without the need for a darkroom or changing bag.

This is possible because it has interchangeable film magazines. If you open the back of an Adox 300, then you see an empty space rather than the film plane, the sprockets to engage and wind the film, the space for a cassette and the take-up spool. The familiar parts and mechanisms used to load and wind the film are contained in the separate magazine, which is loaded in a way similar to any 35 mm camera.

Each magazine also incorporates a metal blind to shield the film from the light. As the magazine is dropped into the camera and the back closed, latches used to lock it also wind the metal film-protecting blind out of the light path. When a magazine needs to be changed mid-way through a film, unlocking the camera back also winds the protecting blind back into place.

Shutter speeds and apertures can be locked together to retain the basic exposure when either is changed. For example, with 1/125 second locked to f/11, changing the shutter speed to 1/250 second automatically changes the aperture to f/8; changing the aperture to f/16 changes the shutter speed to 1/60 second and so on.

A BEWI Automat meter fed by a Selenium cell beside the viewfinder measures the exposure, which is then transferred manually to the camera's shutter speed and aperture settings. For film-winding, the Adox has a lever that protrudes from, and rotates around, one side of the lens, winding the film and tensioning the shutter at the same time. It makes winding and shooting faster than with more conventional top-mounted knobs or levers.

A rangefinder and interchangeable lenses were planned for future versions of the camera, which never got beyond the prototype stages.

Year of launch: 1957.

Shutter speeds: 1–1/500 second.

Standard lens apertures: f/2.8–f/22.

Exposure: meter-assisted manual.

Interchangeable film magazines.

Non-interchangeable lens.

✹ ✹ ✹ ✹ ✹

Other 35 mm magazine camera options: Kodak Ektra and Mamiya Magazine 35, both with coupled rangefinders.

The Adox 300 is one of only a few 35 mm cameras that used integral film magazines.

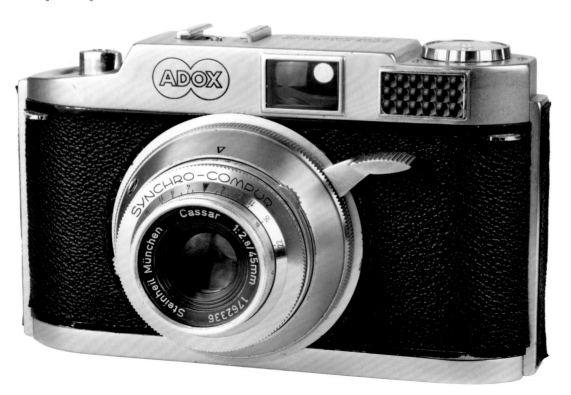

The layout inside the film magazine is similar to the inside of a 35 mm camera, with the addition of the metal blind to protect the film.

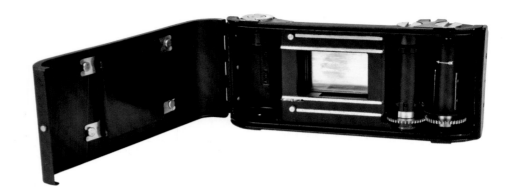

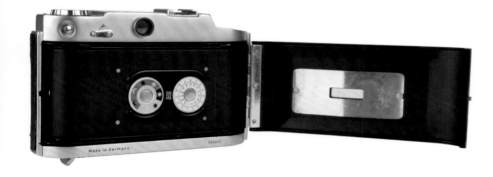

The magazine slotted into the camera.

The space inside the camera is devoid of all the usual mechanisms.

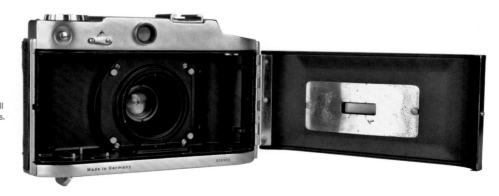

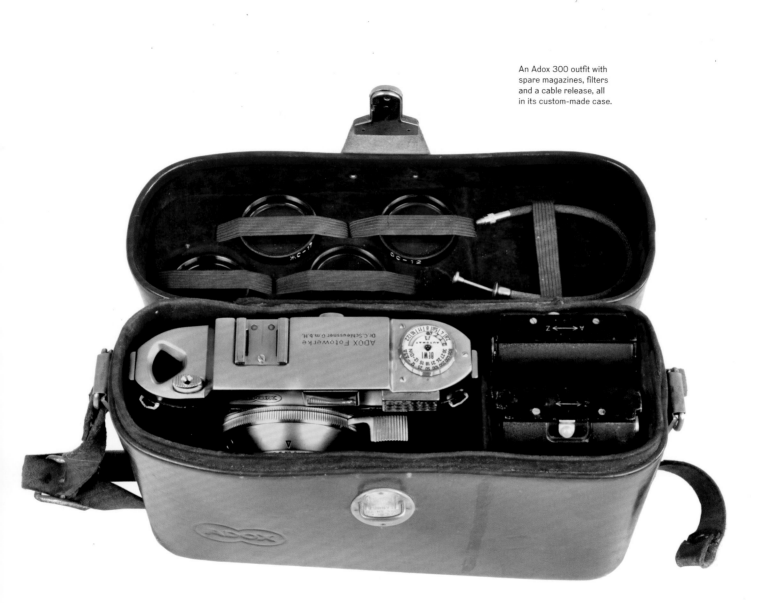

An Adox 300 outfit with
spare magazines, filters
and a cable release, all
in its custom-made case.

Diax Ia

The Diax Ia offered the flexibility of interchangeable lenses, so it needed to have a way to preview different focal lengths. Each camera, therefore, has three viewfinders.

On the back of the body there are three eye-pieces, marked 45–50, 35 and 90, the figures refer to lens focal lengths. To help differentiate between them, the 45–50 viewfinder is clear, the 35 one has a blue tint and the 90 one is yellow.

More traditional accessory viewfinders are also available for lenses with focal lengths from 35 mm wide-angle to 135 mm telephoto. The lenses fit to the camera via an unusual female thread on the lens and a male thread on the body. Close-up lenses and proximeters, filters, lens hoods and a copying stand are among the many dedicated accessories.

DIAX IA

Year of launch: 1952.

Shutter speeds: 1–1/500 second.

Standard lens apertures: f/2–f/16.

Exposure: manual.

Interchangeable lenses.

Three viewfinders for different focal-length lenses.

✳✳✳✳✳✳

Other Diax options: Diax Ib, a lever-film-wind in place of a knob, Diax IIa and IIb with coupled rangefinders.

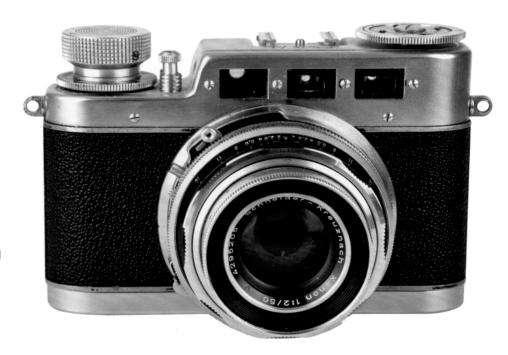

Here you can see (from the front and the back) the three viewfinder windows.

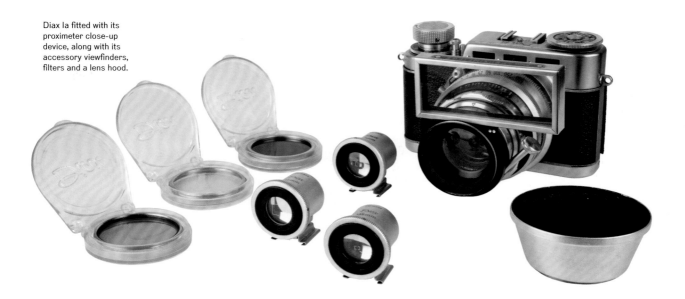

Diax Ia fitted with its proximeter close-up device, along with its accessory viewfinders, filters and a lens hood.

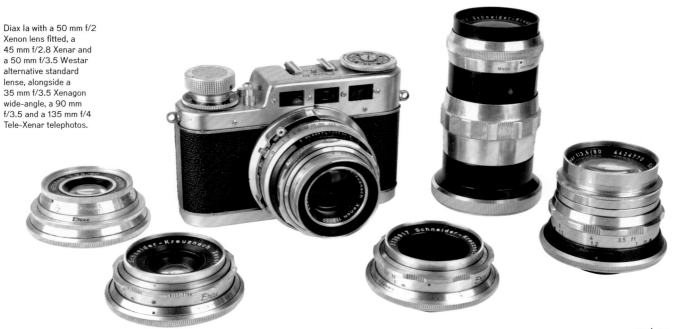

Diax Ia with a 50 mm f/2 Xenon lens fitted, a 45 mm f/2.8 Xenar and a 50 mm f/3.5 Westar alternative standard lense, alongside a 35 mm f/3.5 Xenagon wide-angle, a 90 mm f/3.5 and a 135 mm f/4 Tele-Xenar telephotos.

Rollei B35

This is a palm-sized 35 mm mechanical camera with an in-built Selenium cell exposure meter that deflects a needle in a dial on the top plate. With a control turned to the required shutter speed, the needle moves to suggest the correct aperture. Each is then set manually.

The 40 mm Triotar lens retracts into the body when not in use, which adds to the camera's trim dimensions. However, the lens can only be retracted after the film-wind lever is advanced, which means the camera must be stored with the shutter tensioned.

ROLLEI B35

Year of launch: 1969.

Shutter speeds: 1/30–1/500 second.

Standard lens apertures: f/3.5–f/22.

Exposure: meter-assisted manual.

Fixed lens.

Extremely compact.

✸✸✸✸✸

Other options: Rollei 35 LED, C35, 35T, 35S and 35SE, made with varying specifications until the 1980s.

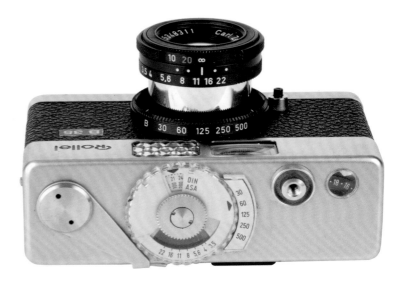

The B35, from above, with the lens extended for shooting.

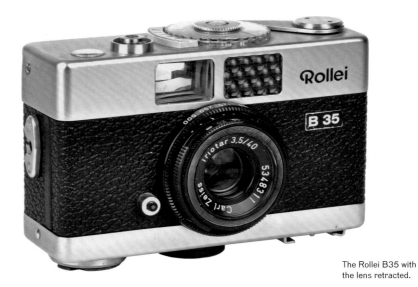

The Rollei B35 with the lens retracted.

Olympus Trip

The Olympus Trip was one of the most successful cameras of its era, and is very simple to use.

If you set the aperture ring to 'A' then the Selenium cell meter that surrounds the lens will automate both shutter speed and aperture. Focus can be set accurately with markings from 3 feet to infinity on the bottom of the lens, or set against four symbols – head and shoulders, two figures, groups and mountains – on the top.

Apertures can also be set manually, which is essential if the Olympus Trip is used with a flashgun. A thumbwheel on the back winds the film.

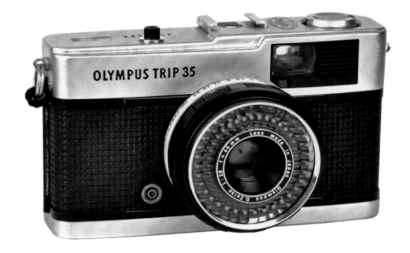

The Olympus Trip from the top, showing its simple lens-focusing symbols.

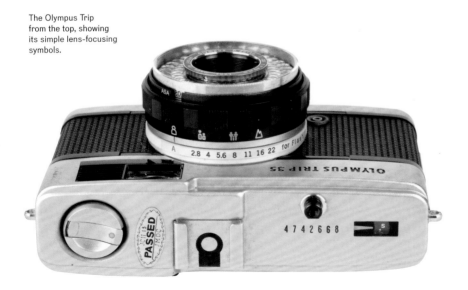

OLYMPUS TRIP

Year of launch: 1967.

Shutter speeds: 1/40 or 1/200 second.

Standard lens apertures: f/2.8–f/22.

Exposure: programmed.

Fixed lens.

Very easy to use.

✱✱✱✱✱

Other options: Olympus Pen and Pen EE series of half-frame cameras that came before the Olympus Trip and largely influenced its design.

Retinette

Kodak launched the Retina in 1934 as the first budget-priced 35 mm camera for the photographer who could not afford a Leica or a Contax. It was a folding camera, as the early Retinettes were. In 1955 the first rigid-body, non-folding Retinette appeared, and was sold at an even lower price than the Retina models. This and the subsequent models will be of most interest to today's retro photographer.

This first Retinette features a viewfinder window directly above the lens. Apertures and shutter speeds are set on rings around the lens, and can be locked together to maintain the same exposure as f-stops or shutter speeds are changed. Focusing from 3½ feet to infinity is set on the front of the lens.

The Retinette, made by a well-reputed maker, is a basic, fully manual viewfinder camera with no unnecessary extras. It is capable of producing good-quality images.

RETINETTE

Year of launch: 1955.

Shutter speeds: 1–1/500 second.

Standard lens apertures: f/3.5–f/22.

Exposure: manual.

Apertures and shutter speeds can be locked together.

☀ ☀ ☀ ☀ ☀

Other options: later Retinette models with larger, brighter viewfinders and, by the 1960s, in-built exposure meters.

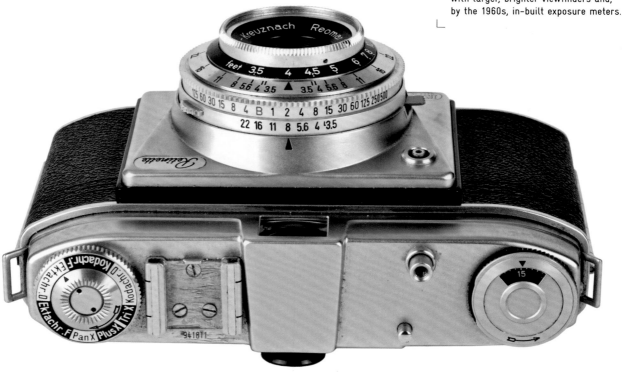

The Retinette, from the top, showing the linked aperture and shutter-speed scales.

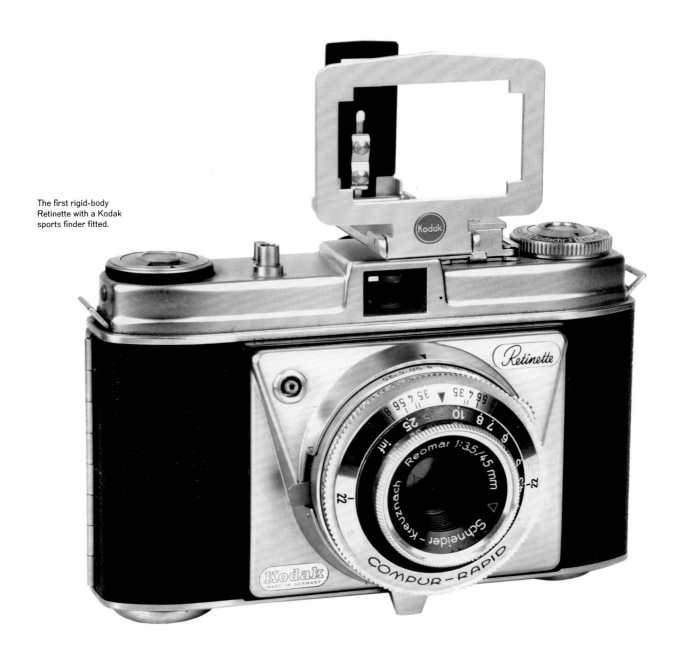

The first rigid-body
Retinette with a Kodak
sports finder fitted.

Werra I

When it was launched, the Werra I must have confused some photographers because it appeared to have no controls other than a shutter button in the top plate.

However, if you remove the conical-shaped lens cover then the usual apertures for the lens are revealed on a ring around the barrel adjacent to the focusing scale and the shutter speeds. The lens cover can then be reversed to make a lens hood.

The unusual film-wind is operated by turning a collar around the lens. It is a strange design but it is capable of good results from its Zeiss optics.

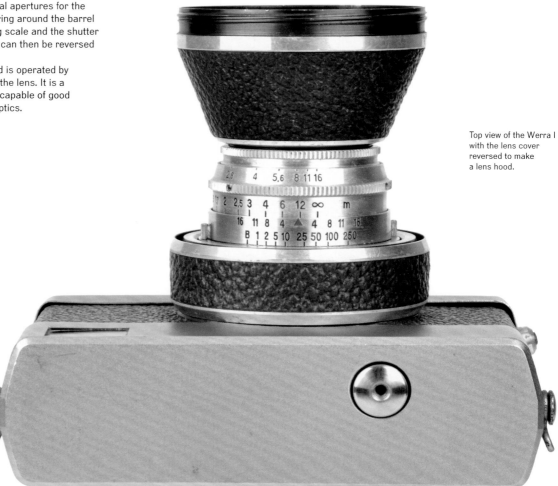

Top view of the Werra I with the lens cover reversed to make a lens hood.

WERRA I

Year of launch: 1955.

Shutter speeds: 1–1/250 second.

Standard lens apertures: f/2.8–f/16.

Exposure: manual.

Fitted lens hood.

❋ ❋ ❋ ❋ ❋ ❋

Other Werra options: variations made into the 1960s as brightline viewfinders, meters and rangefinders were added.

The Werra I with the lens cover in place.

Voigtländer Vito B

There are two versions of the Voigtländer Vito B: the first with a small viewfinder and a later version with a larger, brighter viewfinder. Both are capable of producing quality images.

Film-loading is made simple with the help of a hinged base plate. As the film is advanced with the wind lever, it engages with a sprocket wheel inside the camera, which turns to tension the shutter before firing. Because of this, it is easy to assume that the camera is faulty because the shutter fails to fire unless a film is loaded.

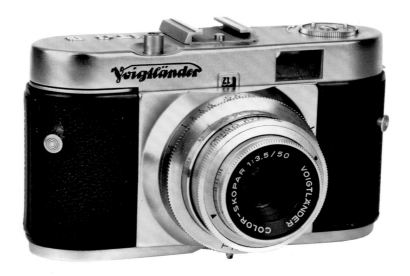

The early version of the Voigtländer Vito B with the smaller viewfinder.

Here you can see how a hinged base plate facilitates easier film-loading.

VOIGTLÄNDER VITO B

Year of launch: 1954.

Shutter speeds: 1–1/300 second.

Standard lens apertures: f/3.5–f/16.

Exposure: manual.

Easy film-loading.

☀☀☀☀☀

Other options: Vito BL, uncoupled exposure meter; Vito BR, coupled rangefinder.

Ricoh Auto Half

As its name suggests, the Ricoh Auto Half is a half-frame camera, which means it takes 72 exposures: 18 × 24 mm on a standard roll of 35 mm film. It is also unusual because it has an in-built clockwork motor drive that advances the film automatically after each exposure.

The two shutter speeds and apertures on the fixed-focus lens are controlled automatically by a large Selenium cell surrounding the lens. Red and yellow indicators in the viewfinder warn when light levels are too low for shooting.

The base of the Ricoh Auto Half, showing the knob that winds the clockwork motor and the film rewind knob.

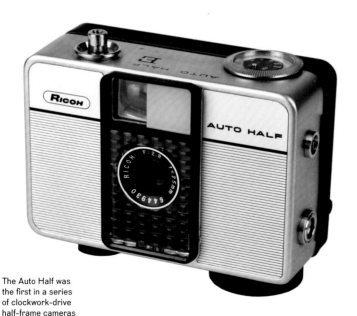

The Auto Half was the first in a series of clockwork-drive half-frame cameras from Ricoh.

RICOH AUTO HALF

Year of launch: 1960.

Shutter speeds: 1/30 or 1/125 second.

Standard lens apertures: f/2.8–f/16.

Exposure: programmed.

In-built clockwork film advance.

✳ ✳ ✳ ✳ ✳

Other Ricoh options: the Auto Half SE, Auto Half SL and Auto Shot.

Favor I

When the original Favor cameras were made in 1948 the factory was based in Saarland, a French-occupied German state, where the company assembled Leicas on behalf of Leitz. This explains the Favor's reputation for being good quality.

The Favor I has everything a good camera needs, without any unnecessary embellishments. The lens focuses to 3 feet and the Prontor-S shutter is tensioned by a lever above the lens and fired by a button on the top plate. All the controls are set on rings around the lens and a depth-of-field scale is positioned behind the focusing distances.

It is a good, basic, easy-to-use manual camera.

FAVOR I

Year of launch: 1950.

Shutter speeds: 1–1/300 second.

Standard lens apertures: f/2.8–f/16.

Exposure: manual.

☀ ☀ ☀ ☀ ☀

Other options: Favor II, with lever film-wind in place of a knob.

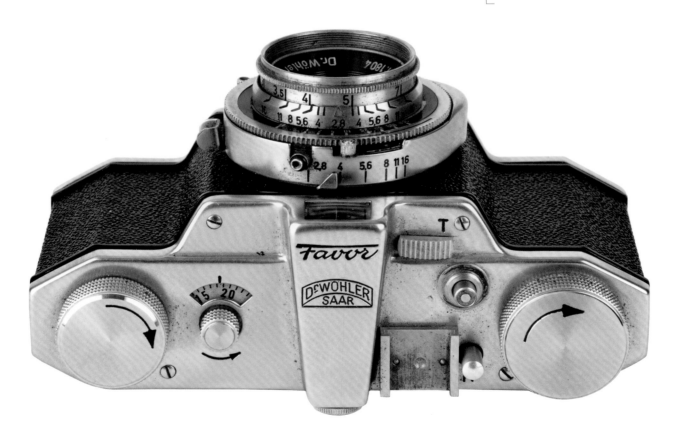

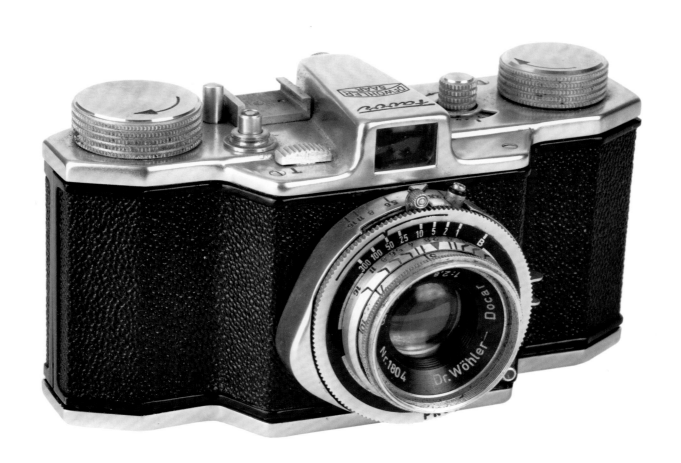

Graflex Century 35A

Graflex was an American company, but by 1959 its cameras were made by Kowa in Japan.

The camera is unconventional because of the film-wind lever that sits beneath the lens. If you hook your left index finger around this lever, with your right index finger on the shutter release, then film-winding and shutter-firing are quicker than normal.

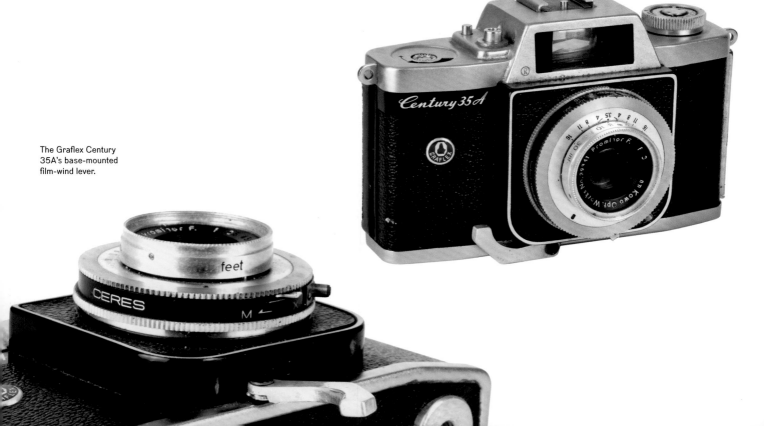

The Graflex Century 35A was made for Graflex by Kowa in Japan.

The Graflex Century 35A's base-mounted film-wind lever.

Contessa S310

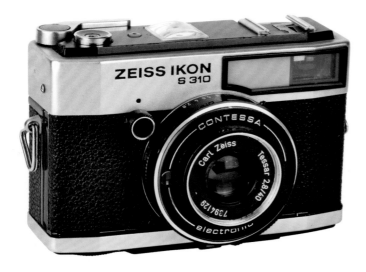

The S310 was one of the last Zeiss Ikon cameras to bear the Contessa name. With aperture-priority and a CdS meter, f-stops are set on a ring around the lens and shutter speeds are automatically set by the camera. The electronics are powered by four PX625, or equivalent, batteries that drop into the base plate.

For such a small camera, the viewfinder is relatively large and extremely bright. It has information about the set speed and aperture, and symbols that indicate the focused distance on the left, right and top.

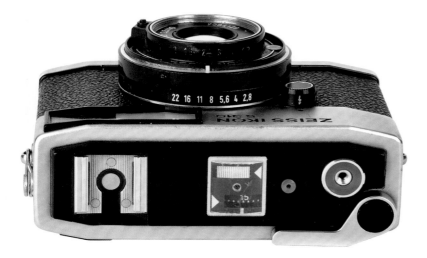

CONTESSA S310

Year of launch: 1971.

Shutter speeds: 1/30–1/500 second.

Standard lens apertures: f/2.8–f/22.

Exposure: aperture-priority.

Quality Zeiss Tessar lens.

✳✳✳✳✳

Another option: S12 model with a rangefinder added.

Minox 35 EL

Famous more for its range of sub-miniature spy-like cameras, Minox diversified into 35 mm viewfinder models with the 35 EL. It was claimed to be the world's smallest full-frame 35 mm camera.

The sleek dimensions are thanks in part to a flap that folds down from the front to allow the lens to emerge from the slim body. With the lens retracted and the flap closed, the camera is about the size of a cigarette packet.

Depending on the set film speed, shutter speeds can extend to a full 30 seconds. A useful depth-of-field scale completes the specification.

The Minox 35 EL open and closed.

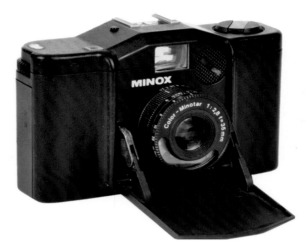

MINOX 35 EL

Year of launch: 1974.

Shutter speeds: 30–1/500 second.

Standard lens apertures: f/2.8–f/16.

Exposure: aperture-priority.

Pocket size when folded.

☀☀☀☀☀

Other options: Minox 35 GL, 35 GT, 35 MB, 35 ML, 35 PL and 35 PE, each has design improvements that lasted until the 1980s.

Ilford Advocate

The Ilford Advocate stands out from the crowd because of its ivory-coloured die-cast aluminium silicon body.

It is a full-frame 35 mm camera, but the fixed standard lens is a wide-angle with a 35 mm focal length. The shutter is released by an unusually placed lever that protrudes from the front of the top plate, and the cable-release socket is at the bottom of the front of the body beside the lens.

Although conventional in its technical specification, the ivory-coloured body set the Advocate apart from its rivals when it was launched and it still remains an eye-catcher for today's retro photographer.

ILFORD ADVOCATE

Year of launch: 1949.

Shutter speeds: 1/25–1/200 second.

Standard lens apertures: f/3.5–f/22.

Exposure: manual.

Unusual ivory-coloured body.

☀ ☀ ☀ ☀ ☀

Other Advocate options: fairly common with f/4.5 Dallmeyer lens, but rarer with the f/3.5 Wray Lustrar lens.

The Ilford Advocate with its rare Wray Lustrar lens.

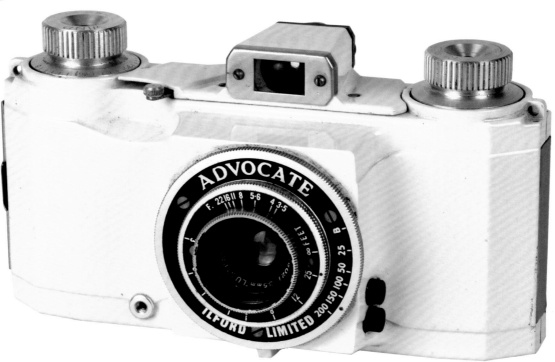

Periflex I

The Periflex I is an English viewfinder camera with an unusual semi-reflex aid to focusing. It was originally intended to be only a body with a focal-plane shutter for the use of Leica screw-fit lenses. As manufacture progressed, however, a focusing aid was added.

A rangefinder was ruled out as being beyond the technical skills of the Corfield factory where the camera was manufactured, and converting the Periflex to an SLR would have meant a total redesign. The unusual compromise was to add a small periscope that could be manually pushed down into the film plane to magnify part of the image by a factor of eight. After that, it was a foregone conclusion that the manufacturer added its own range of lenses. So the Periflex, as it originally came to the market, was born, and its name was derived from the two words that epitomized its design: PERIscope and reFLEX.

The first model, which is rarely seen these days, is made in a distinctive brown pig-skin covering on an aluminium body, with a top and base plate in a black anodized finish. The shutter is tensioned by a rotating knob on the top plate and released by a button on the front of the body beside the lens.

Soon after its launch, when it was discovered the pig-skin body was prone to finger marks, the camera was re-launched with a black leatherette covering. This is the version that retro photographers are more likely to find for use today.

The periscope is used by looking down into an eye-piece. A separate accessory can be found to fit on the top of the periscope, magnifying the image slightly and also turning it through 90 degrees so that the camera can be held at eye-level. A range of optical viewfinders for lens focal lengths between 28 mm and 135 mm fits into the accessory shoe beside the periscope.

For today's retro photographer, the Periflex isn't the most practical of designs, but the camera presents an interesting challenge for those wishing to take a true piece of British photographic history and put it to work.

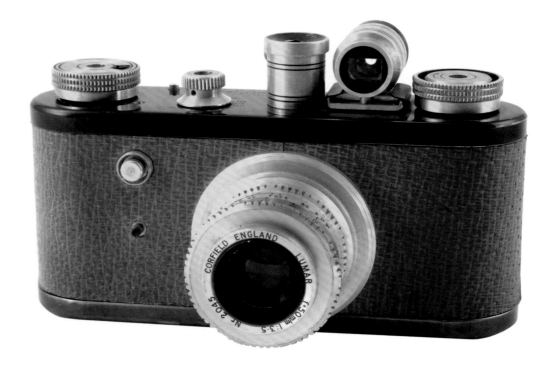

The original Periflex I with its distinctive pig-skin-covered body.

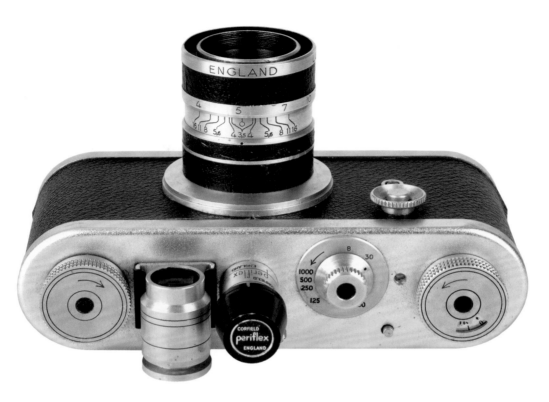

Periflex viewfinders: the periscope version, fitted with its 90-degree accessory; the direct vision viewfinder is beside it.

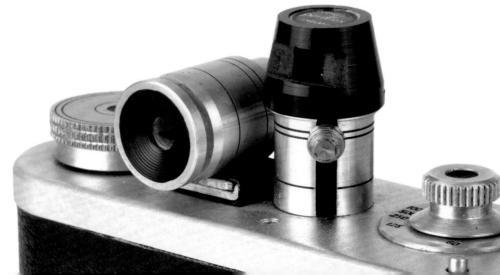

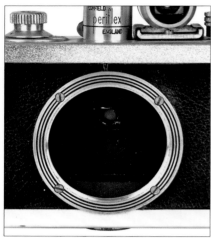

With the lens removed, the periscope mirror can be seen in front of the focal-plane shutter.

PERIFLEX I

Year of launch: 1953.

Shutter speeds: 1/30–1/1000 second.

Standard lens apertures: f/3.5–f/16.

Exposure: manual.

Unusual periscope-type viewfinder.

☀ ☀ ☀ ☀ ☀

Other Periflex options: Periflex 2, 3, 3a, 3b, Gold Star, Interplan and Maxim made into the 1960s.

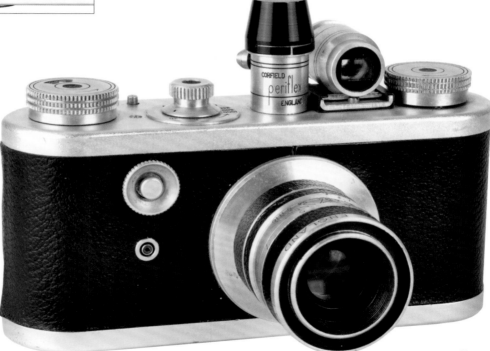

The second version of the Periflex with a black leatherette covering.

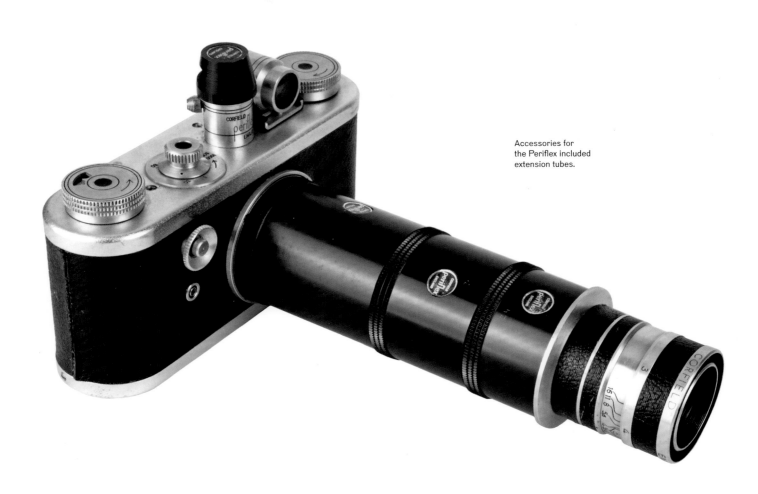

Accessories for
the Periflex included
extension tubes.

Roll-Film Single-Lens Reflexes

A great many single-lens reflexes were made to be used with glass plates. These are avidly sought by collectors, but glass-plate photography is totally impractical for the retro photographer. Roll film is far more practical. The various image sizes produced by the use of roll film are generally grouped under the term medium format.

The earliest roll-film camera, called The Kodak, was introduced in 1888. In the years that have followed, a great many different sizes of roll film have come and gone, but two sizes have endured: 120 and, to a lesser extent, 127.

The history of the two film types began in 1901 when George Eastman introduced the No.2 Brownie, a box camera. The Brownie had first been seen in 1900, but the No.2 Brownie was the first camera to use 120 size film. The 127 size came a little over a decade later in 1912 with the Vest Pocket Kodak, a simple folding camera.

Roll film, as its name suggests, comes in rolls and is attached to backing paper. The backing paper is longer than the film with a leader and trailer at each end to protect the film from exposure to light as it is loaded and unloaded.

The backing paper also contains numbers, which are read through a red window in the back of the camera to indicate the point to which the film must be wound for each exposure. Depending on where the numbers are situated, the position of the red window and a mask at the film plane, one size of film can offer more than one format. Of course, the larger the image size, the lower the number of pictures that can be produced from a roll of film, and vice versa.

Soon after roll film became commercially available, film adapters began to appear for many plate cameras. But for the retro photographer such cameras might be cumbersome and impractical. SLRs made specifically for either 120 or 127 size film are easier to use and better-quality pictures will be obtained.

Unlike 35 mm SLRs, which are commonly used with eye-level viewfinders, most roll-film reflexes are made to be used at waist level. The image is laterally reversed left to right, but many roll-film reflexes offer eye-level viewfinders as optional accessories, which corrects this aberration. Most photographers dedicated to this type of photography, however, prefer to compose their pictures on large, waist-level ground-glass screens.

The 1929 Ensign Roll Film Reflex takes 120 film, which means that it is still usable, but this tropical version is more likely to be considered a collector's item than a working camera.

BUYERS' TIPS

Decide which format best suits your needs and budget.

Choose a waist-level or eye-level viewfinder, according to your preferred type of photography.

Consider the expense of extra lenses, which are considerably more than 35 mm camera optics.

Weigh the advantages of a focal-plane shutter against a leaf shutter.

Think about possible accessories, especially a good, firm tripod.

Remember that larger lenses require bigger and more expensive filters.

Popular names to look for include Mamiya, Hasselblad and Bronica. But consider also Russian cameras such as the Zenith 80 or Pentacon Six.

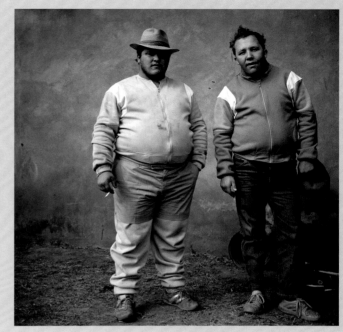

Roger Ballen, *Johan and Bertie, Brothers*, Western Transvaal 1987
Courtesy of Roger Ballen

The No.2 Brownie (near right) and the Vest Pocket Kodak (far right) introduced the 120 and 127 film sizes that we still use today.

Shooting Guide

There are two styles of roll-film SLRs: those used at waist level and those used at eye-level. Many waist-level cameras can be converted to eye-level use by exchanging viewfinders; many eye-level types convert similarly for waist-level use. Cameras made for waist-level operation are usually box-shaped. Eye-level cameras look more like giant 35 mm SLRs.

With a waist-level SLR you see the whole screen at a single glance, which makes it ideal for picture composition. Most cameras incorporate a magnifier, which can be used close to the eye to check sharpness of focus.

A waist-level camera uses a single mirror to reflect the image to the viewfinder, so the image is laterally reversed. This means that anything moving left to right in front of the camera will appear to be moving right to left in the viewfinder. Turning a waist-level camera that shoots rectangular rather than square pictures on its side to shoot vertically is a problem: first, the viewfinder position means it needs to be viewed at 90 degrees to the subject and, second, the image turns upside down. Exchanging the waist-level viewfinder for an eye-level version solves that problem and also corrects the left-to-right image orientation.

An eye-level roll-film SLR that can be converted for waist-level viewing is used in the same way, except that eye-level viewing comes first with waist-level operation as the secondary option.

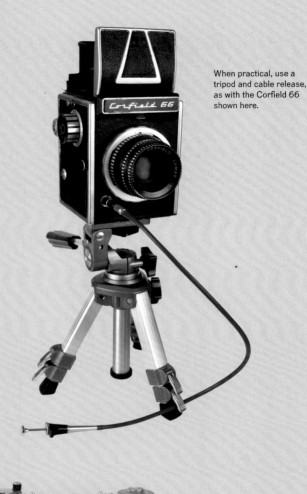

When practical, use a tripod and cable release, as with the Corfield 66 shown here.

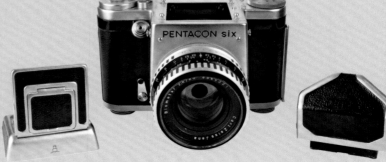

Pentacon Six roll-film SLR with eye-level and waist-level viewfinders.

Here you can see the difference between the image seen by the camera lens (far left) and the laterally reversed image seen in a waist-level SLR viewfinder (near left).

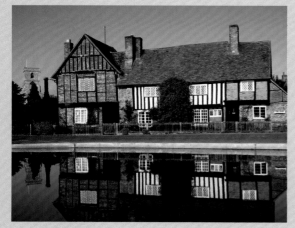

A 6 × 7 cm transparency taken with a Mamiya RB67 roll-film SLR.

- ◉ The way to hand-hold a waist-level SLR is with both hands, elbows bent, tight into the body, so that you can see the whole viewfinder at a glance.

- ◉ A roll-film SLR is best used on a tripod with a cable release to fire the shutter.

- ◉ Working at waist-level, use the highest practical shutter speed to compensate for camera shake, which is inherent in this type of camera when hand-held.

- ◉ An eye-level roll-film SLR can be held and operated like a large version of a 35 mm SLR.

- ◉ If shooting action, the viewfinder image in an eye-level camera is more practical than the laterally reversed image in a waist-level SLR.

- ◉ If your preference is for eye-level working, use a camera made for the purpose; converting a box-shaped camera designed for waist-level operation to eye-level viewing makes it awkward to use.

Mamiya RB67 Pro-S

The Mamiya RB67 Pro-S shoots 6 × 7 cm images, ten to a roll of 120 film.

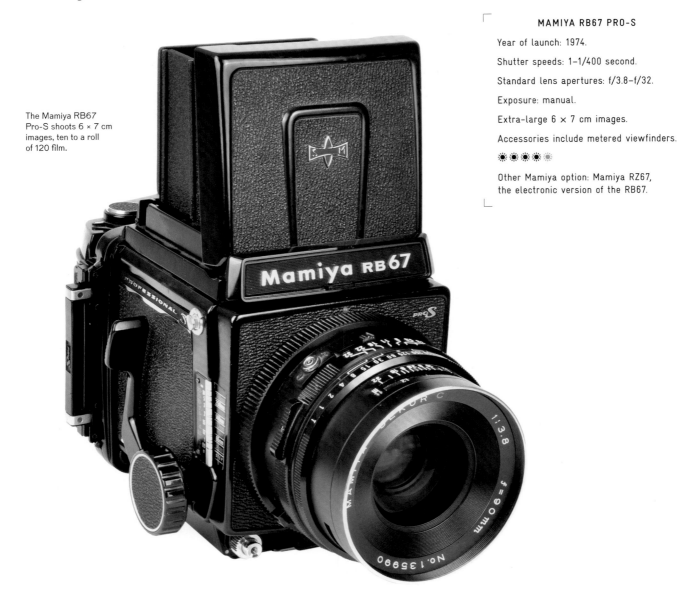

MAMIYA RB67 PRO-S

Year of launch: 1974.

Shutter speeds: 1–1/400 second.

Standard lens apertures: f/3.8–f/32.

Exposure: manual.

Extra-large 6 × 7 cm images.

Accessories include metered viewfinders.

☀☀☀☀☀

Other Mamiya option: Mamiya RZ67, the electronic version of the RB67.

The RB67 was launched in 1970 and followed by the RB67 Pro-S four years later. It was subsequently re-launched as the RB67 Pro SD. The Pro-S is the most popular of the three. It is a mechanical camera that shoots ten 6 × 7 cm images on 120 film. The body contains the focusing screen, the reflex mirror and the lens panel, which extends on bellows. The standard lens contains the shutter, and M and X synchronization means flash can be used at any shutter speed.

Film is loaded into a separate magazine that detaches from the body when sliders top and bottom are pushed to one side. After loading, the film-wind lever is advanced until it locks and the number '1' appears in the frame-counter window beside it. The back is then refitted to the body.

Opening the focusing hood reveals a 7 × 7 cm screen with indicators to show the 6 × 7 cm picture area. The film-back can be rotated through 90 degrees for horizontal or vertical pictures. A lever on the side of the

body is depressed to lower the mirror, enabling the lens to be focused on the ground-glass screen. A magnifier in the back of the hood flips up for more accurate focusing.

Focusing is effected by turning either of two large knobs on the lower sides of the front of the body, which move the lens panel back and forth. As the lens is focused, a scale on the side of the bellows is gradually revealed to show colour-coded distances as they apply to focal lengths from 50 to 60 mm.

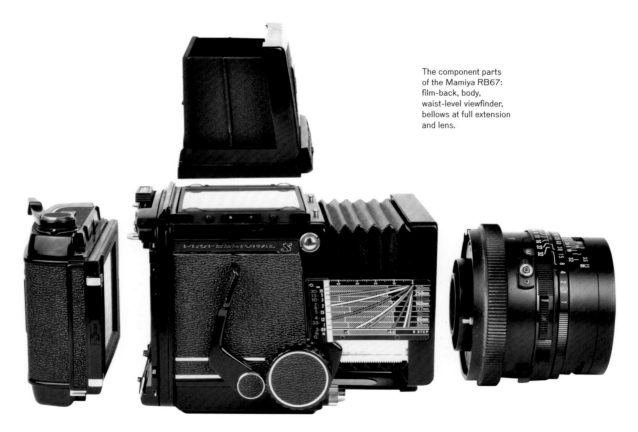

The component parts of the Mamiya RB67: film-back, body, waist-level viewfinder, bellows at full extension and lens.

Mamiya RB67 Pro-S with a speed grip, eye-level prism viewfinder and extension tubes for close-up photography.

The film-back, open ready for loading.

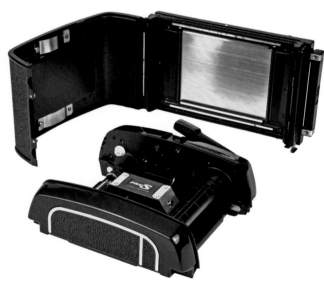

The film-back can be rotated for horizontal or vertical pictures.

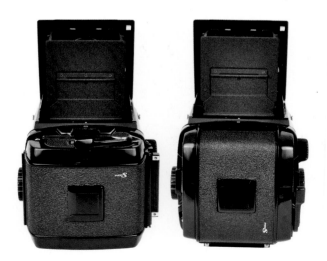

Shutter speeds are set on a ring surrounding the lens. Behind that, a second ring adjusts apertures. At this stage, however, the lens remains open at its full aperture to make focusing easier. A lever beneath the lens manually rotates to indicate depth of field for the chosen aperture at the focused distance.

Before taking the picture, a metal dark slide must be removed from the film-back. This stands between the film and the body and is there to protect the film if the back is changed mid-way through a roll. The shutter will not fire until this slide has been removed. It can be stored by slotting it into grooves on one the side of the body.

As the shutter release is pressed, the mirror moves up, the lens stops down to its pre-selected aperture and the shutter fires at its preset speed. With the picture taken, the viewfinder image disappears until the next time the mirror is lowered. The film is wound by the lever on the magazine.

The Mamiya RB67 Pro-S accepts a wide range of interchangeable lenses from 37 mm fish-eye to 500 mm telephoto, attached and detached on a bayonet mount released by a breach-lock system. Other accessories include fold-down rubberized lens hoods, filters, interchangeable focusing screens, extension tubes, bellows and interchangeable viewfinders for eye-level viewing and CdS metering.

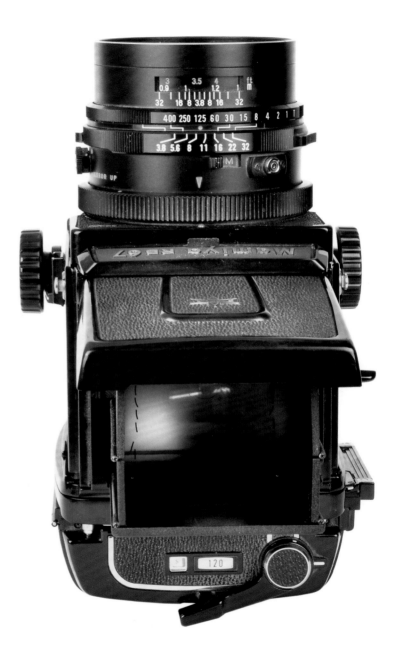

Hasselblad 500CM

The Hasselblad 500CM is a mechanical camera with leaf shutters incorporated into its lenses. It breaks down into the usual modular design of body, lens, viewfinder and film-back. Full-aperture viewing is maintained as the film is wound and the aperture opens to its widest setting, stopping down automatically just before the shutter fires.

The 500CM is notable for the ease with which the viewfinder focusing screens can be exchanged, and it is worth seeking out one that has had the special bright screen fitted, increasing the light to the screen by at least one, maybe two, stops. A wide range of lenses and accessories is available.

HASSELBLAD 500CM

Year of launch: 1970.

Shutter speeds: 1–1/500 second.

Standard lens apertures: f/2.8–f/22.

Exposure: manual.

Modular design.

Leaf shutter in lens.

✹ ✹ ✹ ✹ ✹

Other Hasselblad options: 1600F and 1000F, named for their highest shutter speeds, each using a focal-plane shutter in the body.

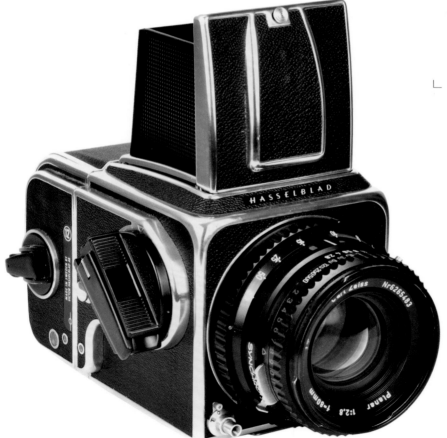

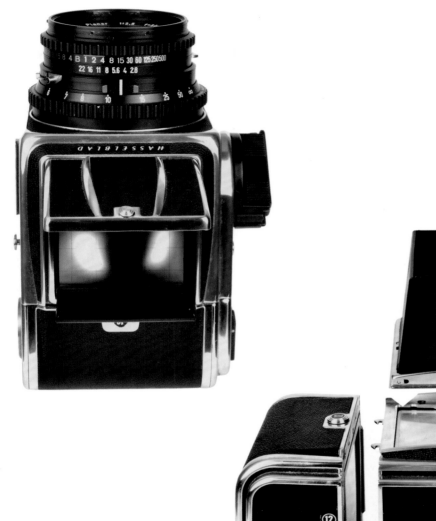

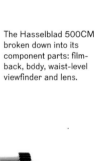

The Hasselblad 500CM broken down into its component parts: film-back, bddy, waist-level viewfinder and lens.

Zenith 80

This is a Russian copy of the first Hasselblad, shooting 12 pictures 6 × 6 cm on 120 film. The standard lens is the 80 mm Industar-29, but two others were made for the camera: a 65 mm f/3.5 Mir-3 wide-angle and a 300 mm f/4.5 Tair-33 telephoto.

A preset lever opens the aperture to its widest setting for focusing. The shutter speed must be set before winding the film, otherwise the mechanism will jam. As the release is pressed, the lens stops down to its pre-selected aperture, the mirror flips up and the shutter fires.

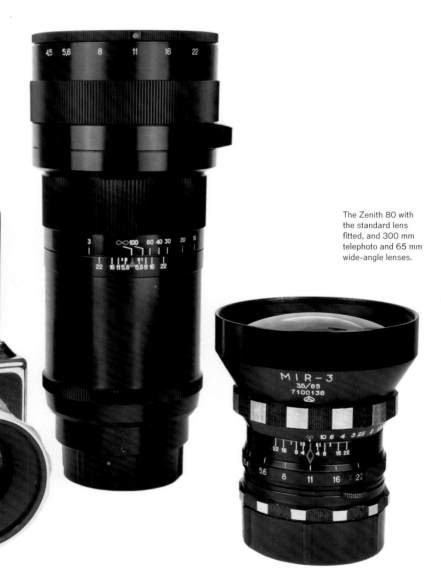

The Zenith 80 with the standard lens fitted, and 300 mm telephoto and 65 mm wide-angle lenses.

ZENITH 80

Year of launch: 1972.

Shutter speeds: 1/2–1/1000 second.

Standard lens apertures: f/2.8–f/22.

Exposure: manual.

Modular design.

Focal-plane shutter.

✳✳✳✳✳✳

Other options: Salyut and Salyut S, similar cameras whose Russian names predated the Zenith 80.

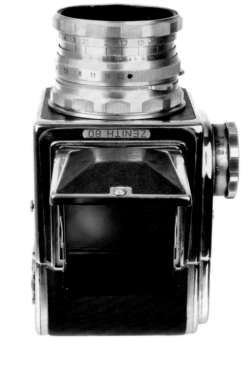

The Zenith 80 broken down into its component parts: film magazine, body, waist-level viewfinder, standard lens and collapsible rubber lens hood.

Pentacon Six

The Pentacon Six resembles a large 35 mm camera, with a choice of eye-level or waist-level viewfinders.

There is no separate film magazine, which means that once the film has been loaded, it cannot be changed. The camera shoots 12 6 × 6 cm exposures on 120 film.

Prestigious manufacturers, including Carl Zeiss Jena and Schneider, made interchangeable lenses in the Pentacon mount. Viewing screens are also interchangeable.

A top-mounted lever winds the film, lowers the mirror and opens the lens aperture to its widest setting. Shutter speeds are set on a top plate dial and apertures are set on a ring around the lens, with the aperture remaining wide open for easier focusing until exposure. The mirror does not return until the film is wound again.

PENTACON SIX

Year of launch: 1956.

Shutter speeds: 1–1/1000 second.

Standard lens apertures: f/2.8–f/22.

Exposure: manual.

Styled like a large 35 mm SLR

Focal-plane shutter.

☀ ☀ ☀ ☀ ☀

Other options: Praktisix with similar specification; Kiev 60, which shares the Pentacon lens mount.

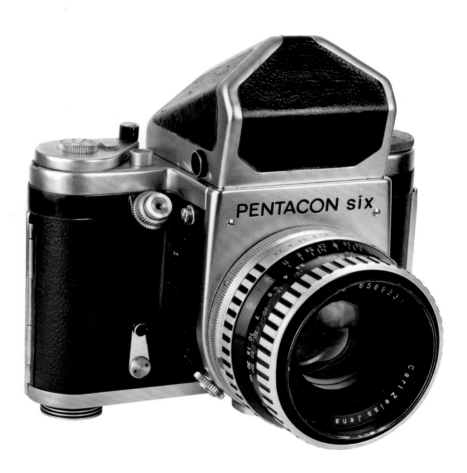

The Pentacon Six with an eye-level viewfinder.

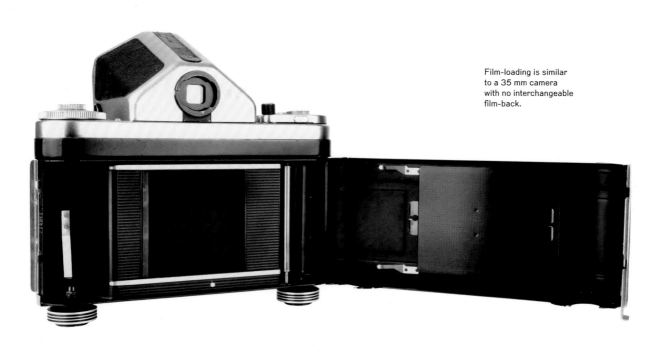

Film-loading is similar to a 35 mm camera with no interchangeable film-back.

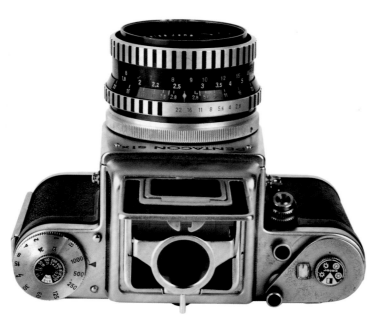

The Pentacon Six, from the top, and fitted with the waist-level viewfinder.

Exakta B

The original Exakta, launched in 1933, was the first truly compact roll-film reflex. The Exakta B, launched two years later, is a better camera because of its extra shutter speeds.

The speeds are set between 1/1000 second and 1/25 second on a conventional top-mounted speed dial, but an ingenious clockwork mechanism, wound by a knob on the top of the camera, adds slow speeds from 1/10 second to a full 12 seconds.

The all-black body has a tapered design that slopes away from the lens panel. The left-handed shutter release is placed beside the lens. The camera takes eight exposures of 4 × 6.5 cm on 127 film and is usually found with a 75 mm Exaktar standard lens. Other lenses were made by independent makers, including Zeiss and Schneider.

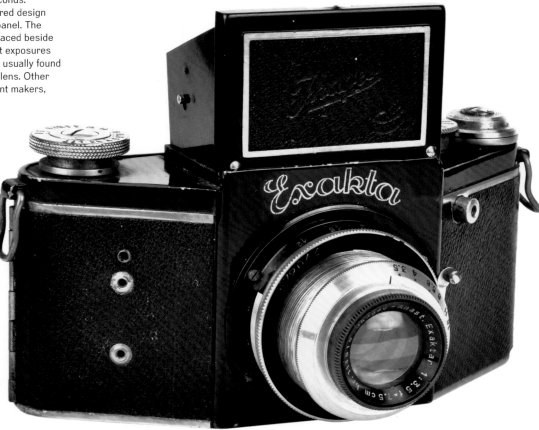

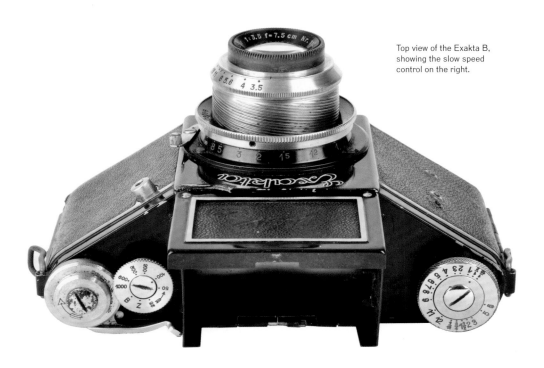

Top view of the Exakta B, showing the slow speed control on the right.

The mirrored back of the focusing hood folds down at an angle to provide eye-level viewing.

EXAKTA B

Year of launch: 1935.

Shutter speeds: 12–1/1000 second.

Standard lens apertures: f/3.5–f/16.

Exposure: manual.

Waist-level viewfinder.

The mirror in the focusing hood provides eye-level viewing.

Focal-plane shutter.

✷✷✷✷✷

Other option: Night Exakta, which is similar in style, but has extra-fast lenses.

Agiflex I

Compared to some other roll-film reflexes, this is a fairly basic camera. It takes 12 6 × 6 cm images on 120 film.

The reflex viewfinder is used at waist level with the option of non-reflex eye-level viewing courtesy of windows in the front and back of the hood. With no separate film-back, film cannot be changed mid-roll. The camera does, however, offer a mirror that lifts as the shutter is fired and then drops back into position, so there is no loss of viewfinder image after exposure.

The lens is interchangeable via a bayonet mount.

AGIFLEX I

Year of launch: 1946.

Shutter speeds: 1/25–1/500 second.

Standard lens apertures: f/3.5–f/32.

Exposure: manual.

Waist-level viewfinder.

Focal-plane shutter.

☀ ☀ ☀ ☀ ☀

Other options: the Agiflex II and restyled Agiflex III add slow speeds, but lens mounts are larger and incompatible with the first model.

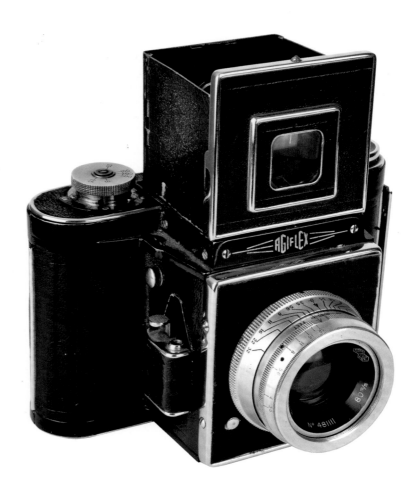

The Agiflex I is a fairly basic English roll-film reflex.

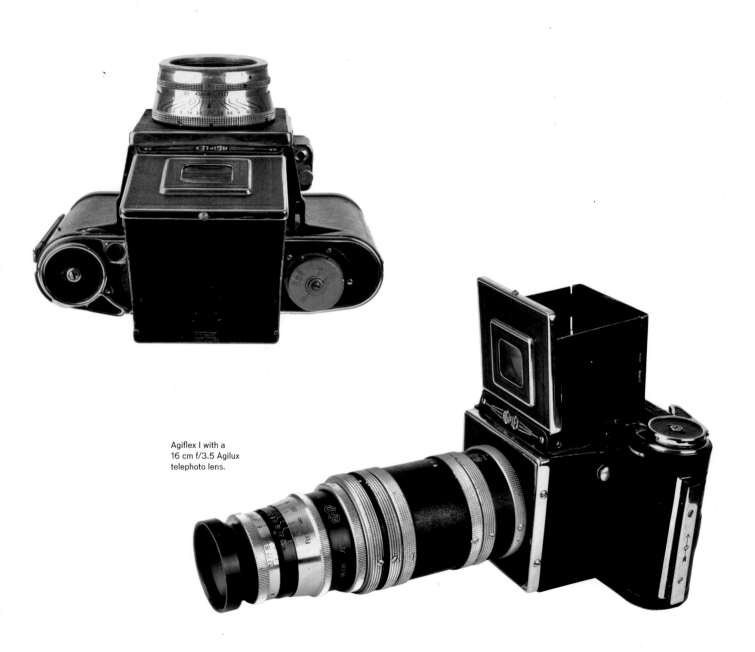

Agiflex I with a
16 cm f/3.5 Agilux
telephoto lens.

Komaflex-S

Very few roll-film reflexes were made for 12 4 × 4 cm exposures on 127 film. This is one of the best. The standard lens is a 65 mm Prominor, which is fixed but with auxiliary adapters that screw to the front for wide-angle and telephoto effects.

Shutter speeds and apertures are set on the prime lens. Film advance is by a quarter-turn of a stubby knob-cum-lever on the side, which is easily operated by the photographer's thumb. A lever beside the lens opens the shutter blades, sets the widest aperture and tensions the shutter.

As the release is pressed, the aperture stops down to its pre-selected setting, the shutter blades close, the mirror flips up and the shutter fires.

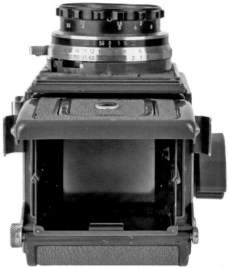

The Komaflex-S from the top.

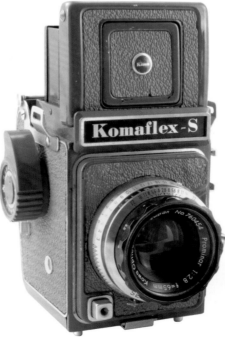

KOMAFLEX-S

Year of launch: 1960.

Shutter speeds: 1–1/500 second.

Standard lens apertures: f/2.8–f/22.

Exposure: manual.

Waist-level viewfinder.

Leaf shutter.

Adapters for wide-angle and telephoto shooting.

☀☀☀☀☀☀

Other options: German Karma-Flex and Japanese Superflex Baby were the only other 4 × 4 cm on 127 reflexes; neither is practical for photography today.

The Komaflex-S with its wide-angle and telephoto lens adapters.

Bronica ETRS

The Japanese Bronica ETR was launched in 1976 and refined as the ETRS three years later. Early models are made of metal and later models are plastic. The camera shoots 6 × 4.5 cm images, 16 to a roll of 120 film or 32 on 220 film.

It is an electronic camera with the lens-integral leaf shutter controlled from the body. If the battery fails, the shutter speed defaults to 1/500 second.

The ETRS accepts waist-level, eye-level and auto aperture-priority exposure viewfinders. The standard focusing screen uses a split-image rangefinder. Lenses from 40 mm wide-angle to 800 mm telephoto are available, as well as a motor drive and interchangeable film magazines that offer panoramic format pictures.

BRONICA ETRS

Year of launch: 1979.

Shutter speeds: 8–1/500 second.

Standard lens apertures: f/2.8–f/22.

Eye-level or waist-level viewfinders.

Exposure: manual with option for aperture-priority with an AE viewfinder.

☀ ☀ ☀ ☀ ☀

Other Bronica options: Bronica SQ, 6 × 6 cm images; Bronica S2, interchangeable film-backs for 6 × 6 cm or 6 × 4.5 cm images.

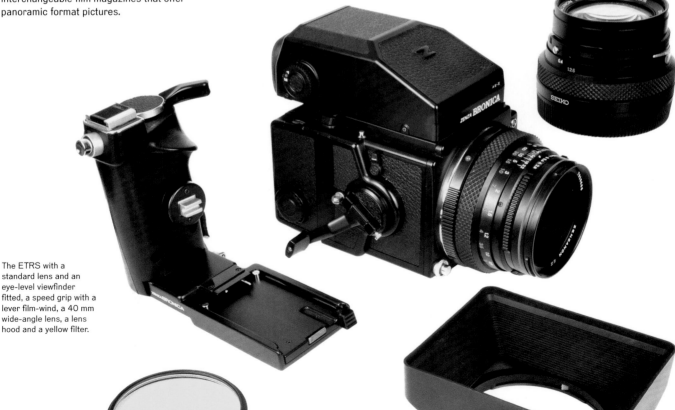

The ETRS with a standard lens and an eye-level viewfinder fitted, a speed grip with a lever film-wind, a 40 mm wide-angle lens, a lens hood and a yellow filter.

Pentax 6×7

The Japanese Pentax 6×7 takes both 120 and 220 film, producing – as its name implies – ten or 20 6 × 7 cm images. It resembles a giant 35 mm SLR with a focal-plane shutter speeded 1 second to 1/000 second. Eye-level pentaprism metered and non-metered viewfinders as well as a waist-level viewfinder are available.

Later versions of the camera offer a mirror lock-up feature, which is useful for avoiding vibration from movement of the camera's huge reflex mirror during exposure.

The standard lens is a 90 mm SMC Pentax 67. Other lenses include a wide range from 35 mm fish-eye to 1000 mm telephoto, as well as 55–100 mm and 90–180 mm zooms.

A heavy-duty handle, which fits to the side, is a useful accessory for hand-holding this giant of a camera, otherwise it is best used on a tripod.

PENTAX 6×7

Year of launch: 1969.

Shutter speeds: 1–1/1000 second.

Standard lens apertures: f/2.4–f/22.

Exposure: manual.

Eye-level viewfinder.

Good range of accessory lenses.

☀☀☀☀☀

Other Pentax options: upgraded in 1989 as the Pentax 67, redesigned and computerized in 1998 as the Pentax 67ii.

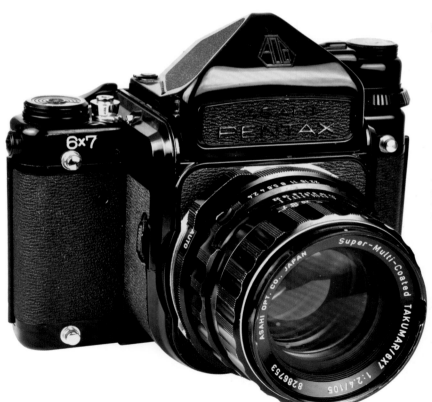

The Pentax 6×7 is a roll-film reflex that resembles a giant 35 mm SLR.

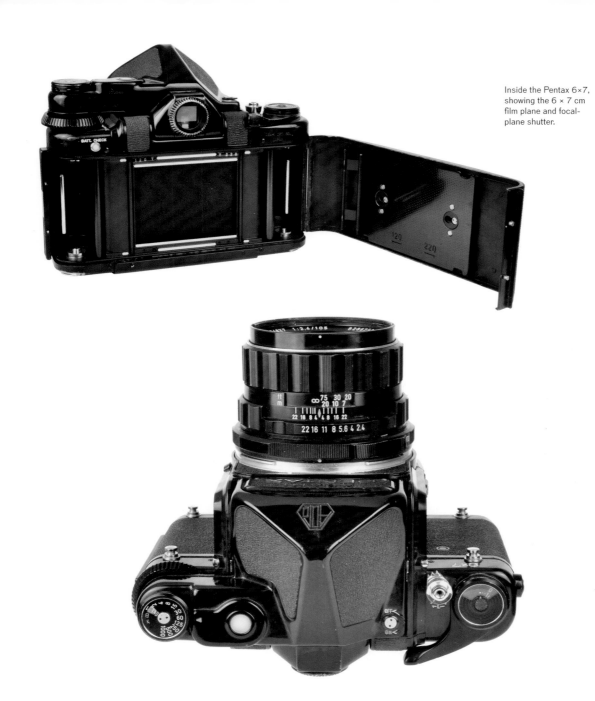

Inside the Pentax 6×7, showing the 6 × 7 cm film plane and focal-plane shutter.

Rittreck IIa

The Rittreck IIa has one advantage over every other make of roll-film SLR: it can shoot four different formats on a roll of 120 film. This led to the camera being advertised, when it was launched, as the world's most versatile single-lens reflex.

The camera is usually found with a multi-format roll-film holder that uses three frame counters in small windows on the top. The first counts from one to ten, the second from one to 12 and the third from one to 15. With the film holder in place, a dark slide is removed and the camera is ready to shoot ten 6 × 7 cm pictures, watching the numbers in the left frame counter window.

To take 12 6 × 6 cm exposures a mask is inserted in the film holder and the numbers in the right window are used. For 6 × 4.5 cm pictures, a different mask is inserted and the counter in the middle checks off the numbers from one to 15. A second film holder offers eight 6 × 9 cm images; 6 × 9 cm sheet film can also be used.

The standard lens is a 10.5 cm Musashino Koki Luminant. Others include focal lengths of 50 mm, 13.5 cm, 18 cm, 21 cm, 30 cm and 40 cm. The standard lens focuses from infinity down to 20 cm, but by reversing it on its special mount brings close focus down to 33 cm. Use of the camera's own extension tubes allows even closer focusing.

The standard viewfinder is a waist-level type, but a now rare eye-level viewfinder can also be found, although its use makes the camera awkward to hand-hold. The extra-large focusing screen covers the full 6 × 9 cm format, with lines etched into it to indicate the field of view for 6 × 7 cm, 6 × 6 cm and 6 × 4.5 cm formats.

The camera does not have an instant return mirror, so the image only appears on the screen after a large shutter-tensioning knob on the left of the body is turned. The shutter is a focal-plane type.

The Rittreck IIa is big and heavy and, compared to most other roll-film reflexes, it is not very practical unless used on a tripod. But for the collector who wants to see results from a collectable camera, or the retro photographer who is interested in the challenge of shooting with a true classic, it's a camera worth seeking out.

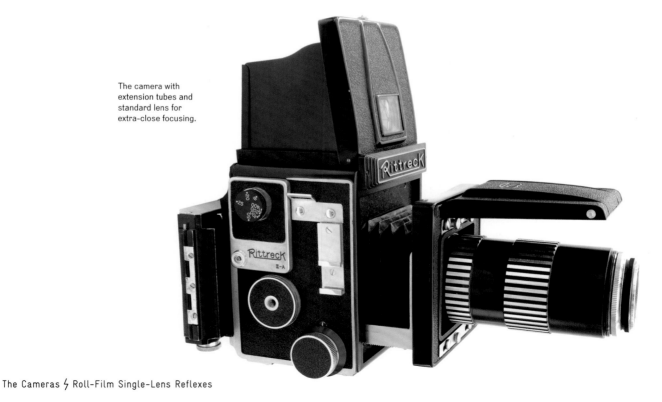

The camera with extension tubes and standard lens for extra-close focusing.

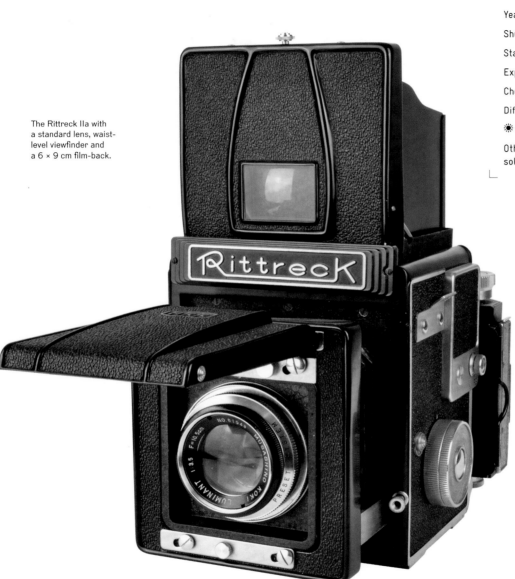

The Rittreck IIa with a standard lens, waist-level viewfinder and a 6 × 9 cm film-back.

RITTRECK IIA

Year of launch: 1956.

Shutter speeds: 1/20–1/400 second.

Standard lens apertures: f/3.5–f/22.

Exposure: manual.

Choice of four image sizes.

Difficult to use without a tripod.

✵ ✵ ✵ ✵ ✵

Other options: the camera was also sold under the name Optika IIa.

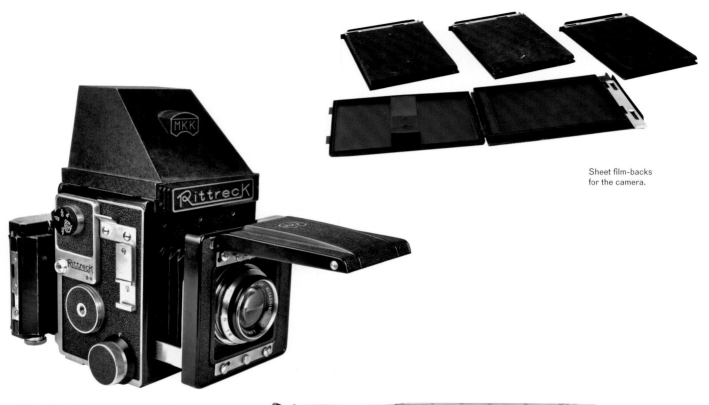

Sheet film-backs
for the camera.

A Rittreck IIa with an
eye-level viewfinder.

Multi-format film-
back and masks.

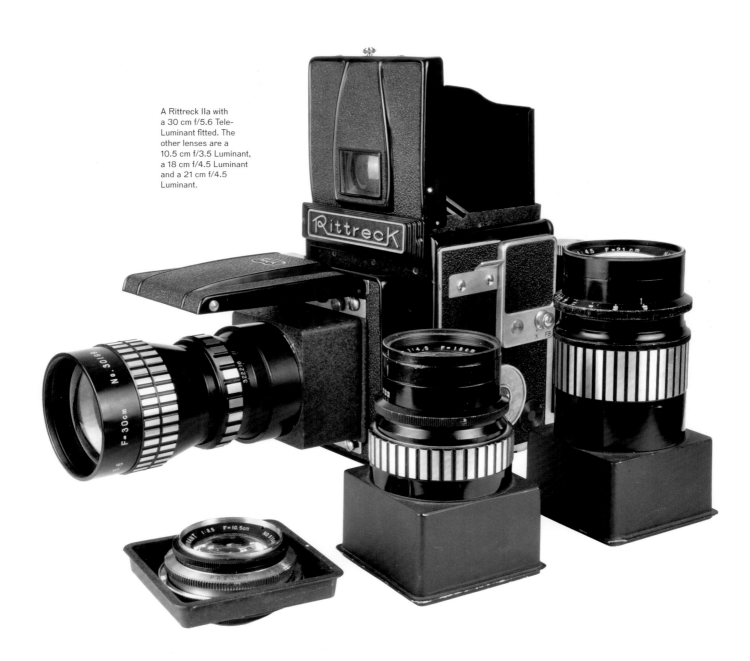

A Rittreck IIa with a 30 cm f/5.6 Tele-Luminant fitted. The other lenses are a 10.5 cm f/3.5 Luminant, a 18 cm f/4.5 Luminant and a 21 cm f/4.5 Luminant.

Sheet and Roll-Film Folding Cameras

Photographs were made on rigid glass plates before the introduction of flexible film. They came in various sizes, usually designated as imperial measurements. Some were as large as 15 × 12 inches, while others measured 10 × 8 inches, but the three most popular sizes were full plate: 8½ × 6½ inches; half plate: 6½ × 4¾ inches; and quarter plate: 4¼ × 3¼ inches. Outside of these parameters, 5 × 4 inches became a popular size, as well as smaller sizes such as 3½ × 2½ inches and sometimes smaller sizes as well.

As the use of glass plates declined, the use of sheet film in similar sizes became the norm. Today, glass plates are not readily available and would not prove practical for the retro photographer. Sheet film, on the other hand, can be obtained, chiefly in the 5 × 4 inches size.

Likewise, a great many different sizes of roll film have been produced over the years, and many of the older sizes can still be purchased from specialist dealers, notably in America. The two sizes still readily available are 120 and, to a lesser extent, 127. Cameras taking these sizes are the most suitable for today's use.

For the really dedicated retro photographer, however, sheet-film cameras offer an interesting and rewarding challenge. Also, as an added bonus, adapters are usually available for sheet-film cameras that convert them for roll-film use, and the film favoured for this purpose is the 120 size.

Many sheet- and roll-film cameras were made in a folding design. Larger film sizes require lenses of longer focal lengths as standard, which, in turn, means that the distance between the lens and the film is greater than with smaller-format cameras. For focusing reasons, the space has to be retained when shooting, but a folding design makes it easier to carry the camera when not in use.

Bellows are an integral part of most folding designs. When not in use, a typical folding camera takes the form of a flat box, in which a flap is opened and the lens pulled out along a baseboard on the end of the bellows, to click stop into the infinity shooting position. In self-erecting designs the lens automatically extends as the flap is opened. Fine focusing is then carried out by moving the lens forwards and back again. The further the lens is positioned from the film, the closer it focuses.

Because of the era in which they were most popular, folding sheet- or roll-film cameras are likely to be older than other retro models, and their use is laborious compared to a 35 mm camera or even a roll-film reflex. But the fact that you have only one exposure per sheet of film or as little as eight on a roll of 120 film concentrates the mind wonderfully on getting exactly the right exposure and picture composition before you press the shutter.

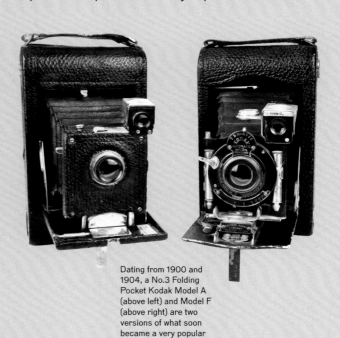

Dating from 1900 and 1904, a No.3 Folding Pocket Kodak Model A (above left) and Model F (above right) are two versions of what soon became a very popular folding roll-film design.

Nadav Kander, *Chongqing XI*, Chongqing Municipality, 2007
© Nadav Kander. Courtesy Flowers Gallery

A Rada roll-film holder
can be used to convert
many plate/sheet-film
cameras to use 120 film.

BUYERS' TIPS

If you are using a sheet-film camera, give preference to one with a roll-film adapter.

The practical format for a sheet-film camera is 5 × 4 inches.

Roll-film cameras for 120 film are the most practical and versatile.

Decide which image size works best for you.

Because roll-film folding cameras might be older than others, pay particular attention to lens clarity, smoothness of aperture controls and accuracy of shutter speeds.

Check bellows for wear at the corners, and for tears and pinholes.

Camera makes to watch out for include MPP, Plaubel, Voigtländer, Ensign and Zeiss Ikon.

Shooting Guide

If you use a sheet-film camera, then the film has to be loaded into special holders in a darkroom or changing bag prior to exposure. This is followed by what at first seems a complicated procedure of inserting the holder into the camera after focusing, withdrawing a dark slide, making the exposure, inserting the dark slide again and removing the holder. With this type of camera you must use a tripod. The process is complicated, but it can be very rewarding when you see the size of the image produced. For a more detailed account of using sheet-film cameras, see the MPP Micro-Technical Camera Mark VI, page 144.

In comparison, a roll-film folding camera is much easier to operate and if you use one that shoots eight exposures on 120 film then you get 6 × 9 cm images. This is 54 square centimetres of medium-format image as opposed to 8.64 square centimetres for a standard 35 mm frame.

Most cameras unfold to place the lens at the correct focusing distance for a subject at infinity. Various methods are then used to move the lens backwards and forwards to attain sharp focus on the subject. The three most common ways of unfolding and getting one of these cameras ready for action are:

1. Pull the lens panel away from the body on struts until it click stops at the right position.
2. Drop down a folding bed until it stands at right angles to the body of the camera and then pull out the lens panel along rails until it comes to a stop.
3. Drop down a folding bed and allow the camera to self-erect with the lens at the correct distance.

The actual operation and setting of shutter speeds, apertures and focus distances varies from camera to camera, but the theory of how they combine to produce a picture is the same as on any non-folding model.

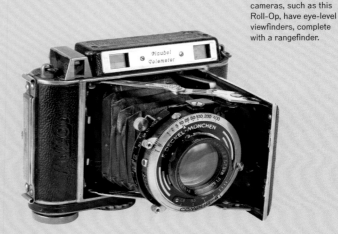

Some folding roll-film cameras, such as this Roll-Op, have eye-level viewfinders, complete with a rangefinder.

📷 A sheet-film camera should be used on a tripod. Methods of holding roll-film models vary according to viewfinder type and the position of the shutter release.

📷 Don't use a sheet-film camera unless you are prepared for the inherent complications.

📷 Do consider a sheet-film camera if it has the option of a roll-film-back.

📷 When extracting the lens from the body ensure that it click-stops correctly at the infinity mark.

📷 An eye-level viewfinder is better than a waist-level type as many waist-level viewfinders are small and inadequate.

📷 Many roll-film cameras use shutters that need to be tensioned before firing; if that's the case, then make sure you operate it in the correct order.

From a 6 × 9 cm colour transparency taken with a 120 film-back on the MPP Technical Camera.

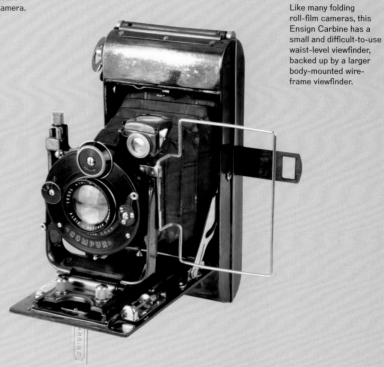

Like many folding roll-film cameras, this Ensign Carbine has a small and difficult-to-use waist-level viewfinder, backed up by a larger body-mounted wire-frame viewfinder.

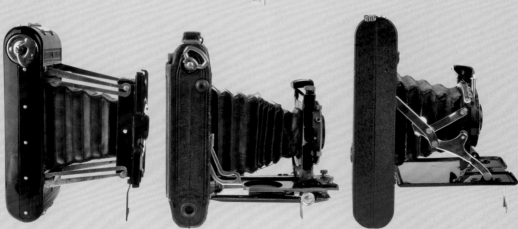

Three ways to unfold a roll-film camera, left to right: on struts (Soho Model B), on rails (Zeiss Ikon Ikarette) and self-erecting (Kershaw Penguin). All three take 120 film.

MPP Micro-Technical Camera Mark VI

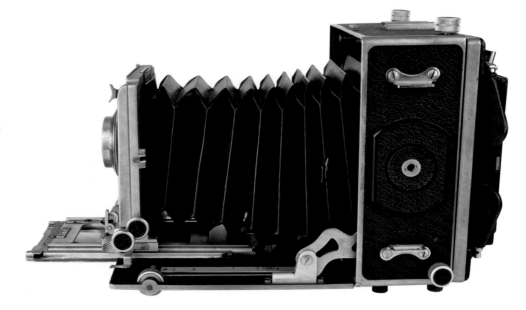

The lens at full extension for close-up photography.

For the retro photographer who wishes to try large-format sheet-film photography, with the back-up of being able to use roll film, MPP cameras are a good choice. The Mark VI version takes single sheets of 5 × 4 inch film with the option of fitting a 120-roll film-back to shoot eight 6 × 9 cm exposures.

The camera is the shape of a chunky box when folded. One side drops down and the lens panel is pulled out on bellows, focused by a knob, coupled to a coincident image rangefinder. The lens panel offers horizontal and vertical shift, and the back of the camera tilts to give more movements. It also extends to double its normal extension for close-up photography. Cameras of this style can be used with a large range of lenses and shutters.

To use as a 5 × 4 inch sheet-film camera, the film is first loaded into holders using a darkroom or changing bag. With the camera on a tripod, and the shutter opened on its 'B' setting, the view is composed and focused on a ground-glass screen shielded by a hood on the back of the body. The shutter is then closed.

The focusing screen and hood on the MPP are sprung so that the assembly can be moved back on springs to allow the film holder to be inserted between it and the camera body. The film holder's dark slide is removed, the exposure made and the dark slide inserted again before removing the holder.

For roll-film use, the film is loaded into the camera's special back. The picture is composed on the ground-glass screen,

which is etched with lines for the smaller format that comes with the use of roll film. The focusing screen and hood are removed, the film holder can be slid into place, its dark slide removed and the exposure made. The dark slide must be inserted again before the film-back is removed, but it can be left out if further pictures are going to be taken without the use of the focusing screen. For this purpose, accessory wire-frame viewfinders can be mounted in an accessory shoe on top of the body to match different formats. Although cameras such as the MPP are complicated to use, there can be tremendous satisfaction in going through all the motions needed to make medium- and large-format exposures, and there is little to touch the quality of the resulting negative or transparency.

MPP MICRO-TECHNICAL CAMERA MARK VI

Year of launch: 1951.

Shutter speeds: 1–1/500 second.

Standard lens apertures: f/4.5–f/22.

Takes 5 × 4 inch sheet film.

Easily adapts for 120 roll film.

Exposure: manual.

Needs to be used on a tripod.

Other sheet-film camera options:
Toyo-View, Wista, Speed Graphic and
Linhof.

The MPP Micro-
Technical Camera
Mark VI unfolded
and ready for action.

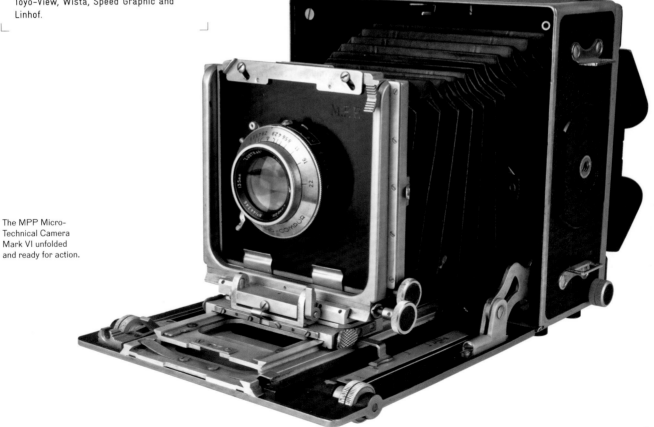

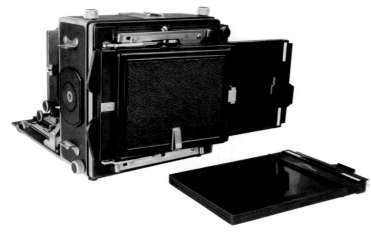

Two sheet-film holders; one is partially inserted in the camera.

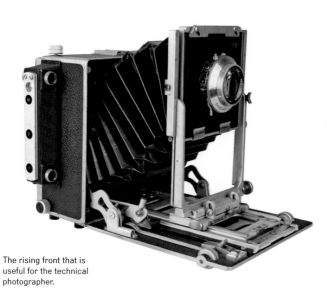

The rising front that is useful for the technical photographer.

The left and right shift of the lens for technical photography.

The hood that shields the
ground-glass focusing
screen at the rear.

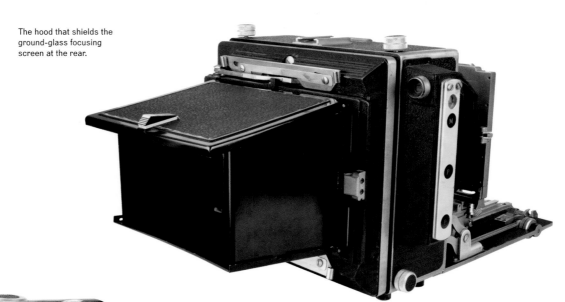

Wire-frame viewfinders
for use when the focusing
screen is not practical.

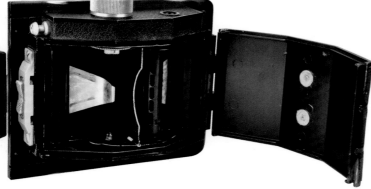

The camera's roll-film
adapter.

Voigtländer Bessa II

The unusual shutter release lever emerges from the bed as the camera is unfolded.

When the Voigtländer Bessa II was launched, this style of folding roll-film camera was very popular. Pressing a button on one side releases the drop-down bed as the lens extends on self-erecting struts. At the same time, the shutter release lever emerges from a slot in the bed close to the body. If using the camera horizontally, then the release falls conveniently under the left index finger.

Turning a knob on the top plate moves the lens back and forth for focusing. Accuracy is confirmed by a coincident image rangefinder in the viewfinder window.

VOIGTLÄNDER BESSA II

Year of launch: 1950.

Shutter speeds: 1–1/500 second.

Standard lens apertures: f/3.5–f/22.

Takes 120 film.

Exposure: manual.

Self-erecting lens.

Unusual left-handed shutter release.

☀ ☀ ☀ ☀ ☀

Other option: Bessa II with 105 mm f/4.5 Apo-Lanthar lens, which is much rarer and a lot more valuable.

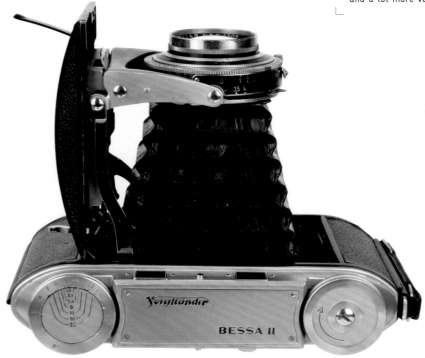

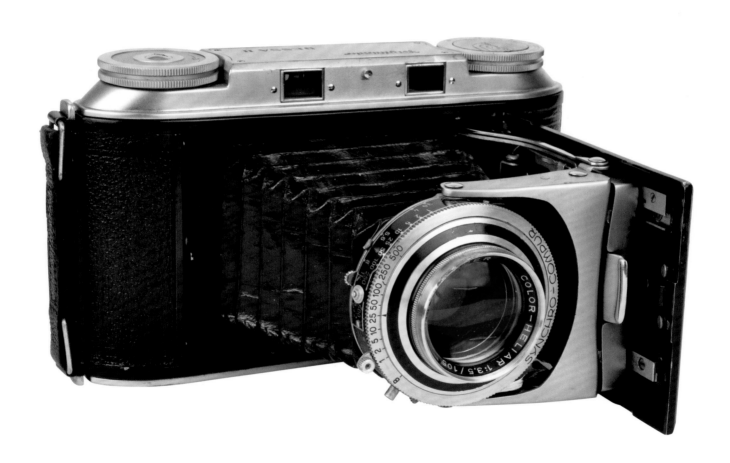

Ensign Commando

Moving the lens backwards and forwards adjusts the focus in most cameras. However, in the Ensign Commando the lens remains static and the film plane moves backwards and forwards as a knob on the top plate is turned. A coincident image rangefinder in the viewfinder confirms the focus. The lens is self-erecting and there is a choice of two red windows to read the film numbers and an internal mask. The Commando offers 12 6 × 6 cm or 16 6 × 4.5 cm pictures. It was originally designed for military use.

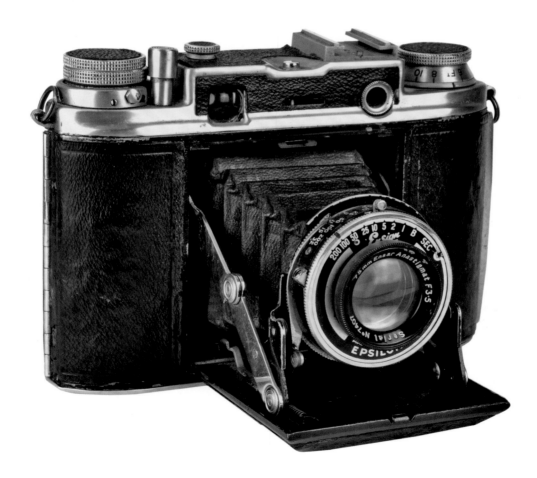

ENSIGN COMMANDO

Year of launch: 1946.

Shutter speeds: 1–1/200 second.

Standard lens apertures: f/3.5–f/32.

Exposure: manual.

Takes 120 roll film.

Unusual focusing mechanism.

☀ ☀ ☀ ☀ ☀

Another option: 1950 version with remodelled wind knob and top 1/300 second shutter speed.

The moving film plane
inside the camera.

Minolta Best Model II

Cameras made in Japan were little known outside of the country until the late 1950s and early 1960s. The pre-Second World War Best is a rarity in this sense, which makes it an interesting camera for both the collector and the retro user.

Instead of bellows, the lens is pulled forward from the body on three telescopic plastic boxes reinforced with stainless steel. With two red windows and an internal mask, the camera offers a choice of eight 4 × 6.5 cm or 12 4 × 4 cm images.

It is often mistakenly called the Minolta Vest, in reference to the vest pocket-size images it takes, or the Marble because of the name on the front (it actually refers to the shutter name).

The viewfinder is divided for eight or 12 exposures.

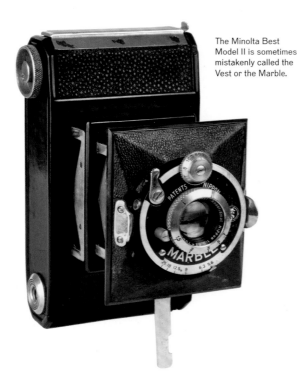

The Minolta Best Model II is sometimes mistakenly called the Vest or the Marble.

The telescopic boxes, shown from the top, which replace the more usual bellows.

Zeiss Ikon Super Ikonta A

Zeiss made a range of cameras with the Super Ikonta name, but this one – designated as model 530 – was the first. It is extremely compact when folded, with a self-erecting lens that springs forward as it is unfolded.

The camera uses the twin-prism rangefinder system favoured by Zeiss and shoots 16 6 × 4.5 cm exposures to a roll of film. If you can find one in good condition then it can produce excellent results. However, because the lens is uncoated, it will tend to flare if shooting against the light.

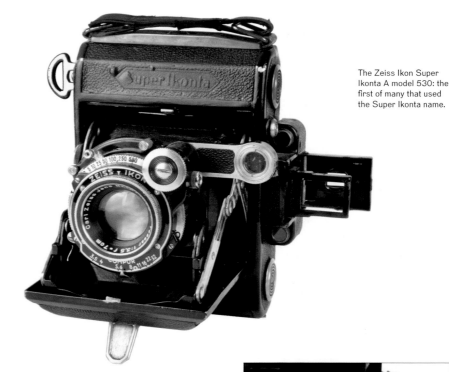

The Zeiss Ikon Super Ikonta A model 530: the first of many that used the Super Ikonta name.

ZEISS IKON SUPER IKONTA A

Year of launch: 1934.

Shutter speeds: 1–1/500 second.

Standard lens apertures: f/3.5–f/32.

Exposure: manual.

Takes 120 roll film.

Uses a twin-prism design rangefinder.

✺✺✺✺✺

Other options: many variations on the Super Ikonta that continued to be made until the late 1950s.

The Zeiss Ikon Super Ikonta A when folded.

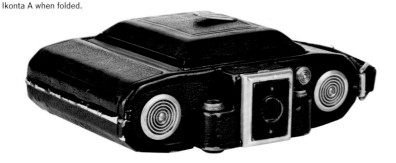

The twin-prism rangefinder.

Primarette

Often mistaken for a twin-lens reflex because it uses two lenses, the Primarette's unusual design actually resembles two cameras: one on top of the other.

The lenses sit in a panel that extends from the body on bellows. The lower lens, around which shutter speeds and apertures are set, shoots eight pictures 6 × 4 cm on 127 film.

The upper lens focuses its image on a small ground-glass screen with a hood at the back. A drop-down magnifier aids focusing.

As a knob on top of the lens panel adjusts focus, distances are indicated on a needle moving across a scale between the lenses, while the upper lens moves up and down to compensate for parallax.

PRIMARETTE

Year of launch: 1933.

Shutter speeds: 1–1/300 second.

Standard lens apertures: f/3.5–f/32.

Exposure: manual.

Takes 127 roll film.

Unusual twin-lens design.

Another option: it is also sold under the Planovista name.

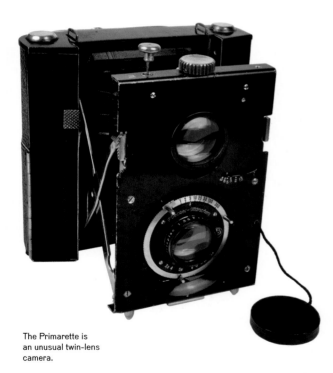

The Primarette is an unusual twin-lens camera.

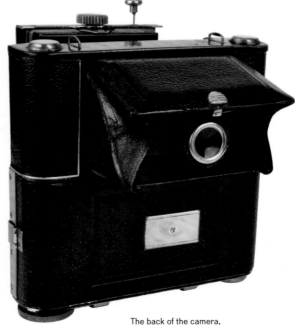

The back of the camera, showing the focusing screen and the hood for the upper lens.

Dolly Vest Pocket Model B

Many sheet-film cameras could be adaptable for roll film, but fewer roll-film cameras could be adapted for sheet film. The Dolly Vest Pocket Model B offers an interchangeable back for that purpose.

The roll film-back contains two red windows which, with an internal mask, give 16 3 × 4 cm exposures on 127 film. Releasing that back allows a ground-glass focusing screen with a hood to be fitted and then exchanged for sheet-film holders to shoot 6 × 4 cm images.

The lens and shutter self-erect when the camera is unfolded, and a direct vision viewfinder is found on the side. A lever below the lens adjusts its position to allow for the different distances between lens and film, depending on whether roll film or sheet film is used.

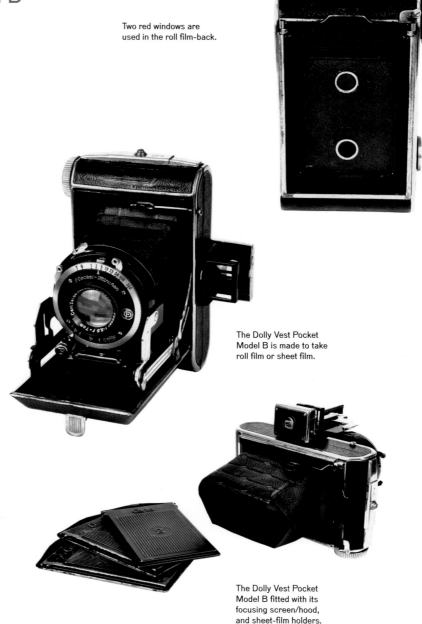

Two red windows are used in the roll film-back.

The Dolly Vest Pocket Model B is made to take roll film or sheet film.

The Dolly Vest Pocket Model B fitted with its focusing screen/hood, and sheet-film holders.

DOLLY VEST POCKET MODEL B

Year of launch: 1936.

Shutter speeds: 1–1/300 second.

Standard lens apertures: f/3.5–f/32.

Exposure: manual.

Takes 127 roll film.

Adaptable for sheet film.

❁❁❁❁❁

Another option: Dolly Vest Pocket Model A without the sheet-film facility.

Plaubel Makina III

The German company Plaubel began making Makina cameras as early as 1912, but by the time the Makina III was launched the camera had reached the peak of its versatility.

From the start, Makina cameras were made for use with sheet film for which film holders are available, together with a special back containing a ground-glass screen and a focusing hood. Using this combination, the lens is focused on the screen, which is then replaced with the loaded film holder. The dark slide is removed, the exposure made and the dark slide re-inserted before removing the holder. In this way, the camera shoots single 6.5 × 9.5 cm images.

The Makina III, however, is usually found with an easier-to-use Plaubel roll-film holder with its own dark slide to shoot eight 6 × 9 cm exposures on 120 film. Film is wound by a knob on the base of the film holder and, once correctly loaded, a ratchet and pawl automatically stop film-wind in the correct place for each exposure. A rare back to take 35 mm film is also available.

Whether using sheet film or roll film, the basic operation is the same. The lens panel is extended from the body on scissor-like struts that click stop at two positions. The first is used with the 73 mm WW Orthar wide-angle lens; the second when using the 10 cm Anticomar standard lens and 19 cm Tele Makinar telephoto lens.

Focus is controlled by a knob on the side of the front panel, which moves it backwards and forwards, and is coupled to a coincident image rangefinder with its own viewing window on top of the body. Needles move across two focusing scales on the top of the lens panel: one is used for standard and telephoto lenses and the other for the wide-angle lens. The camera also features two viewfinders: an optical finder with parallax adjustment for the standard lens, with etched markings for the telephoto, and a wire-frame finder for the wide-angle lens. The shutter is tensioned by a lever on the side of the lens panel and released by a button on top.

PLAUBEL MAKINA III

Year of launch: 1949.

Shutter speeds: 1–1/200 second.

Standard lens apertures: f/4.2–f/32.

Exposure: manual.

Takes 6 × 9 cm sheet film.

Adaptable for 120 roll film or 35 mm film.

☀ ☀ ☀ ☀ ☀

Other options: Baby Makina for 6 × 4.5 cm exposures, Makina I without a rangefinder or interchangeable lens, and a Makina II with a rangefinder.

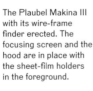

The Plaubel Makina III with its wire-frame finder erected. The focusing screen and the hood are in place with the sheet-film holders in the foreground.

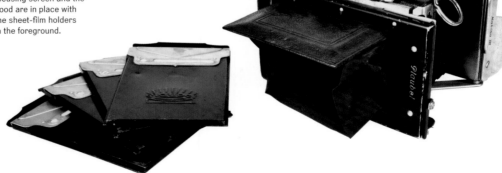

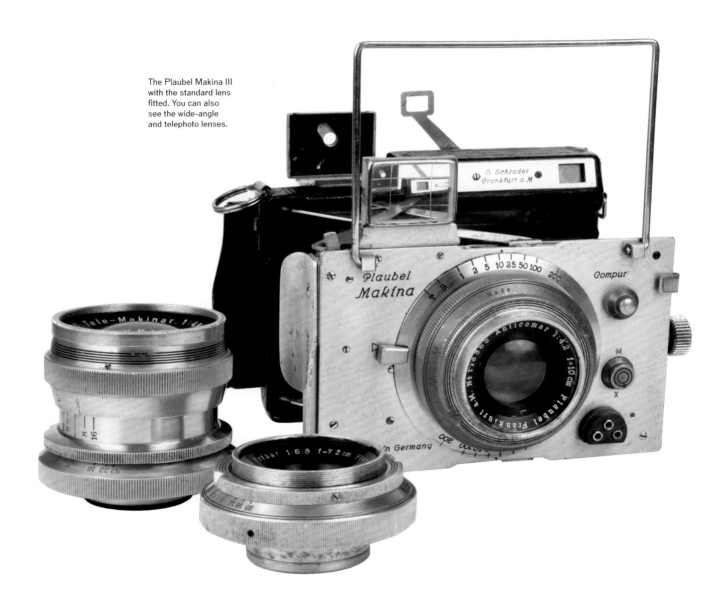

The Plaubel Makina III with the standard lens fitted. You can also see the wide-angle and telephoto lenses.

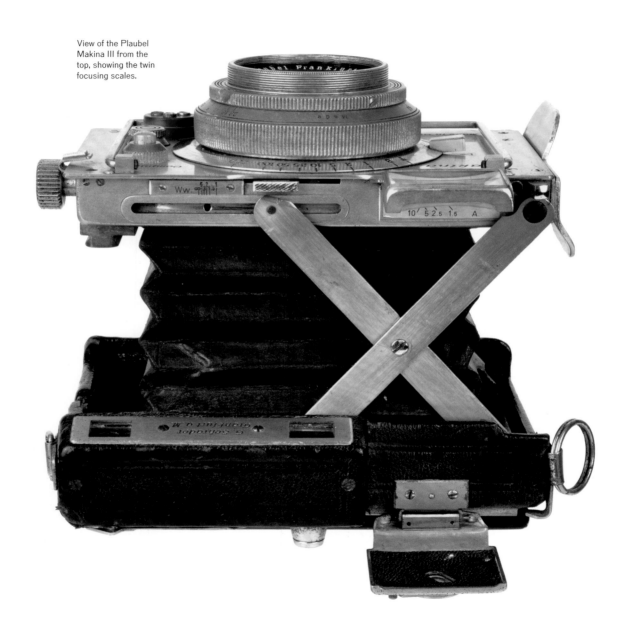

View of the Plaubel
Makina III from the
top, showing the twin
focusing scales.

Here the optical finder is erected and the 120 film-back has been fitted to the camera; and the rare 35 mm back.

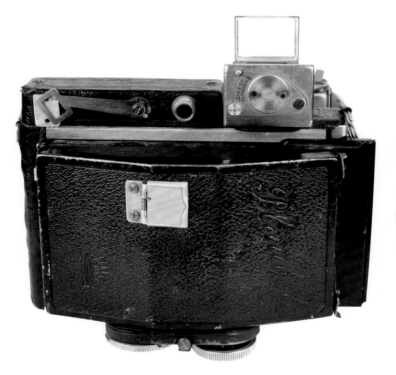

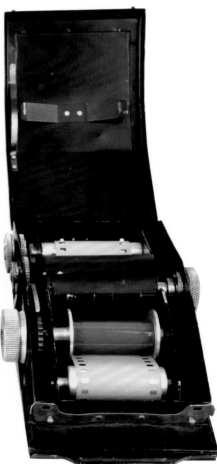

Eve Arnold, *Self-portrait*, 42nd Street, New York City, USA, 1950
© Eve Arnold/Magnum Photos

Twin-Lens Reflexes

A twin-lens reflex (TLR) uses two lenses, usually – but not always – arranged one above the other. The lower lens focuses its image on the film to take the picture, while the upper lens reflects its image via a 45-degree mirror to a screen on the top of the body, protected by a folding hood. The two lenses are linked to focus simultaneously. In some rare designs the two lenses are arranged side by side, but the theory remains the same: one lens takes the picture, while the other reflects its image, via a mirror, onto a screen above.

The twin-lens reflex design was used in the days of glass-plate photography, but in 1928, German camera maker Franke and Heidecke made the Rolleiflex, the first compact roll-film TLR. It took the now unavailable 117 size film. Today, some of these original models might be found converted for 120 film use, but these are more for the collector than the photographer. Rolleiflex TLRs, with a change to 120 size film, were improved upon and made until the 1980s. Special editions continued to be made in the 1990s.

These later Rolleiflex models are still capable of producing stunning pictures, but the cameras command extremely high prices. Today's retro photographers in search of viable TLRs for use might be better setting their sights on other makes equally capable of producing quality images.

With the majority of TLRs, the viewing screen on top of the body matches the size of the film format. The most common film size is 120, which produces 12 6 × 6 cm images. Because the images are square there is no need to turn the camera at an angle to produce a horizontal or vertical picture, as is the case with rectangular formats.

There are exceptions: a few rare TLRs shoot 6 × 9 cm images, with a revolving back for horizontal or vertical pictures. Although the majority of TLRs have fixed lenses, some models offer interchangeable lenses. A significant number of TLRs were also made for 127 film, producing 12 4 × 4 cm images. A small selection of models took 35 mm and even subminiature film.

Using a TLR is unlike using any other camera. It is equally at home on a tripod or hand-held and the large viewfinder screen is excellent for picture composition. The image quality from medium-format film is superb.

The original Rolleiflex (near right) and a later, more usable Rolleiflex 2.8F (far right).

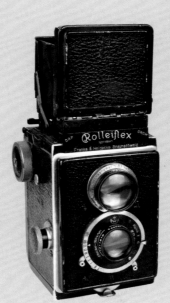
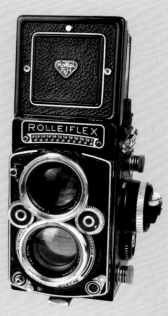

Choose a TLR that takes square pictures on 120 film if possible.

Beware of tarnished mirrors, which will affect the viewfinder, though not the picture taking.

Older cameras might have sticky shutters, especially at slow speeds.

Check the taking lens for scratches or fungus.

Run a film through the camera before buying to make sure the winding mechanism works accurately.

Make sure the focusing hood opens smoothly and is not damaged.

Avoid a camera with badly scratched, scraped or dented bodywork, which might be a sign of careless professional use.

Don't be fooled by simple cameras that may look like TLRs, but their taking and focusing lenses are not linked.

Two TLRs with different film sizes: the English Microcord for 120 film and the Japanese Primo-Junior for 127 film.

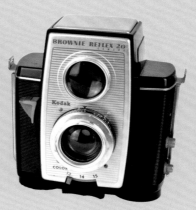

Two Kodak Brownie Reflex cameras that are usable but, despite their names, do not have linked taking and viewing lenses and so are not true TLRs.

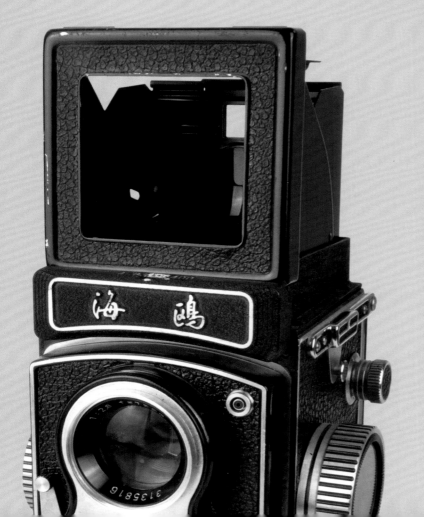

Many TLR focusing hoods incorporate eye-level viewfinders.

When loading a 120 film TLR the arrows on the backing paper can be lined up with indicators inside the body. (Mamiya C3)

Shooting Guide

Using a TLR is unlike using any other kind of camera. The most common type takes 120 film to shoot 12 6 × 6 cm square pictures to a roll. Unlike cameras that take rectangle-shaped pictures, and need to be turned on their side for vertical subjects, a square format TLR is always used in the same orientation.

Although a few TLR designs run the film horizontally through the body, the vast majority of 120 film cameras run it vertically, usually from the bottom to the top. Film-loading is conventional, drawing it off the full spool and slotting it onto the take-up spool.

Some TLRs have knobs to wind the film, with exposure numbers on the backing paper that can be read through a red window on the back of the camera. Others have a crank, like a small handle, and no red window. With this type, film is loaded in the normal way but, before closing the camera back, it is wound until arrows on the backing paper line up with indicating marks – usually in the form of red dots – inside the camera, either side of the film. The back is then closed and the crank wound until it stops at the first exposure position. Thereafter, following each exposure, the crank is turned until it stops at the next exposure position. Some designs use both a red window and a crank, with the first number wound to the window to start the roll, then the crank used to wind and automatically stop at the right position for the following exposures. Knobs are sometimes used in place of cranks but work in a similar way.

To shoot, a hood on the top of the body is opened to reveal the focusing screen, which displays its image from the camera's top lens. Most hoods incorporate a magnifier that flips up from the back for fine focusing. Some focusing hoods incorporate a flap that opens in the front to line up with an eye-piece in the back to make an eye-level viewfinder.

Shutter speeds and apertures are set on the lower picture-taking lens, which is linked to the viewing lens

for focusing. Sometimes they move in tandem backwards and forwards on a panel as a knob on the body is turned. In other designs, the two lenses are linked by cogged rims that rotate together. Either way, the top lens focuses together with the lower lens. The shutter release is usually found on the front of the body below and to one side of the lower lens.

Roll-film TLRs for 127 film work in much the same way. TLRs that take 35 mm film are usually loaded like any other 35 mm camera, but the film is more likely to run horizontally across the body. As with a roll-film camera, lenses are linked for focusing.

Traditionally, a TLR image is composed on its focusing screen that matches the size and shape of the film image.

Film in a 35 mm TLR is loaded in the same way as most other 35 mm cameras.

- ◉ The best way to hold a roll-film TLR is at waist level, elbows in, hands gripping each side and index finger on the shutter release.

- ◉ Take care when loading to make sure the film is firmly attached to the take-up spool before closing the back.

- ◉ Hold the camera so that you can see the whole focusing screen for accurate composition.

- ◉ Make sure the horizon, or any other straight horizontal line, is level in the viewfinder.

- ◉ Remember that the viewfinder image is laterally reversed.

- ◉ Allow for parallax differences between the two lenses, which means the shooting lens sees less at the top and more at the bottom of the picture than the viewing lens sees. There are no parallax differences to the sides of the image.

When working close, the difference between the view on the focusing screen (far left) and the view seen by the taking lens (near left) can be crucial.

Mamiya C3

Mamiya made the C series of twin-lens reflexes between 1957 and 1983. Each has a slightly different specification, but they all share an uncommon TLR (twin-lens reflex) feature: interchangeable lenses. The C3 makes a good entry-level camera for the retro TLR photographer.

The lenses are sold in pairs, attached to each other, ready to be dropped into the lens panel on the front of the camera. A sprung wire clip secures them at the top and the bottom. Each lens pair has a range of apertures and a shutter built into the lower one with another lens of a similar focal length and its widest aperture for the viewfinder screen. The standard lens has a focal length of 80 mm; other lenses include a 65 mm wide-angle, a 105 mm portrait, and 135 mm and 180 mm telephotos.

The lenses are focused by moving backwards and forwards in tandem on bellows as twin knobs at the base of the body are turned. As the lenses extend, focusing scales on plates at the side of the bellows are revealed to indicate distances for different focal lengths of lenses.

The waist-level focusing screen on the top of the body is revealed when the hood is unfolded. It incorporates a magnifier as a focusing aid and the front of the hood can be adapted with a mask to produce a direct-vision viewfinder with views for 80 mm and 105 mm lenses. The ground-glass focusing screen is etched with lines to help identify parallax differences between the taking and viewing lenses.

The camera can be fitted with a sheet film-back, but is more likely to be used with 120 roll film. Once the film has been loaded and advanced until the figure '1' appears in the red window on the back of the camera, the window can be closed and a film-advance crank on the side of the body automatically winds film to the correct position between exposures. The C3 was the first camera in the C series to incorporate this feature. Automatic double-exposure prevention is also offered.

Accessories include the Mamiya Porofinder and Paramender. The former replaces the focusing hood to provide eye-level viewing. The latter is an unusual device that fits between the camera and a tripod, using a knob on the side to wind the camera up and down the exact distance required to correct the parallax between the viewing and the taking lenses.

The Mamiya C3 is an unusual TLR with interchangeable lenses.

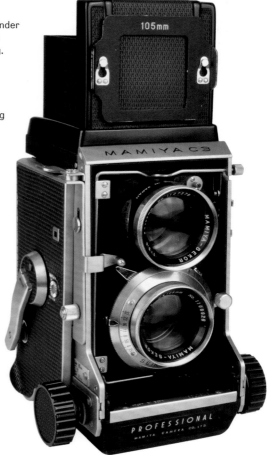

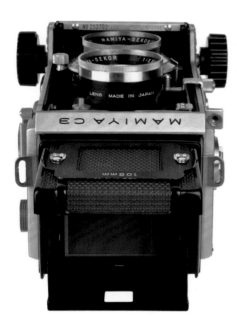

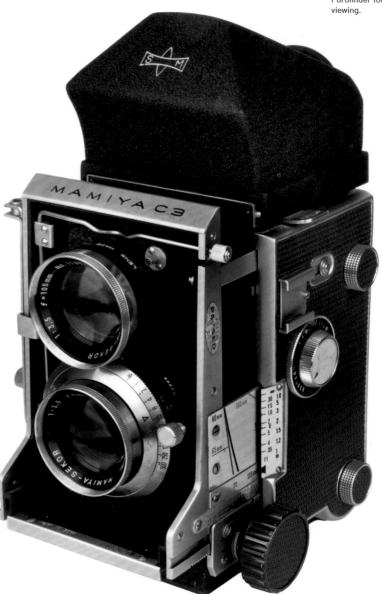

The Mamiya C3 with its Porofinder for eye-level viewing.

The Mamiya C3 with the back open, ready for film-loading.

The focusing scales on one side of the bellows.

The bellows at full extension for close-up photography.

Two positions of the Paramender, which are used to compensate for parallax differences between the lenses.

MAMIYA C3

Year of launch: 1962.

Shutter speeds: 1–1/500 second.

Standard lens apertures: f/2.8–f/32.

Shoots 12 6 × 6 cm images on 120 film.

Range of interchangeable lenses.

Shutters in the lenses.

Larger and heavier than most contemporary TLRs.

☀ ☀ ☀ ☀ ☀

Other options: Mamiya C2, C22, C33 and C330 range.

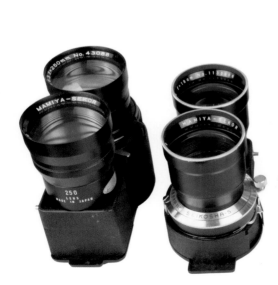

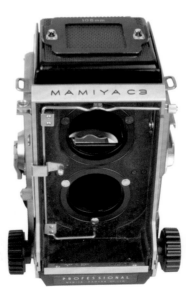

The body with lenses removed and accessory lenses.

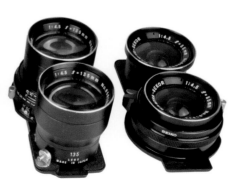

Rolleicord I

Rolleicord cameras are stripped-down, less-expensive versions of the Rolleiflex. As such, they are more accessible to the retro photographer than their more expensive counterparts.

Various models were made until the 1960s, mostly with black leather covering. If you want something with a little more style, then look for the original version, made in an attractive nickel-plated, cross-hatch art deco design, with a comprehensive exposure calculator on the camera back.

The lenses focus in tandem. A knob on the side, surrounded by a focusing scale, moves them both backwards and forwards. Viewfinding is by the usual TLR style of ground-glass screen under a fold-up hood.

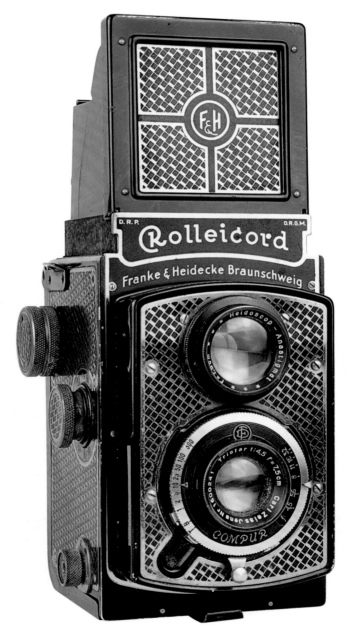

The first version of the Rolleicord I.

The Rolleicord's exposure calculator on the back of the body.

Exposure, sunlight, diaphragm	○	5,6	8	11	16
Snow and water,				1/300	1/100
Broad streets, squares			1/300	1/50	1/25
Narrow streets	1/100	1/100	1/50	1/25	1/10
Landscapes light foreground	1/300	1/300		1/100	1/50
" dark "		1/100	1/50	1/25	1/10
Portraits, groups,- open air	1/300		1/100	1/50	1/25
" " under trees	1/50	1/25	1/10	1/5	1/2
Light-Room Portraiture	1/25	1/10	1/5	1/2	1
Dull " "	1/10	1/5	1/2	1	2
2700 H.D. May, June, July, August 10 TO 2 HR					
1000 H.D. or without sun: DOUBLE THE EXPOSURE					

F:	4,5	5,6	8	11	16	22	
∞	13 -∞	11 -∞	8 -∞	6 -∞	4,5-∞	3,3-∞	∞
10	6,3-24	5,8-36	5 -∞	4 -∞	3,3-∞	2,5-∞	10
5	3,9-7	3,7-8	3,3-10	3 -17	2,5-∞	2,1-∞	5
3,3	2,8-4,1	2,7-4,3	2,5-5	2,3-6	2 -10	1,7-45	3,3
2,5	2,2-2,9	2,1-3	2 -3,3	1,7-5	1,5-8	2	
2	1,8 -2,3		1,7-2,5	1,6-2,8	1,4-3,3	1,3-4,5	2
1,8	1,45-1,8		1,4-1,9	1,3-2	1,2-2,3	1,1-2,8	1,8
1,4	1,3 -1,55		1,2-1,6	1,2-1,7	1,1-1,9	1 -2,3	1,4
1,2	1,1 -1,3		1,05-1,4		1 -1,6	0,9-1,8	1,2
1	0,95-1,05		0,9 -1,15		0,8 -1,3		1
0,8	0,76-0,84		0,73-0,88		0,68-0,98		0,8

ROLLEICORD I

Year of launch: 1933.

Shutter speeds: 1–1/300 second.

Standard lens apertures: f/4.5–f/32.

Shoots 12 6 × 6 cm images on 120 film.

Attractive art deco design.

✳ ✳ ✳ ✳ ✳

Other options: Rolleicord I in black leather and gradually upgraded models, Ia, II, III, IV, V, Va and Vb.

Voigtländer Superb

At first sight, it seems that the Superb's shutter speeds are engraved on their dial back-to-front and upside down. This is because, for ease of operation, they are designed to be read from above via a tiny prism beside the lens.

The two lenses are linked by cogs that turn the upper as the lower is focused. At the same time, the upper lens moves and tilts to compensate for parallax.

Film transport travels horizontally across the body, rather than vertically, as is more usual in a TLR. A lever advances it with numbers read in the camera's red window.

The specification is unusual for a TLR, but the camera's picture quality is, as its name suggests, superb.

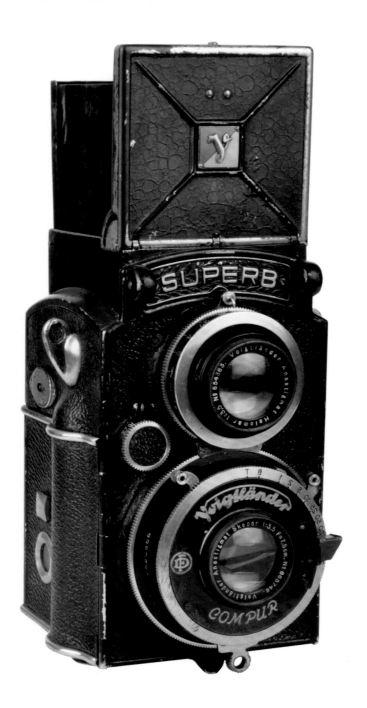

VOIGTLÄNDER SUPERB

Year of launch: 1933.

Shutter speeds: 1–1/250 second.

Standard lens apertures: f/3.5–f/22.

Shoots 12 6 × 6 cm images on
120 film.

Parallax correction with focusing.

☀☀☀☀☀

Other Voigtländer TLR option: Voigtländer
Brillant, which is inexpensive with an
extra-bright viewfinder.

The back-to-front
shutter speeds and tiny
prism that allows them
to be read from above.

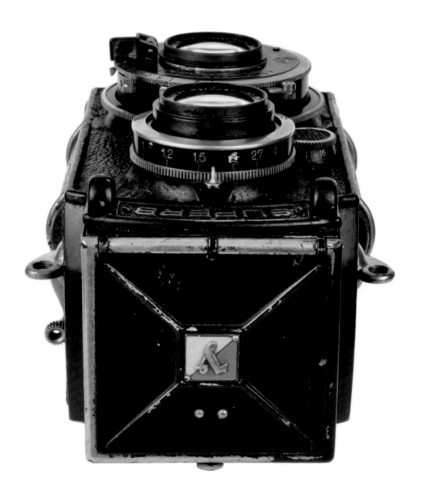

Voigtländer Focusing Brillant

In early models of the Brillant (often incorrectly called the Brillant) viewing and shooting lenses were not linked. In this version, however, they are connected by cogs to focus together, making it a true twin-lens reflex.

The camera takes its name from the glass lens that stands in place of the usual ground-glass focusing screen, which gives a much brighter than usual image.

A door in the side of the body hides a yellow filter, which fits the taking lens, and a circular extinction meter that fits the viewing lens. This projects a circle of orange numbers onto the viewfinder screen with a series of progressively dimmer green dots surrounding them. The orange number seen against the last visible green dot is matched to a table inside the filter/meter compartment that translates the numbers into suggested shutter speeds and apertures.

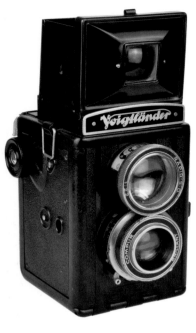

The focusing version of the Voigtländer Brillant.

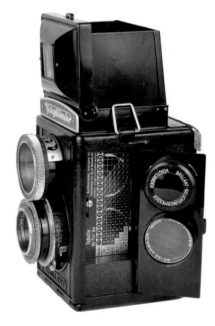

The meter and filter compartment in the side of the body.

VOIGTLÄNDER FOCUSING BRILLANT

Year of launch: 1938.

Shutter speeds: 1–1/300 second.

Standard lens apertures: f/4.5–f/16.

Shoots 12 6 × 6 cm images on 120 film.

Extra-bright viewfinder.

☀ ☀ ☀ ☀ ☀

Other options: early models with non-coupled lenses and Lubitel 2, a Russian copy of the Focusing Brillant, made in 1955.

The Voigtländer Brillant from the top, showing its extra-bright focusing screen.

Yashica 44LM

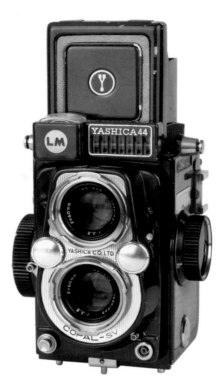

The Yashica 44LM, from above, showing the meter needle scale above the lens.

The Yashica 44LM and the 44, from which it was derived, are among the few TLRs made to take square pictures on 127 film. The two lenses move backwards and forwards to focus as a knob on the side is turned.

A Selenium meter cell activates a needle in a window in front of the viewing hood that moves across a scale marked zero to ten. The indicated number is then transferred to a rotating scale inset into the film-wind knob, from which suggested shutter speeds are indicated against apertures. These are set manually on the camera.

Two knurled wheels, each side of and between the lenses, adjust shutter speeds and apertures, which are shown in a window above the viewing lens.

YASHICA 44LM

Year of launch: 1959.

Shutter speeds: 1–1/500 second.

Standard lens apertures: f/3.5–f/22.

Shoots 12 4 × 4 cm images on 127 film.

In-built meter to aid exposure.

☀☀☀☀☀

Other 127 TLR options: Yashica 44 without meter, Baby Rollei (pre-war and post-war versions), Primo-Junior and Ricoh Super 44.

The rotating exposure scale inset into the film-wind knob, shown from the side.

Agfa Flexilette

Agfa was one of the few manufacturers that attempted to make a TLR for 35 mm film. It resembles a 35 mm SLR much more than the usual shape of a TLR.

The Flexilette has two lenses mounted one above the other, the lower lens is to shoot the picture and the upper one is to reflect its image to a waist-level viewfinder screen under a fold-up hood on the top of the body. It is the same size as a 35 mm frame, so the screen is very small, but it is covered by a magnifier.

Both lenses are mounted on a circular panel, focused together when a ring around the pair is turned to move them backwards and forwards.

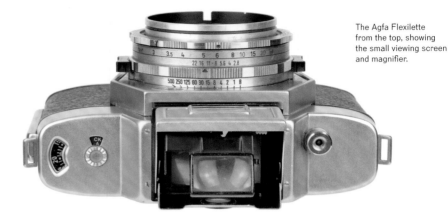

The Agfa Flexilette from the top, showing the small viewing screen and magnifier.

AGFA FLEXILETTE

Year of launch: 1960.

Shutter speeds: 1–1/500 second.

Standard lens apertures: f/2.8–f/22.

Shoots 36 24 × 36 mm images on 35 mm film.

Handles like a 35 mm camera.

☀ ☀ ☀ ☀ ☀

Another Agfa 35 mm TLR option: Optima Reflex, a similar design with an eye-level pentaprism viewfinder.

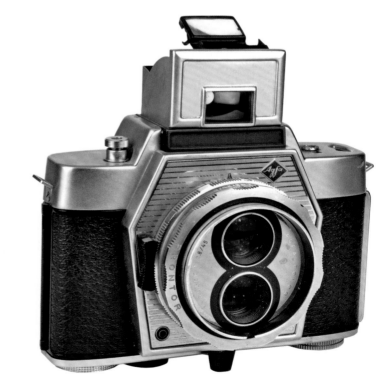

Samocaflex 35

The Japanese Samocaflex is a 35 mm TLR with an optical viewfinder added next to the reflex viewing screen. This means that the image from the upper lens is focused on the waist-level screen in the usual way, but viewfinding can also be handled at eye-level.

The twin lenses move in and out of a front panel as a radial arm beside them is rotated. Shutter speeds and apertures are set on scales around the lower lens.

The Samocaflex 35 is an unusual but workmanlike camera.

SAMOCAFLEX 35

Year of launch: 1955.

Shutter speeds: 1–1/500 second.

Standard lens apertures: f/2.8–f/16.

Shoots 36 24 × 36 mm images on 35 mm film.

The auxiliary viewfinder is very useful.

☼ ☼ ☼ ☼ ☼

Another Samoca TLR option: Samocaflex 35 II, similar but with an improved shutter.

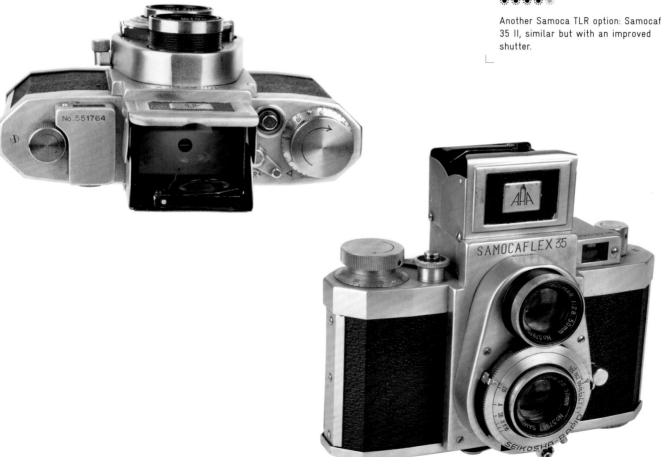

Contaflex

The Contaflex is more usually known as the Twin Lens Contaflex to differentiate it from a series of 35 mm SLRs with the same name that were made by Zeiss in the 1950s. Today, it is a much sought-after collectable camera, but it is also eminently usable.

The camera takes 35 mm film, but unlike most TLRs, it uses two different focal lengths of lens for focusing and shooting. In this way, it offers a focusing screen that is larger than the 24 × 36 mm film format. Instead of the usual ground-glass, the viewing screen is a glass lens, which gives a brilliant image.

The Contaflex was the first camera with an in-built photo-electric exposure meter. It operates via a Selenium cell found under a flap above the viewing lens. This drives a needle in a small window beside the viewfinder that is linked to a lever next to the viewing lens. Rotating the lever moves a shutter-speed scale against an adjacent scale of apertures so that when the meter needle lines up with a central mark the correct exposure is indicated on the two scales. Apertures are then set manually on the taking lens and shutter speeds on a body-mounted knob.

The Contaflex is also unusual because TLRs don't usually accept interchangeable lenses. It has a choice of 50 mm standards, plus a 35 mm wide-angle, an 85 mm portrait and a 135 mm telephoto. A very rare plate back is also available, which is interesting to collectors but impractical for today's users.

Inside, the focal-plane shutter is metal and the film is run horizontally.

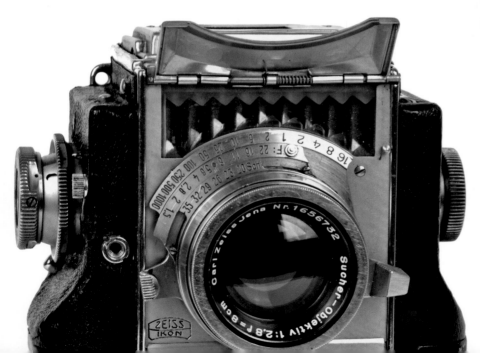

The Selenium meter cell behind a flap above the viewing lens.

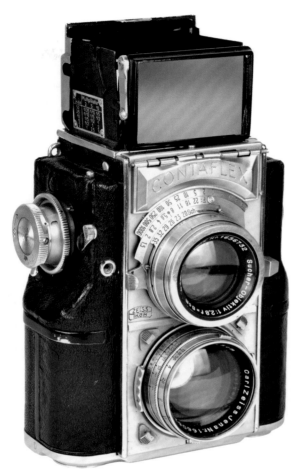

CONTAFLEX

Year of launch: 1935.

Shutter speeds: 1/2–1/1000 second.

Standard lens apertures: f/1.5–f/22.

Shoots 36 24 × 36 mm images on 35 mm film.

The viewing screen is larger than the film's image size.

Extra-bright viewfinder image.

☀☀☀☀☀

Other options: less expensive with f/2 or f/2.8 standard lenses.

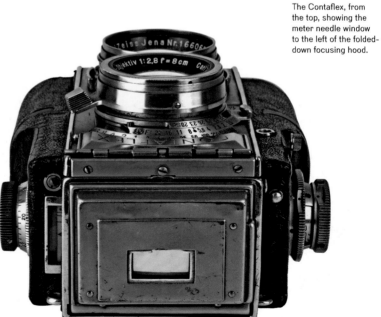

The Contaflex, from the top, showing the meter needle window to the left of the folded-down focusing hood.

Instamatic Cartridge Cameras

In the early 1960s snapshot photography was a popular pastime that was marred by the fact that so many snapshot photographers had difficulty loading a conventional camera. Then came the Kodiak cartridge, a plastic container with the film already pre-loaded. All the snapshot photographer had to do was open one of the special Instamatic cameras made for the system, drop in the cartridge, snap the back shut and start shooting. The cartridge was made so that it could only be inserted into a camera in the correct way.

The system was launched in 1963 and became an immediate success. This was thanks in no small part to the fact that Kodak allowed other manufacturers to make their own cameras to take the Kodapak cartridge. This meant more film sales for Kodak, even though other manufacturers were also allowed to make their own films.

The film was 35 mm wide, wound with backing paper containing frame numbers, with one perforation per frame and an image size of 28 × 28 mm. The size was known as 126.

For nine years the Kodak Instamatic system dominated snapshot photography, with simple, point-and-shoot cameras made around the world by all the big camera makers. Then, in 1972, Kodak did it again. In that year, the Kodak Pocket Instamatic system was launched.

The theory was much the same as with the 126 cartridge system. The difference was in the film size, now 16 mm and enclosed in long, narrow cartridges, which dictated a new shape of snapshot camera. The new film was designated as 110 and had a frame size of 13 × 17 mm.

Again, manufacturers around the world began retooling for the new snapshot format, which became just as popular – if not more so – than the 126 cameras.

The vast majority of cameras made for 126 and 110 films are unsophisticated, aimed originally at people who knew nothing about the technicalities of photography.

Most lenses are fixed focus and, where focusing is possible, distances are more likely to be identified by symbols rather than in feet or metres. Likewise, exposure settings, where they are available, are more likely to use weather symbols than anything as sophisticated as apertures or shutter speeds.

But, as with everything, there are exceptions: a select band of cameras that handle and behave in the same way as any 35 mm camera, except that they use 126 or 110 cartridges. They come from top names in camera manufacturing: Pentax, Minolta, Rollei, Zeiss, Ricoh and, of course, Kodak.

For today's retro photographer looking for a slightly different camera experience, it is worth seeking out this small, select group of cameras.

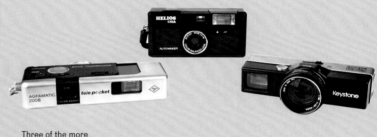

Three of the more sophisticated 110 cameras (above): Agfamatic 2008 Telepocket in-built standard and telephoto lenses; Keystone Zoom 66, with a zoom lens; and Helios 110, with a built-in electronic flash and motorized film-wind.

The Pocket Instamatic 300 was one of the first 110 cartridge cameras.

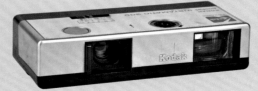

The Kodak Instamatic 50 and 100 were the first 126 cartridge cameras.

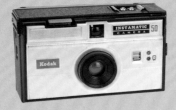 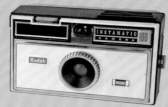

The Kodak Instamatic 400 followed the basic design with the addition of an in-built bulb flashgun and a clockwork motor drive.

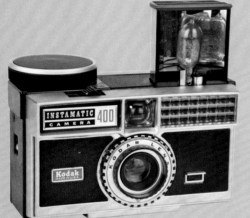

You can see here how a 126 Kodapak cartridge is loaded into the camera.

A 126 cartridge and a 110 cartridge.

Shooting Guide

The small range of 110 and 126 film cameras that feature shutter speed, aperture and focusing controls can be used in much the same way as any 35 mm or roll-film camera.

One difficulty with using these cameras is the scarcity of film. An internet search is likely to reveal a few specialist dealers who still sell it but, otherwise, older outdated film can often be found on eBay. Do not be put off by the 'use by' date on such films. If they have been stored correctly then they are often good for many years past the recommended time frames.

The other alternative is to load your own film: 126 cartridges with 35 mm film and 110 cartridges with 16 mm. Of the two, the 126/35 mm route is the most practical.

Information on how to do it can be found on the internet. In brief, it is a matter of working in a darkroom or changing bag, carefully breaking open the cartridge and attaching 35 mm film, straight from the cassette to the take-up spool. Masking tape can be used to secure it. About 30 cm of film can be withdrawn from the cassette, rolled tightly and placed in the cartridge's empty chamber. The cartridge can then be snapped together again, using gaffer tape to secure it if necessary.

Because there is no backing paper on the film, the cartridge's rear window, through which the backing paper numbers would normally be read, must be covered to prevent light leakages.

When loading a 126 cartridge with 35 mm film, the back window of the cartridge must be masked to prevent light leakage.

This is how the image looks when 35 mm film is loaded into a 126 cartridge. Note the way the image overlaps the top row of sprocket holes.

- Cartridge cameras are usually eye-level models, and so are best held in a similar way to 35 mm viewfinder cameras.

- If using a cartridge-film camera with only a fixed shutter speed/aperture/focusing specification, always shoot in bright, sunny conditions.

- At 28 mm deep, a cartridge-film image is 4 mm deeper than a 35 mm image, placed between the sprocket holes. In a cartridge, the top row of sprocket holes will be hidden in the film-wind mechanism, but the image will overlap the bottom row. Because lenses invert the image, the sprocket holes will appear at the top of the final pictures.

- Allow for the area where the sprocket holes will appear at the top of the image when composing the picture.

- True cartridge film has only one sprocket hole per frame, but 35 mm has eight. Therefore, when using reloaded 35 mm film, wind three or four times between exposures, and remember to cover the lens if this involves pressing the shutter release to free the winding mechanism.

From a colour print taken using a Pentax Auto 110 with a standard 24 mm lens.

Pentax Auto 110 Super

Only Pentax and Minolta made SLRs for 110 cartridge film. The Pentax Auto 110 Super is the best model made by either company.

It is a small palm-size camera with an impressive range of interchangeable lenses. The standard lens has a focal length of 24 mm, which gives a similar field of view to a 50 mm lens on a 35 mm camera. Also available are an 18 mm wide-angle, 50 mm and 70 mm telephoto lenses, and a now-rare 20–40 mm zoom lens.

The lenses all have focusing facilities but are unusual because they don't have aperture controls. Instead, apertures are adjusted by 'L'-shaped movable masks within the camera body. These, combined with an electronic shutter, give fully programmed automation with through-the-lens exposure reading.

Batteries, which control the camera's functions, sit inside, at the end of the body, so they can only be inserted when the camera back is opened for film-loading.

Despite its small size, the Pentax Auto 110 stands at the centre of a system of accessories that includes a dedicated flashgun, motor drive, filters and close-up lenses. Look for complete outfits, which were originally sold in their own custom-made cases.

The camera's viewfinder is bright, with a split-image rangefinder incorporated as an aid to focusing. Film-wind is by a single-stroke lever and the shutter release can be locked when not in use. The lever that locks the release also acts as a delayed action control.

Green and yellow LEDs in the viewfinder serve as slow-speed warnings: green means a safe speed of above 1/45 second has been selected by the camera; yellow warns of camera shake because the speed is below 1/45 second. In his case, the camera is equipped with a tripod bush to steady it, although the sight of such a tiny camera on a full-size tripod is a little incongruous.

For those more used to using a 35 mm SLR, the Pentax feels intuitively familiar and it is easy to forget that you are actually holding such a small camera, especially since the viewfinder is so comparatively large.

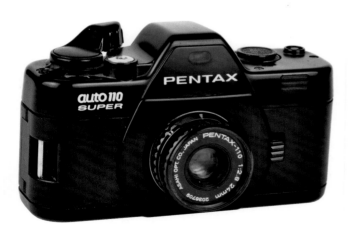

Pentax Auto 110 Super with a standard 24 mm lens.

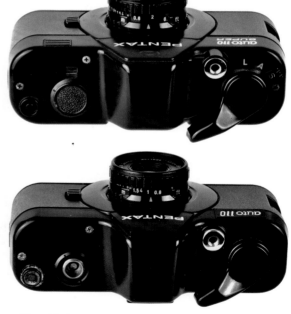

Top views of the original Pentax Auto 110 and the Super version.

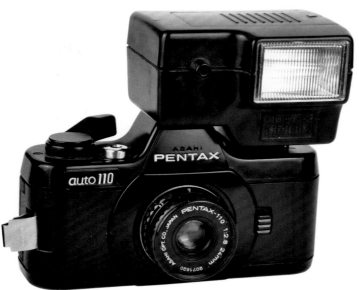

The earlier 'non-Super'
Pentax Auto 110 with
its dedicated flashgun.

PENTAX AUTO 110 SUPER

Year of launch: 1982.

Shutter speeds: 1–1/750 second.

Standard lens apertures: f/2.8–f/13.5.

Fully auto-programmed automation.

No manual settings possible.

✸✸✸✸✸

Other options: 'non-Super' Auto 110
launched four years earlier with a
double-stroke film-wind; no delayed
action and a slightly smaller viewfinder.
A deluxe brown version of the camera
can sometimes be found.

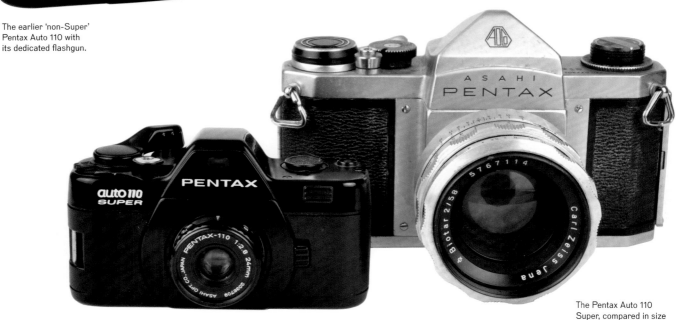

The Pentax Auto 110
Super, compared in size
to a 35 mm Pentax S1A.

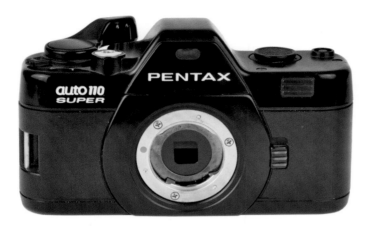

With the lens removed, you can see the 'L'-shaped masks that adjust apertures.

The lenses available for the camera: 18 mm wide-angle, 24 mm standard, 50 mm and 70 mm telephotos.

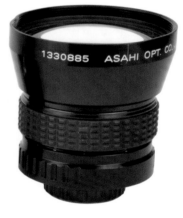

Inside the camera, showing the battery compartment at the right-hand end.

The camera in its outfit case with a flashgun, motor drive, filters, close-up lenses, soft case and film.

Rolleiflex SL26

Compared to a 35 mm SLR, the Rolleiflex SL26 is a chunky camera that is nevertheless very comfortable to use. It incorporates a small, fixed pentaprism viewfinder with an in-built split-image rangefinder and match-needle metering. As apertures and shutter speeds are adjusted on separate rings around the lens, the needle on the right of the viewfinder swings up and down a scale with correct exposure attained when it meets a notch at its centre point.

The shutter is released by a button on the top plate and the film wound by a single-stroke lever. There are no other controls.

The 40 mm standard lens has a removable front element, which can be replaced with accessory optics to convert the rear elements to 28 mm wide-angle or 80 mm telephoto.

ROLLEIFLEX SL26

Year of launch: 1968.

Shutter speeds: 1/2–1/500 second.

Standard lens apertures: f/2.8–f/22.

Match-needle metering.

Wide-angle and telephoto converters available.

☀ ☀ ☀ ☀ ☀ ☀

Other 126 film SLR options: Kodak Instamatic Reflex, Zeiss Ikon Contaflex 126 and Keystone K1020.

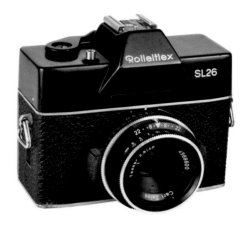

Rolleiflex SL26, one of the few SLRs made for 126 cartridge film.

The Rolleiflex with the front element removed and an 80 mm telephoto converter.

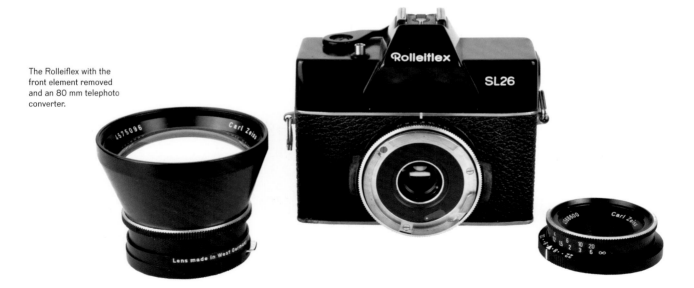

Minolta Weathermatic

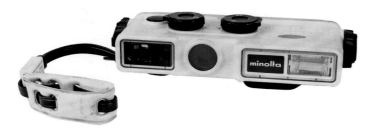

The Minolta Weathermatic
water-resistant camera.

The Sirius Dive-110 is
an alternative weather-
resistant 110 camera.

The Weathermatic
from the top, showing
the two main controls.

MINOLTA WEATHERMATIC

Year of launch: 1980.

Shutter speed: 1/200 second.

Standard lens apertures: f/3.5–f/8

Rugged and weather-resistant.

☀ ☀ ☀ ☀ ☀

Other waterproof 110 option: Sirius
Dive-110.

As 110 film cameras go, they don't come much more rugged than the Minolta Weathermatic. Not only is it weatherproof, but it can be used underwater to a depth of five metres (16½ feet).

A bulky yellow plastic case encompasses the camera. One knob on the top adjusts focus according to five distance symbols, while the other adjusts apertures according to three weather symbols. The shutter speed is fixed. A lever on the bottom of the case winds the film, and the camera incorporates an in-built flashgun.

Even if you don't use the Weathermatic underwater, its design will protect it against dust, sand and generally damp conditions on a beach.

Minolta 110 Zoom Mark II

Minolta made two SLRs for 110 film. The Mark I looks like a conventional 110 camera with a pentaprisim bolted on top, while the Mark II looks and handles more like a 35 mm SLR. The zoom range is 25–67 mm.

It is an aperture-priority camera with the f-stops set on a dial on the top plate. A second dial at the opposite end locks the shutter or sets auto mode. The 'B' setting is for extra-long exposures and the 'X' setting for flash. A button on top of the lens puts it into macro mode for close-up photography.

If you can find one, a now-rare teleconverter will double the focal length of the lens.

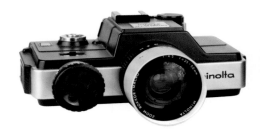
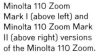

Minolta 110 Zoom Mark I (above left) and Minolta 110 Zoom Mark II (above right) versions of the Minolta 110 Zoom.

MINOLTA 110 ZOOM MARK II

Year of launch: 1979.

Shutter speeds: 1/4–1/1000 second.

Standard lens apertures: f/3.5–f/16.

Aperture-priority.

No manual exposure.

☀☀☀☀☀

Another Minolta 110 Zoom option: Mark I, which is a different shape with a 25–50 mm zoom lens.

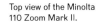

Top view of the Minolta 110 Zoom Mark II.

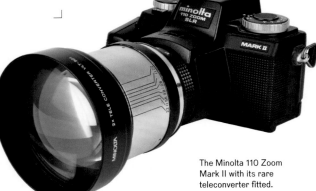

The Minolta 110 Zoom Mark II with its rare teleconverter fitted.

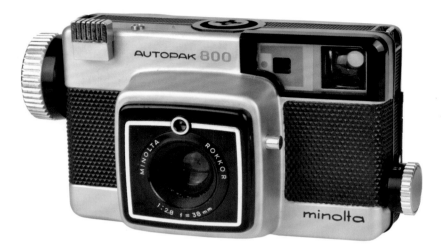

The Minolta Autopak 800 is more sophisticated than most 126 cartridge cameras.

Minolta Autopak 800

The Autopak 800 is more sophisticated than most 126 cartridge cameras. It features an in-built CdS meter for shutter-priority automation, it has a coupled rangefinder with lens focusing via a knob on the side of the body and it incorporates a clockwork motor for automatic film advance between exposures.

Although flashcubes are rarely used today, if one is inserted into the top of the body it can remain there, controlled by the meter to fire only when light levels demand it.

It is an easy camera to use, but the engineering that ensures its simplicity is far from simple.

MINOLTA AUTOPAK 800

Year of launch: 1969.

Shutter speeds: 1/45 and 1/90 second.

Standard lens apertures: f/2.8–f/16.

Shutter-priority.

Coupled rangefinder.

✸✸✸✸✸

Other options: Autopak 400-X and 500, auto exposure; Autopak 550 and 600-X, automatic with clockwork motor drives.

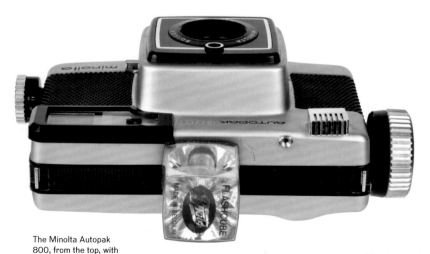

The Minolta Autopak 800, from the top, with a flashcube fitted.

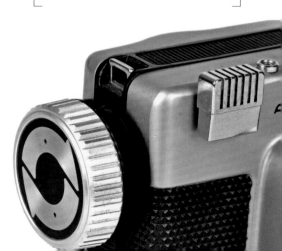

The shutter release and the large knob that winds the clockwork motor drive.

Rollei A26

The Rollei A26 didn't get the acclaim it deserved because it was launched in the year that Kodak switched from 126 to 110 cartridges in its new range of cameras.

It remains, nevertheless, one of the better-made 126 cartridge cameras. Folded, the lens is hidden behind a circular cover. Pulling gently on the two ends of the body extends it to reveal the viewfinder and the lens, which comes forward automatically from behind its cover.

Focusing is manual on the lens, opening and closing the body advances the film and exposure is automatic. Two years after the A26, Rollei launched the A110, a similar but smaller camera to take 110 cartridge film.

ROLLEI A26

Year of launch: 1972.

Shutter speeds: 1/30–1/250 second.

Standard lens apertures: f/3.5–f/22.

Programmed automation.

Dedicated C26 flashgun available.

☀ ☀ ☀ ☀ ☀

Another option: Rollei A110, for use with 110 film cartridge.

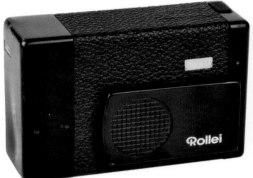

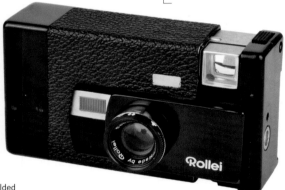

The Rollei A26 folded and unfolded.

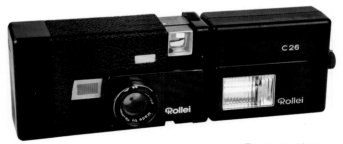

The camera with its dedicated C26 flashgun.

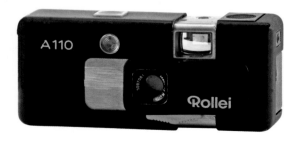

The subsequent Rollei A110, which was smaller.

Tasco Bino/Cam 8000

The Tasco Bino/Cam 8000 combines a 110 film camera with a pair of 7 × 20 mm binoculars.

The binoculars form the viewfinder and the camera lens rests between them. The standard lens is 100 mm focal length, which matches the view seen through the binoculars. Interchangeable 70 mm and 150 mm lenses are also available.

The camera is fully manual with a choice of two shutter speeds, simply marked '1' and '2', and apertures set on a ring around the lens.

TASCO BINO/CAM 8000

Year of launch: 1980.

Shutter speeds: 1/125 and 1/250 second.

Standard lens apertures: f/5.6–f/22.

Doubles as pocket-size binoculars.

☀ ☀ ☀ ☀ ☀

Another option: Bino/Cam 7800 with a single shutter speed and fixed lens.

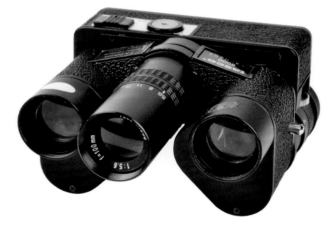

The Tasco Bino/Cam 8000 works as a camera and binoculars.

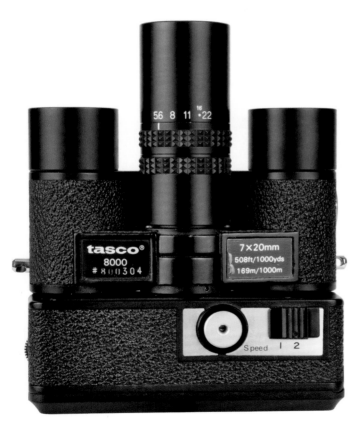

126/110 Novelty cameras

Drinks cans hide 110 cartridge cameras.

The Transistomatic combines a working radio with an Instamatic 100 camera.

Mickey-Matics take 110 size film and are found in two colours.

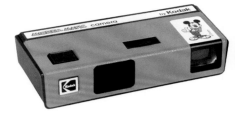

The 126 and 110 cartridge film sizes were adopted more than most by makers of novelty cameras.

Mickey Mouse and his pal Donald Duck cropped up a few times in camera designs of the instamatic era. Child Guidance Products in the US made the Mick-A-Matic for 126 film. It was shaped like Mickey's head with a lens in his nose, a viewfinder in the middle of his forehead and a socket on top for a flashcube. When 110 size film was launched, Kodak made two typically-shaped toy cameras for the cartridges called Mickey-Matics. They were coloured blue and pink for boys and girls.

Meanwhile, Helm Toy Corporation in New York made a simple snapshot camera for

Kodak 126 Instamatic film. It showed Mickey straddling a toy train with a lens in the front and featured Donald Duck holding a notice, which said 'smile'.

Cartridge cameras were also built into radios, notably the Transistomatic, made by the American General Electric Company, which took 126 film cartridges. The camera part was actually a Kodak Instamatic 100, but the rest of the bulky body was a radio that received medium- and long-wave transmissions, tuned by a large knob beside the camera lens.

Mickey Mouse and Donald Duck were not the only cartoon characters to find their way into and onto cameras. Snoopy, the dog from

the Peanuts cartoon strip, can be found lying across the roof a kennel, which is actually a 126 cartridge camera called the Snoopy-Matic.

The 110 cartridge has also found its way into cameras disguised as a McDonald's pack of fries, a Coca-Cola, as well as many other soft drinks, cans, miniature airliners, full-size cigarette packets, small tyres and tiny dictionaries.

Although such models might be considered more collectable than usable, they can still be of interest to today's retro photographer who wants to shoot with something a little out of the ordinary.

Snoopy on the roof of his kennel is actually a Snoopy-Matic camera for 126 cartridges.

126/110 NOVELTY CAMERAS

Years of launch: 1963–1980s.

Shutter speeds: single and fixed.

Standard lens apertures: fixed.

☀ ☀ ☀ ☀ ☀ to ☀ ☀ ☀ ☀ ☀

Other options: many and various, especially in the soft-drink can versions.

A miniature car tyre, a book and fake cigarette packet all conceal 110 film cameras.

The Mick-A-Matic is shaped like Mickey Mouse's head and takes 126 film.

Stereo Cameras

Stereo cameras, also known as 3D cameras, have been around since the birth of photography. They date back as far as the daguerreotype process, which was the first viable method of taking pictures, and were popular in the days of both wet-plate and dry-plate photography. Later, stereo cameras were made for roll film. These cameras are the most practical for today's retro photographer.

Stereo cameras mostly have two lenses, spaced apart by a distance close to that of human eyes. Each lens takes its own picture to form a stereo pair. Depending on the design of the camera, the two images appear on film side by side, or spaced apart by other images which, in turn, also make up stereo pairs.

The reason why we see the world in three dimensions is that the brain takes the two slightly different views seen by each of our eyes, compares them and combines them to give the illusion of depth. It is the same with the pictures taken with a stereo camera. When the film is processed, prints or transparencies are mounted side by side and placed into a stereo viewer. In this way, the left eye sees only the picture taken with the camera's left lens and the right eye sees only the picture taken with the right lens. The brain once again performs its magic and an illusion of depth is created.

The most popular and practical stereo cameras for use today date from the 1950s and early 1960s, and were made to take 35 mm or 120 size film. The vast majority work on the two-lens principle, although some cameras appear to have three lenses, with one in the middle acting as a viewfinder lens.

In the 1980s there was a brief craze for four-lens stereo cameras. They shot four half-frame pictures, side by side on 35 mm film, and used a specialized lenticular printing process to produce a three-dimensional impression without the need for a special viewer.

Without access to the complicated printing process, however, such cameras are impractical for use today. A few photographic manufacturers produced stereo beam-splitting devices that enabled a non-stereo camera to take stereo pairs. The attachments, especially those purpose-made for specific cameras, are rare and therefore sought out by collectors. However, because they are usually designed for use with 35 mm cameras, they are also practical propositions for today's retro stereo photographer.

Stereo cameras date back to the early days of photography. This one, made by Meagher in the 1860s, was made for the wet-plate process.

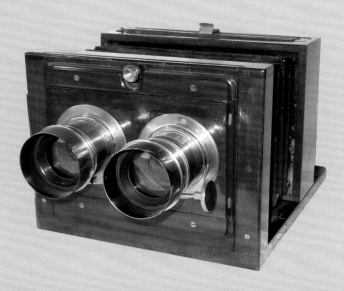

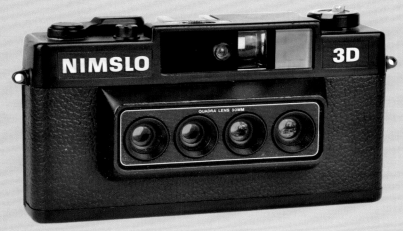

Nimslo four-lens
stereo camera.

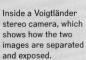

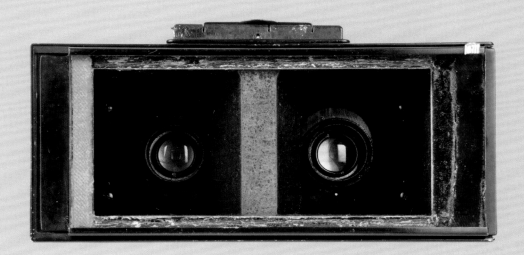

Inside a Voigtländer
stereo camera, which
shows how the two
images are separated
and exposed.

Shooting Guide

You need to think three dimensionally when using a stereo camera. A landscape where most of the interesting elements are far from the camera will make a poor stereo image. The best stereo picture has a strong subject in the foreground, something of interest in the middle-ground and a striking background. Shooting from beneath trees or arches, which form natural frames around more distant subjects, also helps. In this way, the subject is built up in layers from foreground to background – and it is those layers that make stereo images more dramatic.

This involves keeping everything in sharp focus, from the foreground to the background, so a deep depth of field needs to be created, which means shooting at the smallest practical aperture. Focusing the lens at its hyperfocal distance (see page 86 on using viewfinder cameras) helps in this respect.

When the film is processed, each subject will have two images that need to be mounted for viewing in a stereo viewer. Viewers for reversal (transparency) film back-light the image, either by holding the viewer against natural or artificial light, or by an in-built battery and torch-type bulb. Viewers for print film are less sophisticated, consisting of little more than two lenses that focus individually on each picture in the stereo pair.

Using print film, the negatives can be scanned and printed digitally to match the requirements of any viewer available for the purpose.

A landscape where the subject is distant from the camera makes a poor stereo image.

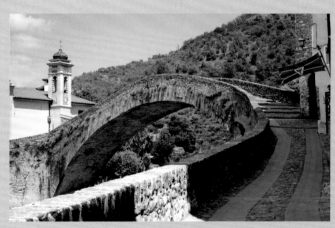

A different view of the same subject (see top), with something interesting in the foreground, middle-ground and background, makes a better stereo picture.

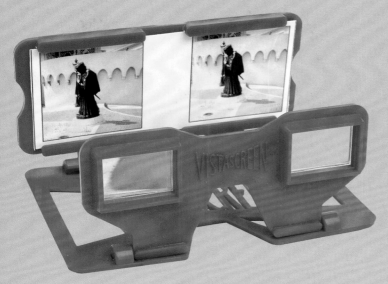

- Hold a stereo camera in the same way that you would hold a rangefinder or viewfinder camera.

- Think in three dimensions when composing the picture.

- Always work at the smallest practical aperture.

- Remember that small apertures mean slow shutter speeds, which might risk camera shake.

- Look out for an old stereo viewer in second-hand shops and flea markets. Measure the size of images it uses and the distance between each picture in a pair, and then digitally print your film negatives to match.

- When mounting pictures for viewing, ensure that the left and right images are orientated correctly.

A stereo pair, printed digitally and ready for viewing in an inexpensive viewer.

A stereo pair, taken with a Stereo Realist camera.

Stereo Realist

Conventional stereo cameras use two lenses, but at first sight the American Stereo Realist camera appears to have three. They are protected under a wide flap that folds up from the front of the body. The two outer lenses shoot the stereo pair and the central one reflects its image down to a viewfinder on the base of the body. Its position means the camera is used in a kind of upside-down way, with the bulk of the body above eye-level and pressed against the forehead.

Beside the viewfinder, a separate window houses a split-image rangefinder, linked to a knob on one end of the body. It focuses the camera by moving the film plane backwards and forwards, rather than moving the lenses in the conventional way. Apertures are set around the left-hand lens, which is linked

to similar apertures in the right-hand lens; shutter speeds are set on a ring around the viewfinder lens.

The Realist shoots 24 × 24 mm images on standard 35 mm film. The shooting and winding mechanism is designed so that its matching picture pairs appear on film three frames apart. A tiny notch at the film plane, in the bottom of the right image area, registers on the film when it is exposed to indicate right from left images when mounting for viewing.

A bulb flashgun and stereo viewer are both available, made specifically for use with the camera. The viewer is a robust piece of equipment with focusing viewing lenses and is equipped with a battery and bulb to illuminate the stereo pairs. It can only be used with transparencies.

STEREO REALIST

Year of launch: 1947.

Shutter speeds: 1–1/150 second.

Standard lens apertures: f/3.5–f/22.

Shoots 35 stereo pairs on 35 mm film.

Wide base rangefinder for accurate focusing.

☀ ☀ ☀ ☀ ☀

Other Realist options: a similar camera with f/2.8 lenses and a macro version launched in the 1970s.

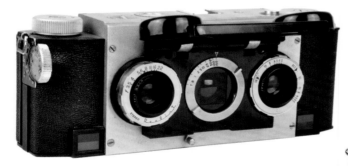

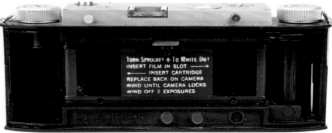

The film plane, which moves for focusing, inside the Stereo Realist.

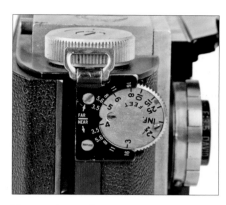

The camera's unusual
focusing control on
the end of the body.

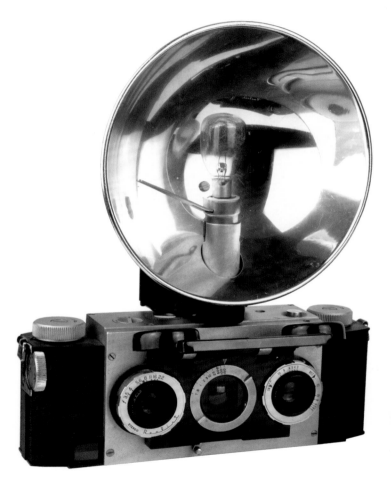

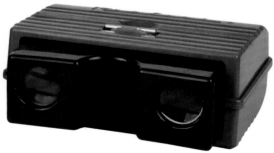

The flashgun and
stereo viewer made
to complement the
Stereo Realist.

Wray Stereo Graphic

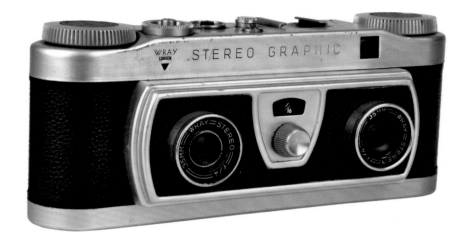

The Wray Stereo Graphic is a simple snapshot camera, but it is capable of good stereo results.

Although the lenses are fixed focus, each one is focused at a different distance: one at infinity, the other on the mid-foreground. This ensures that when the stereo pair is viewed in the Wray stereo viewer there is sharp focus on one of the images all the way from the foreground at around 4 feet to infinity.

The camera has a fixed shutter speed with the option of a 'B' setting for time exposures. Apertures are set on a knob between the lenses and indicators appear in a small window above. With the exception of f/16, each aperture is linked to a type of weather, from 'brilliant' at f/11 to 'cloudy' at f/4.

The camera can often be found with its own Wray stereo viewer.

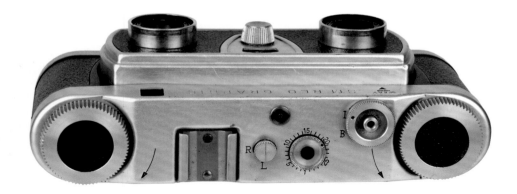

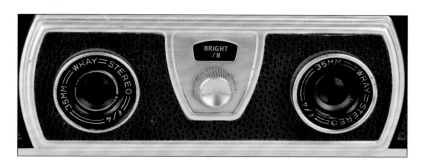

The Wray Stereo
Graphic's twin lenses
and simplified exposure
control.

WRAY STEREO GRAPHIC

Year of launch: 1955.

Shutter speed: 1/50 second.

Standard lens apertures: f/4–f/16.

Shoots 28 stereo pairs on 35 mm film.

Simple exposure system.

✳ ✳ ✳ ✳ ✳

Other options: American Graflex Stereo
Graphic; the same camera with Graflar
lenses.

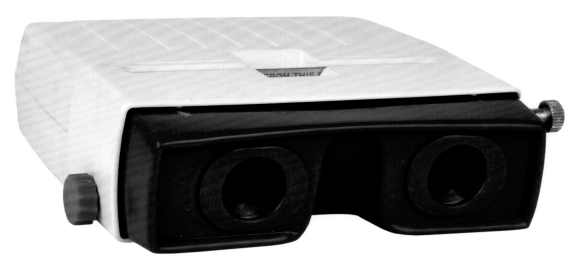

The Wray Stereo
Graphic's dedicated
stereo viewer.

View-Master Personal Stereo

The camera from the top, showing the exposure calculator, aperture and shutter-speeds controls.

View-Master are best known as makers of children's 3D viewers and picture reels, but they also introduced a couple of cameras for the tiny 12 × 13 mm images. This is the deluxe version of the first model.

The camera takes 35 mm film in an unusual way. Images are recorded only on the top half of the film on its first run through the camera. A knob on the front of the body then shifts the lenses vertically and reverses the travel of the film for the next set of exposures. As it winds back into the cassette, the second set of images is recorded on the lower part of the film.

Shutter speeds and apertures are set on twin dials on the top of the body and linked to an exposure calculator.

VIEW-MASTER PERSONAL STEREO

Year of launch: 1952.

Shutter speeds: 1/10–1/100 second.

Standard lens apertures: f/3.5–f/16.

Shoots 69 stereo pairs on 35 mm film.

Mechanical exposure indicator linked to shutter speeds and apertures.

✷✷✷✷✷

Another option: the more common, and less expensive, version in black; there are also accessories for mounting pictures in reels.

Inside the View-Master Personal Stereo you can see how pictures are recorded first on the top half of the film and then on the bottom half.

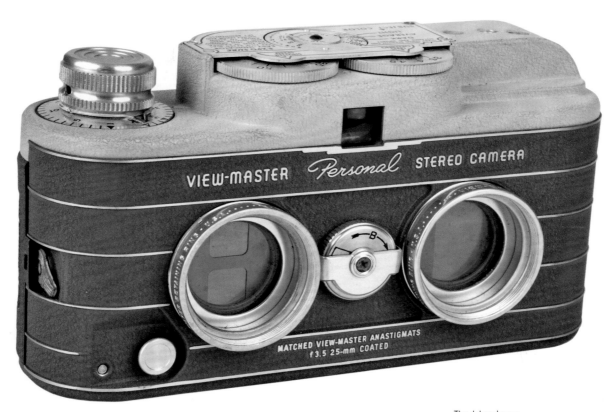

The deluxe brown
and beige version
of the View-Master
Personal Stereo.

View-Master Stereo Color Camera

The Stereo Color Camera was made to take similar-size stereo pairs to those produced with the Personal Stereo Camera (see pages 204–205), but this camera works in a very different way.

The film is wound diagonally through the body with stereo pairs recorded horizontally, so that matching images are seen side by side on the top and lower halves of the film. The camera also features a complicated exposure calculator that relies on matching weather symbols to blocks of colours that most resemble the colours of the scene being shot.

Film is wound by an unusual trigger on the top plate.

VIEW-MASTER STEREO COLOR CAMERA

Year of launch: 1961.

Shutter speed: approximately 1/50 second.

Standard lens apertures: f/2.8–f/16.

Shoots 75 stereo pairs on 35 mm film.

☀☀☀☀☀

Sophisticated exposure calculator.

Another option: Mark II version with small cosmetic changes.

The unusual diagonal film path inside the View-Master Stereo Color Camera.

Duplex Super 120

The Duplex Super 120 is different from most stereo cameras in that it uses 120 film, which is run through the body vertically to record 24 × 24 mm stereo pairs side by side.

Shutter speeds are set on a thumbwheel below the left lens, apertures on another thumbwheel below the right lens and focusing by a third thumbwheel above the lenses. Film-wind and shutter release are linked to prevent double exposures.

It is a small, easy-to-use camera, but because the lenses are closer together than on most stereo cameras, the three-dimensional effect is more pronounced when shooting close subjects than if shooting landscapes.

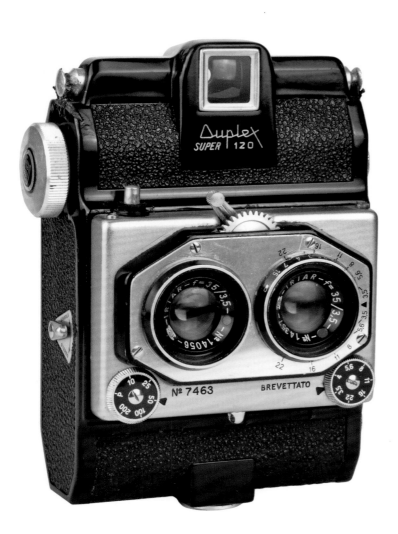

The Duplex Super 120, a small and unusually designed stereo camera.

DUPLEX SUPER 120

Year of launch: 1956.

Shutter speeds: 1/10–1/200 second.

Standard lens apertures: f/3.5–f/22.

Shoots 24 stereo pairs on 120 film.

The lenses are closer together than in most stereo cameras.

☀ ☀ ☀ ☀ ☀

Another option: Duplex 120 with fixed-focus lenses and a three-speed shutter.

Coronet 3-D Camera

Stereo cameras came with simple and sophisticated specifications. The Coronet 3-D Camera is one of the simpler models, with a fixed shutter speed and aperture, and two fixed-focus lenses.

It takes 127 film. With stereo pairs, the user watches the backing-paper numbers through the camera's red window and winds only to odd numbers 1, 3, 5 and 7. By operating a blind that covers the left lens, and then shooting at all the numbers between 1 and 8, the camera also takes eight non-stereo pictures.

The camera is made of Bakelite and features an unusual binocular viewfinder that is used with both eyes open.

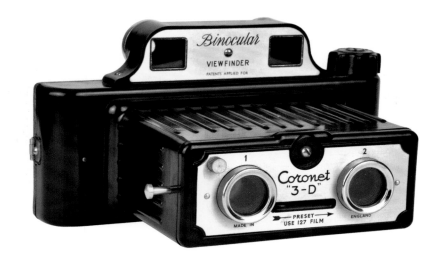

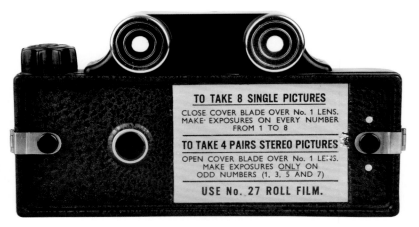

The Coronet from the rear, showing the unusual binocular viewfinder.

CORONET 3-D CAMERA

Year of launch: 1953.

Shutter speeds: 1/50 second.

Standard lens aperture: f/11.

Shoots four stereo pairs on 127 film.

Basic snapshot camera.

Other options: a similar camera with a single viewfinder; also versions with a multi-coloured flecked body.

Sputnik (CNYTHNK)

This is a Russian camera that was based on the same manufacturer's Lubitel twin-lens reflex. It has three lenses. The one in the centre, which is slightly above the taking lenses, is used to reflect its image to a large, bright viewfinder on the top of the body. The lenses are linked by cogs to retain the same focus in all three.

A lever beneath the lenses links the aperture scales on both, and shutters in the two lenses are also mechanically linked. A metal viewer for stereo prints can be found to match the camera.

Examine a Sputnik carefully before buying because since it is made of Bakelite it can easily chip. Also note that the shutters are sometimes prone to sticking.

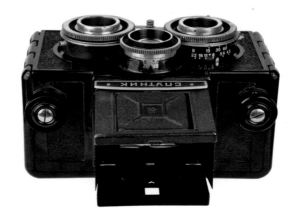

The Sputnik's own stereo viewer.

The Sputnik (CNYTHNK) stereo camera for 120 film.

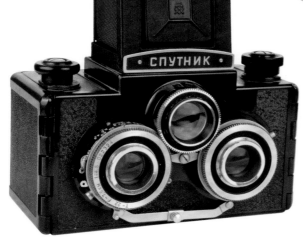

SPUTNIK (CNYTHNK)

Year of launch: 1959.

Shutter speeds: 1/15–1/125 second.

Standard lens apertures: f/4.5–f/22.

Shoots six stereo pairs on 120 film.

Large, bright viewfinder.

☀ ☀ ☀ ☀ ☀

Other options: Sputnik 2 with f/4 lenses; various other models with variations in shutter speeds and name spellings.

Panoramic and Wide-Angle Cameras

The conventional format for many cameras is 1:1.5. This means the width of the image is one and a half times its depth: 24 × 36 mm on 35 mm film, 6 × 9 cm on 120 film are two prime examples. Images produced by panoramic cameras will usually retain the conventional depth, but are wider than normal, with ratios such as 1:4 and, with some specialized models, even wider.

The two most common ways of achieving these formats are with swing-lens cameras and rotating cameras. The earliest of these took archaic film sizes that are no longer available. Some even took glass plates. Later examples for use with 35 mm and 120 film can still be found today.

A swing-lens camera has a lens which, rather than pointing straight at the subject, points instead to one side. It is contained at the end of a cylinder with a slit at the opposing end, and the film is fed around a semi-circular path. As the shutter is released, the lens swings in an arc as its image, projected through the slit, is built up gradually on the film. In most cameras of this type, the shutter speed is dictated by the speed of the lens's swing.

A rotating camera achieves a similar effect by allowing the camera to revolve as the exposure is made. At the same time, the film moves from one spool to another in the opposite direction across the film plane as the image is built up on it through a slit behind the lens. Depending on the type of picture required, and the subsequent width of the panorama, the camera might revolve through 180 degrees, or through anything up to a full 360-degree circle.

Panoramic pictures can also be made with wide-angle cameras. Such cameras differ from interchangeable lens cameras merely fitted with wide-angle lenses because they have a fixed short focal-length lens as their standard. Some of these cameras take panoramic pictures on wider-than-usual film formats. Others produce images in the conventional format, which can be cropped top and bottom to produce the panoramic effect.

In the last days of film, there was a craze for inexpensive 35 mm compact cameras that were called panoramic models. In fact they were 35 mm cameras in which the film plane had been masked top and bottom to create a panoramic effect. This style also found its way into a few single-lens reflexes, which could be adjusted for normal or panoramic images, and even into single-use 35 mm cameras. The design was most prevalent in Advanced Photo System (APS) cameras, which used a film size and type that found fleeting fame at the end of the film era.

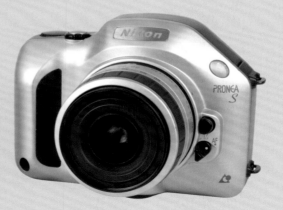

APS film is still available for cameras such as this Canon Ixus L-1 and Nikon Pronea S single-lens reflex. Each offers the option of standard or panoramic pictures.

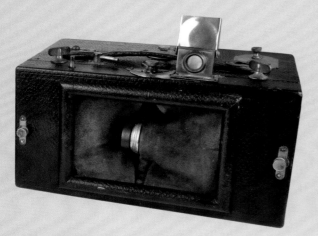

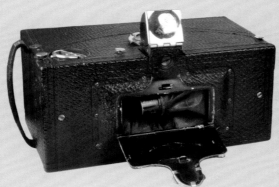

Two early swing-lens cameras from the 1900s: Al-Vista (above) and Kodak No.1 Panoram (right).

┌ ┐
BUYERS' TIPS

Give preference to panoramic cameras that use 35 mm or 120 film.

If buying a swing-lens camera, then make sure the lens swings at a constant rate. Older cameras might start slow and speed up during the swing.

Check that a swinging lens moves at the same speed from left to right as from right to left.

If the lens is contained in a flexible leather or cloth sheath, then check its pliability.

With rotating cameras, ensure that the speed of rotation is constant throughout the exposure.

If rotation is controlled by clockwork, check that the key to wind it is present and that the spring has not been over-wound.

Check that the film movement within a rotating camera is synchronized with the camera's rotation.

If buying a wide-angle camera, make sure the focal length of the lens is wider than a standard (less than 50 mm on 35 mm and less than 80 mm on 120).
└ ┘

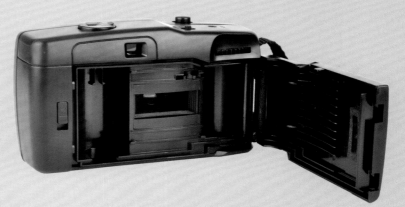

Inside an inexpensive Panorama 35 mm compact camera. The film plane is masked top and bottom to make a 14 × 36 mm panoramic image.

Shooting Guide

Photographers are encouraged to concentrate on the principal subject and cut out the peripheral details when shooting with a conventional camera. With panoramic, and some wide-angle cameras, the opposite is true. Human eyes see in a panoramic format and that is what you are emulating when you shoot a panoramic picture: a principal subject, often in the centre but sometimes to the side, surrounded by other interesting details.

The key word here is 'interesting'. In a conventional picture it doesn't matter if details around the subject are bland – you are not including those in your picture. A panoramic picture, on the other hand, sees everything.

When you are preparing to take a panoramic picture it is a good idea to face what you consider to be the main subject, stand still and move your head, taking in what looks good on each side. With a rotating camera that takes in a full 360-degree circle you need to go one step further, turning on the spot to look at what is around you.

Because a panoramic picture is wider than usual, part of it might be in sunlight and part in shadow. Unless you want to exploit this in the composition, it helps to shoot panoramic pictures on days that are bright but slightly cloudy, diffusing sunlight and giving a more even spread of light across a wide area.

- Hold a panoramic camera by its edges, rather than wrapping your hands around the body, to prevent out-of-focus fingers appearing at each side of the image.

- When using a swing-lens model, point the camera at the subject you want to appear in the centre of the picture, even though the lens is initially pointing to one side.

- When using a rotating camera, hold it above your head or place it on a tripod and duck below it, otherwise your out-of-focus face will appear in part of the picture.

- It is important to keep a panoramic camera level without tilting it. If yours has an in-built spirit level, use it.

- Do not use flash for a panoramic picture because its beam will not cover the full width of the picture.

- If negatives are to be commercially processed, tell the processor they are not to be cut into standard 35 mm frames.

From a print made with the Horizon 202 camera, shooting a 24 × 58 mm format on 35 mm film.

From a print made
with the FT-2 camera
shooting a 24 × 105 mm
wide format on 35 mm
film.

From a colour reversal
(transparency) image
made with a Globuscope
shooting a 24 × 150 mm
format on 35 mm film.
The path on each side of
the picture is actually in
front of and behind the
camera.

Noblex 135 & Pro 6/150

Noblex cameras were first manufactured in Germany in the 1990s and were made until relatively recently, so they can often be found new and unused. The Noblex 135 and Pro 6/150 take different film sizes, but work in similar ways. They are swing-lens cameras with a difference. In more traditional models, the speed of the lens swing can be sometimes slower at the start of its movement than at its end, leading to unevenly exposed panoramas. With Noblex cameras, the lens is contained within a cylinder that rotates 360 degrees, but with the movement beginning before the start of the actual exposure. This ensures that by the time the exposure begins the lens has accelerated to its optimum speed and the resulting picture is evenly exposed across its width. The film lies in a curved film plane.

Both cameras are battery-driven. Each has a special viewfinder mounted top and centre to give a panoramic preview of the picture being taken. Each viewfinder has an in-built spirit level to ensure that the camera is held level, an essential aspect of shooting panoramic pictures.

On both cameras, shutter speeds are selected on knobs on the top plate. Apertures are selected by thumbwheels inset into the lens cylinders in their rested positions. The lenses can also be moved vertically, inducing a small degree of shift to accommodate tall subjects without tilting the camera, another thing to avoid when shooting panoramas. The lenses are fixed focus.

The Noblex 135 takes 35 mm film to produce 24 × 66 mm images. Although

the lowest shutter speed is 1/30 second, slower speeds can be induced by employing the camera's multiple exposure control and allowing the lens to rotate more than once. The number of rotations ranges from two, to emulate 1/15 second, to 128 to give the equivalent of four full seconds.

The Noblex Pro 6/150 takes 120 film to produce 50 × 120 mm images. The slowest shutter speed is 1/15 second, shown on the shutter-speed control in white. Slower speeds down to two seconds, shown on the control in red, can be accessed with the connection of the slow-exposure module, a cylindrical-shaped accessory connected mechanically and electronically to the base of the camera.

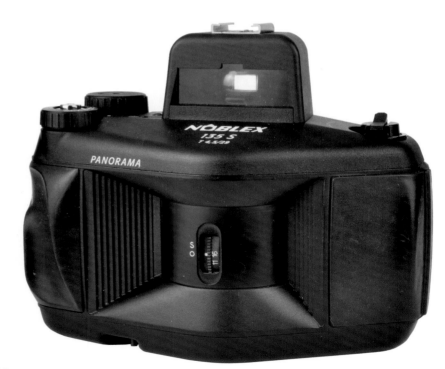

Noblex 135 for 35 mm film.

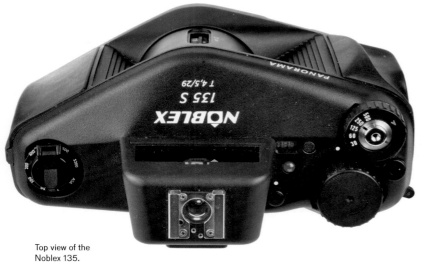

Top view of the
Noblex 135.

NOBLEX 135

Year of launch: 1992.

Shutter speeds: 1/30–1/500 second.

Standard lens apertures: f/4.5–f/16.

Shoots 19 24 × 66 mm images.

Requires four AAA batteries.

☀ ☀ ☀ ☀ ☀

Other options: Noblex 135 Pro Sport,
without a lens shift or viewfinder spirit
level.

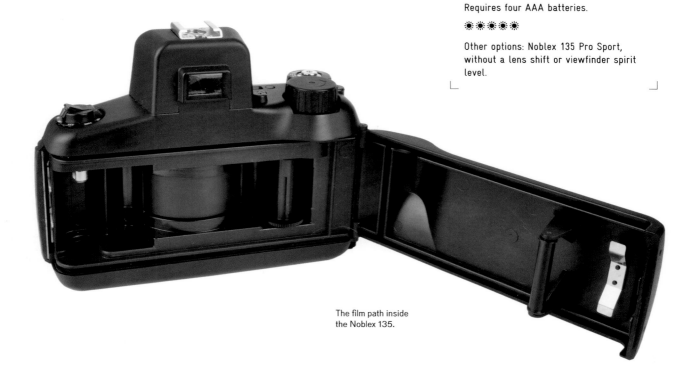

The film path inside
the Noblex 135.

The film path inside the Noblex Pro 6/150.

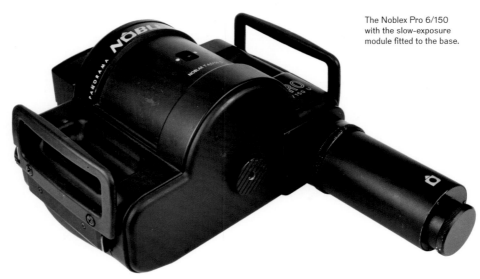

The Noblex Pro 6/150 with the slow-exposure module fitted to the base.

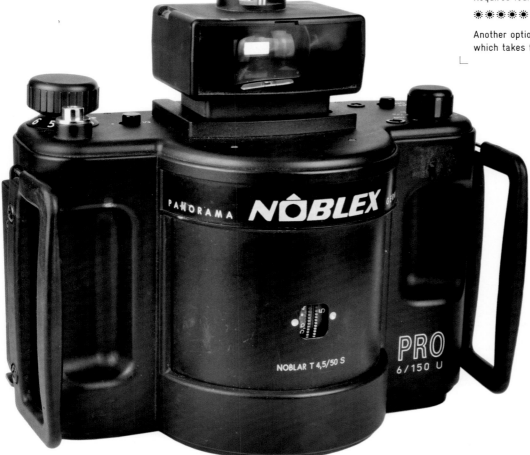

Noblex Pro 6/150
for 120 size film.

NOBLEX PRO 6/150

Year of launch: 1992.

Shutter speeds: 2–1/250 second (slow speeds with slow-exposure module).

Standard lens apertures: f/4.5–f/16.

Shoots six 50 × 120 mm images.

Requires four AA batteries.

☀ ☀ ☀ ☀ ☀

Another option: the Noblex Pro 5/175, which takes four 50 × 170 mm images.

FT-2

This is a Russian swing-lens camera that takes 24 × 105 mm panoramic images, three times the width of a standard 35 mm frame. Although it uses 35 mm film, it must be pre-loaded into the camera's unique cassette, for which a darkroom or changing bag is necessary.

The aperture is fixed, but the camera has three shutter speeds that control the speed of the lens swing. The speeds are set by adjusting two levers on top of the body, according to instructions on an adjacent metal plate.

When winding, film is taken from one cassette, led around a curved path and fed into a second cassette. As a knob is turned to advance the film, a pointer on a circular dial inset into the camera's top must be allowed to rotate three times before it comes to rest on the next exposure number.

If buying an FT-2 for use, make sure it has both its special-size cassettes: it won't work without them.

The camera top, showing how the two levers are adjusted to set the shutter speeds.

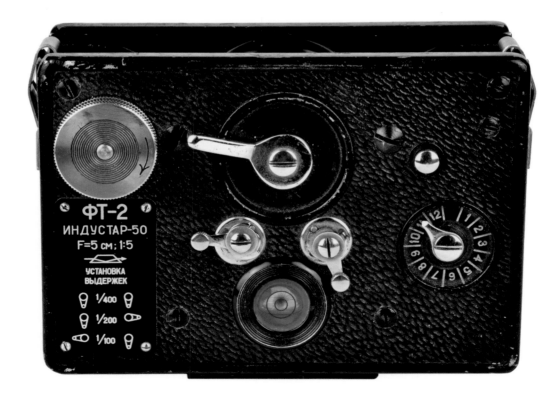

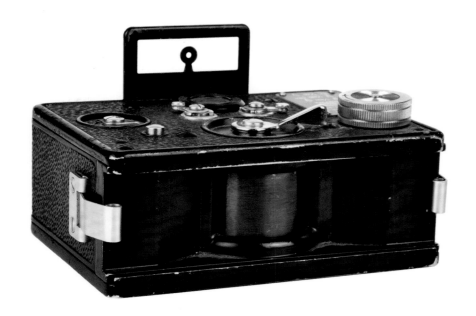

FT-2

Year of launch: 1958.

Shutter speeds: 1/100–1/400 second.

Standard lens aperture: f/5.

Shoots 12 24 × 105 mm images.

Film needs to be pre-loaded into a special cassette.

☀☀☀☀☀

Other options: FT-1 with a single shutter speed, FT-3 with variable apertures; both cameras are much rarer than the FT-2.

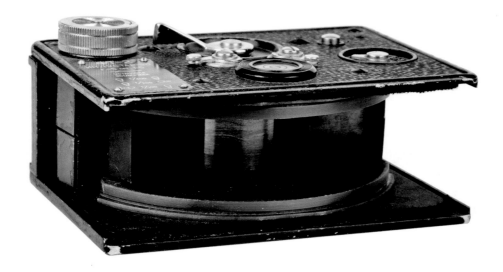

The film path inside the FT-2.

Horizon 202

With a panoramic image size of 24 × 58 mm, the Horizon is made of injection-moulded plastic and uses standard 35 mm film to produce its pictures by the swing-lens method. It is best used with a hand grip that screws to the base.

The lens is fixed focus, but the camera has a range of apertures and shutter speeds set by pointers on scales above the lens.

The pointers don't appear until the film is wound, ready for an exposure. The shutter speeds are on two scales one above the other: yellow for slow speeds and white for fast, selected according to whether a lever on the top plate is set against a yellow or a white dot.

The Horizon 202 can still be bought new on the internet and from specialist camera dealers.

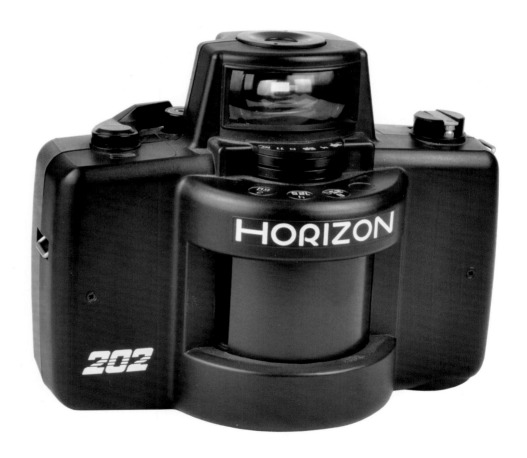

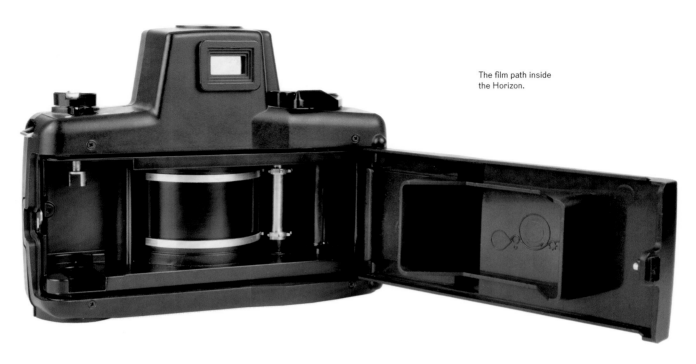

The film path inside
the Horizon.

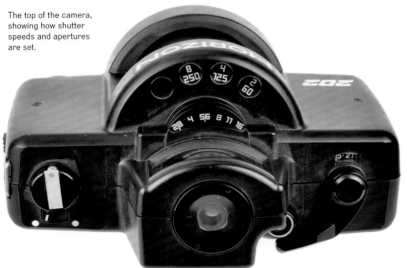

The top of the camera,
showing how shutter
speeds and apertures
are set.

HORIZON 202

Year of launch: 1989.

Shutter speeds: 1/8–1/250 second.

Standard lens apertures: f/2.8–f/16.

Shoots 24 24 × 58 mm images.

☀ ☀ ☀ ☀ ☀

Other options: Horizon 203 S3 Pro
with shutter speeds of 1–1/250 second;
also variations on the Horizon 202 in
a cream colour.

Horizont

The Horizont panoramic camera with its dedicated hand grip.

The Krasnogorsk factory near Moscow in Russia made the Horizont after the FT-2 and before the Horizon. It is the best of the three: it is better than the FT-2 because it has a range of apertures and better than the Horizon because it is made of metal.

It's a swing-lens camera that takes 24 × 58 mm images. Shutter speeds and apertures are set on a dial on the top plate. The lens is fixed-focus.

If you are buying a Horizont to use, then make sure it has its dedicated hand grip that screws to the base of the camera and its panoramic viewfinder which attaches via an accessory shoe on the front of the body. Also, pay attention to the complicated film-loading. A diagram inside the back explains how this works.

HORIZONT

Year of launch: 1967.

Shutter speeds: 1/30–1/125 second.

Standard lens apertures: f/2.8–f/16.

Shoots 24 24 × 58 mm images.

✷✷✷✷✷

Other options: it is also sold under the names Global-H and Horizont Review.

The dedicated panoramic viewfinder is an important accessory if you want to use the camera.

A diagram inside the Horizont explains how to load the film.

Globuscope

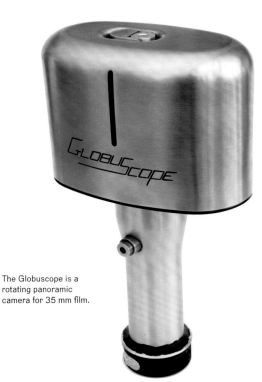

The Globuscope is a rotating panoramic camera for 35 mm film.

GLOBUSCOPE

Year of launch: 1981.

Shutter speeds: 1/40 and 1/200 second.

Standard lens apertures: f/3.5–f/16.

Shoots eight 24 × 150 mm images on 35 mm film.

✳✳✳✳✳

Other option: a variation where the shutter speeds vary with the width of the lens slit; it can only be changed before the camera is loaded.

Inside the Globuscope.

The American Globuscope is a rotating camera that uses standard 35 mm film cassettes. Set to shoot a complete 360-degree circle, it takes 24 × 150 mm pictures, but can shoot narrower widths with less camera rotation.

The camera is oval shaped on top of a handle that houses a clockwork motor. The handle is wound to tension the spring and a release on the side sets the camera in motion. As it rotates, the 35 mm film inside passes across a slit at the rear of the lens to build up the picture.

Two shutter speeds are changed by inserting an alum key into the tripod bush. The aperture control has an extra setting that completely closes the lens when the camera is not in use to prevent light from fogging the film.

The recommended way to use the camera is set for two revolutions, allowing the desired panoramic portion to be cropped from the final image. The downside is that this gives only four exposures to a roll of 35 mm, which would normally yield 36 conventional pictures.

Envoy Wide Angle

The Envoy is an English camera that shoots 6 × 9 cm images on 120 film. The standard lens for that format is around 100 mm, but the fixed lens on the Envoy has a 64 mm focal length. The pictures produced are therefore in a wide-angle format.

If the images are cropped top and bottom to something around 4 × 9 cm they make very credible panoramic pictures. The lens is fixed focus but, with a small maximum aperture and short focal length, depth of field takes care of most focusing needs.

The camera takes 120 film, but can be adapted to take individual sheets of 6 × 9 cm sheet film.

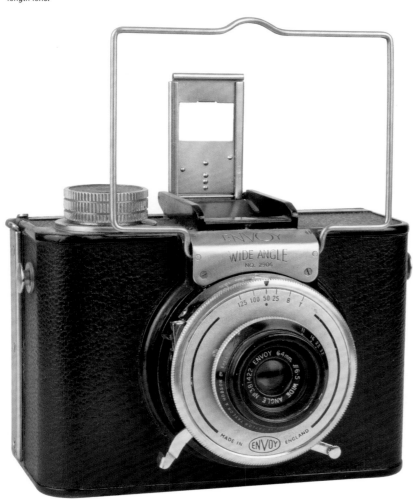

The Envoy Wide Angle camera with its shorter-than-standard focal-length lens.

ENVOY WIDE ANGLE

Year of launch: 1950.

Shutter speeds: 1/25–1/125 second.

Standard lens apertures: f/11–f/32.

Shoots eight 6 × 9 cm images on 120 roll film.

☀ ☀ ☀ ☀ ☀

Another option: variation with f/6.5 lens and shutter speeds of 1–1/250 second.

Spinner 360°

Lomo cameras are modern film models, which are made in many different styles. The Spinner is the company's take on a rotating panoramic camera. It produces images up to 165 mm wide on 35 mm film.

The camera sits on top of a chunky handle from which a ring on the end of a cord protrudes. The ring is pulled out and released, which activates the camera to rotate on the handle through 360 degrees as the film inside moves past a slit at the rear of the lens. The power comes from a thick rubber band connecting the camera to the handle.

Two apertures are identified by sunny and cloudy symbols on a sliding control. The shutter speed can be erratic, but it should be somewhere between 1/125 and 1/250 of a second.

The settings assume the use of ISO 400 film speed. If slower films are used, then the aperture control needs to be set to cloudy at all times.

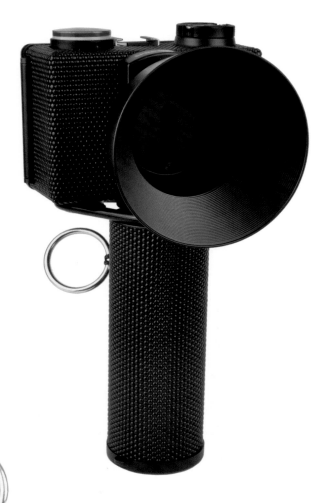

The ring that pulls the cord and the rubber band that powers the camera's rotation.

Year of launch: 2010.

Shutter speeds: approximately 1/125–
1/250 second.

Standard lens apertures: f/8 and f/16.

Shoots eight 24 × 165 mm images.

Sold new with a lens hood, spare rubber
band and sample panoramic picture.

✳✳✳✳✳

Another option: Lomo Fish-eye 2 for
super-wide-angle pictures on a standard
35 mm film frame.

Inside the Spinner 360°.

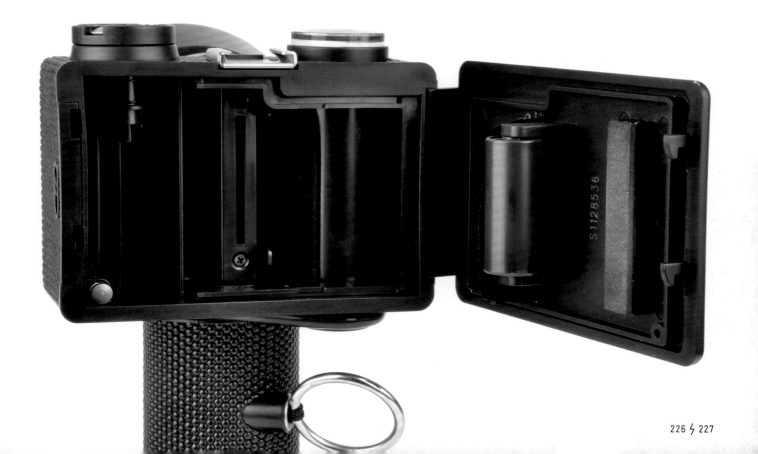

No.6 Cirkut

Cirkut cameras were first made by the Rochester Panoramic Camera Company in 1904, and later by Folmer Graflex and various divisions of Eastman Kodak. They carved out a unique niche in the story of panoramic photography by being the cameras used for those super-wide pictures of schools, sporting groups, or any subject that demanded the photography of a large number of people.

Although launched at the start of the twentieth century, they continued to be made until 1945 and used by specialized photographic studios until relatively late in the film era. Today they are considered to be more collectable than usable, but it is still possible to buy the film from specialist dealers who can be found on the internet. They present an interesting exercise for today's retro photographer who is up for a challenge.

The Cirkut is a rotating camera. As it rotates, the film moves from spool to spool past a slit behind the lens. The camera can only be used on its own purpose-made tripod, and therefore needs to be purchased as part of a complete kit that should be inspected before buying to make sure everything is present and accounted for. Also part of the kit will be the key that winds the camera's clockwork mechanism and a set of gear wheels that link the camera to the tripod, which are all housed in a compartment at the end of the body. An appropriate gear wheel is chosen for each picture in keeping with the focal length of the lens in use and the camera-to-subject distance.

Cirkut cameras use triple convertible lenses, which means each can offer three focal lengths, according to which elements are used. Focusing is controlled by a ground-glass screen, manipulated into the slit behind the lens. After focusing, the screen is moved away prior to exposure.

Although Cirkut cameras can be adjusted to rotate in a complete 360-degree circle, they were historically more often used to shoot through 180 degrees, mostly to photograph large groups of people, who were posed in a semi-circle around the camera.

The No.6 Cirkut in its folded position.

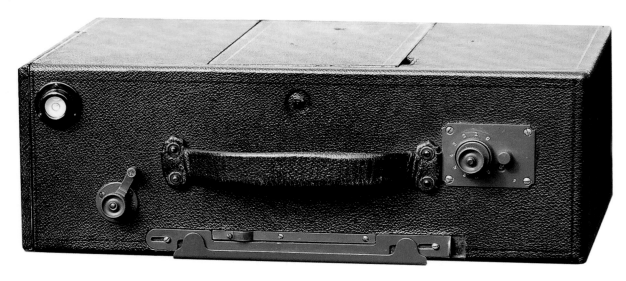

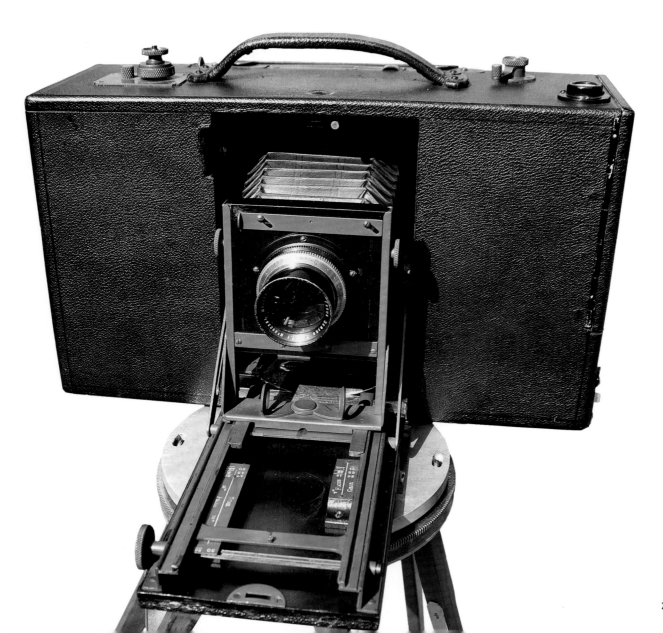

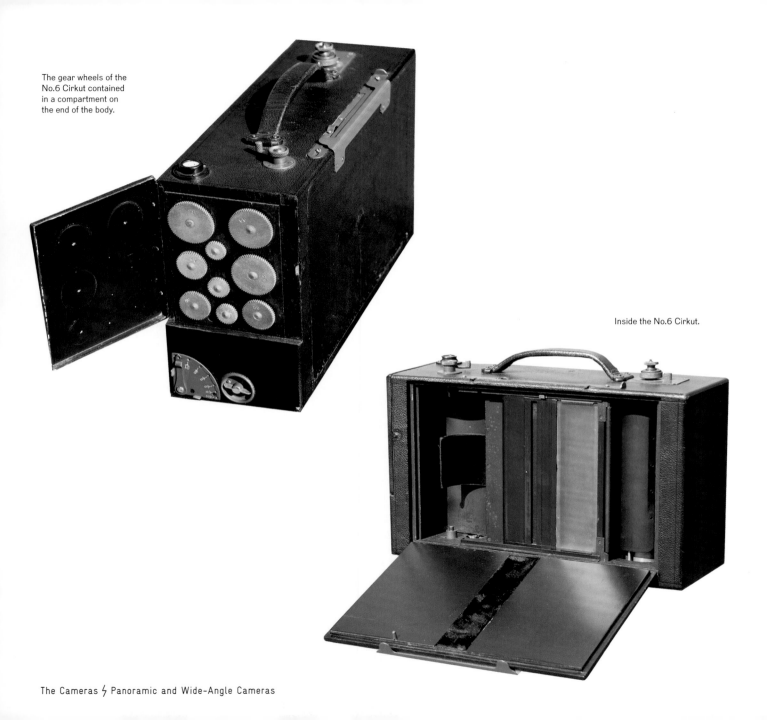

The gear wheels of the No.6 Cirkut contained in a compartment on the end of the body.

Inside the No.6 Cirkut.

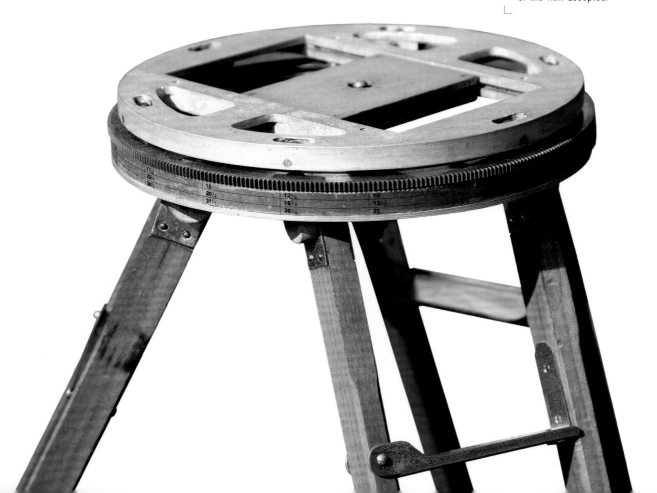

NO.6 CIRKUT

Year of launch: 1907.

Shutter speeds: 1/2–1/25 second.

Standard lens apertures: f/7.7–f/64.

Shoots images 6 inches (15 cm) deep and up to 6 feet (180 cm) wide.

☀ ☀ ☀ ☀ ☀

Other options: Cirkut No.5, No.8, No.10 and No.16; similar cameras with the numbers referring to the maximum width of the film accepted.

The dedicated tripod with a special head that must be used with the camera.

Miniature Cameras

It is generally thought that the smallest film format that is truly viable for serious retro photography is 35 mm, but there have been – and still are – smaller films used in small cameras that can deliver good results.

If you mention miniature or subminiature cameras to collectors their thoughts turn to 16 mm, which is a film size that first appeared in the Mini-Fex camera in 1932, but peaked in the 1950s and 1960s. At that time, 16 mm cameras were made in every style, from single-lens reflex to twin-lens reflex, from stereo to panoramic, as well as many others. Many of these cameras were superbly made and still survive today. The film, however, is not easy to come by. Minolta was the last company to produce usable 16 mm film for their series of Minolta 16 cameras. It can still be found second-hand and outdated on the internet and, for the retro photographer who enjoys experimenting, it can be bought and reloaded into the different shapes and sizes of cassettes used by 16 mm cameras. If you are tempted to buy outdated film, ask the seller if it has been refrigerated. If it has, it might still yield acceptable results, but be aware that it will have lost some of its speed over the years, and might be a little fogged – or indeed very fogged.

Another popular miniature format of the past was 17.5 mm. This size was in the form of tiny roll films. It first appeared in the Hit camera in 1950 and subsequently became very popular for many tiny cameras made all around the world. Retro photographers, however, should avoid 17.5 mm cameras for two reasons: the film is almost impossible to find and most of the cameras for which it was made were low quality and little more than toys.

But all is not lost for the retro photographer who wants to shoot with a miniature camera, because one type uses a miniature film that can still be bought new. The name of the film, and the camera it is made for, is Minox.

Although originally made specifically for Minox cameras, the tiny film cassettes can also be used in a small range of cameras from other manufacturers. These were mostly made in the past, but a very few are still being produced today. They make the most practical route into miniature camera photography.

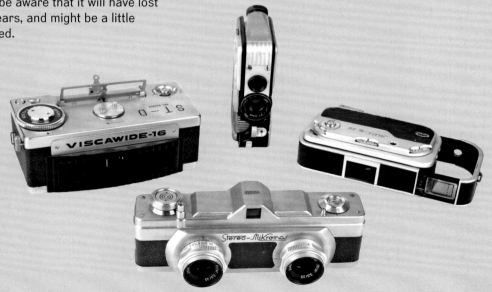

A selection of some of the more sophisticated cameras made for 16 mm film: Minicord, an unusual twin-lens reflex; Mec 16SB, the first camera with through-the-lens metering; Viscawide, a swing-lens panoramic camera; and a Mikroma stereo camera.

BUYERS' TIPS

Give preference to miniature cameras
that use Minox film.

Buy a 16 mm camera only if you have
ascertained a source for the film.

Most 16 mm cameras use their own
specialized cassettes. Make sure
the one you choose has its cassette
included.

Avoid miniatures that were made more
as toys than as serious cameras.

Check if the camera has adjustable
shutter speeds, apertures and focusing;
a combination of all three is an
indication of its quality and ability
to shoot acceptable pictures.

Avoid miniature cameras whose controls
are too small to adjust easily.

Minolta 16 film (above)
can be found second-
hand and loaded into
16 mm camera
cassettes; Minox film
is still available new.

Avoid low-quality
cameras such as the
Hit (below left) and the
Coronet Midget (right),
which took miniature
17.5 mm roll film.

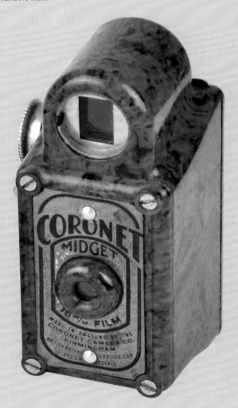

Shooting Guide

To use miniature cameras today there are two popular film options: 16 mm and Minox. For the real enthusiast, finding 16 mm film and pre-loading it into the many different types of cassette employed by the cameras can be very satisfying. For those less inclined to go to the trouble, there is Minox.

Although Minox made small 35 mm cameras, it is the miniature pseudo spy cameras with their long, thin bodies that are opened and closed to wind the film for which the company is best known. Many variations on the theme were manufactured, some of which are expensive due to their interest on the collector's market, The three most common and less expensive cameras recommended for use are the Minox B, Minox C and Minox EC, differentiated by their metering and exposure systems. All work on the same principle of push-pulling two halves of the body to tension the shutter and wind the film, with the usual controls on the top.

To load a film, the camera must be in its open position. Inserting a thumbnail into a tiny catch on the base, then pulling the two halves of the camera further apart reveals the film chamber. The twin film cassette is placed into position and the two halves of the body pushed back again, ready for shooting.

- Hold the camera by the thumb and tips of the first fingers, each side of the body, with the right finger on the shutter release.
- Beware of camera shake inherent in the use of miniature cameras.
- Check the internet for the availability of film and processing.
- Look for accessory viewfinders that offer waist-level viewing, purpose-made for different models.
- Search for filter kits made for different models.
- Consider using other miniature cameras that accept Minox film.

From a colour print taken with a Minox B.

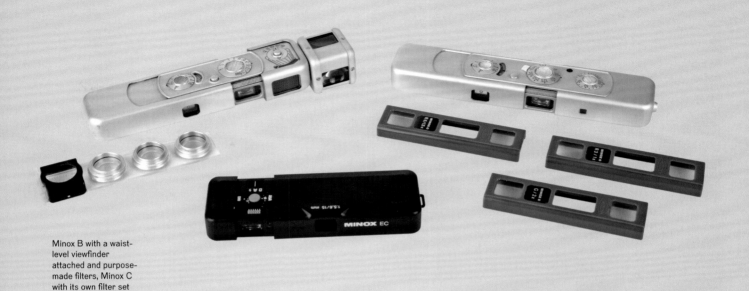

Minox B with a waist-level viewfinder attached and purpose-made filters, Minox C with its own filter set and the Minox EC, the smallest of all Minox cameras.

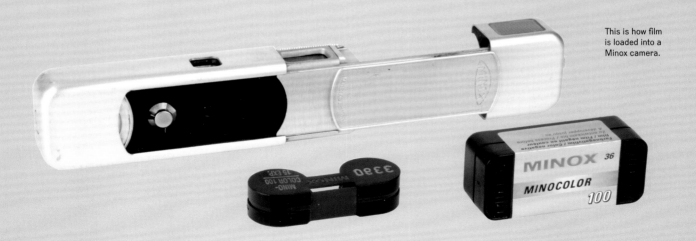

This is how film is loaded into a Minox camera.

Minox B

The first Minox was made in Latvia in 1937. Today, it is very collectable and expensive to buy. For the retro photographer who wants a miniature camera that they can use, the Minox B is a better proposition than the first model. It is more abundant than other models and the prices are correspondingly more reasonable.

The design of the Minox B features a long body that is roughly the length of an index finger in its closed position. To open it, the two ends are pulled gently apart to reveal the viewfinder and to slide a lens cover aside. The shutter is released by a button on the top and then the two halves of the camera are slid together again. The action of opening and closing the body winds the film and tensions the shutter. Two dials sit on top of the body.

One adjusts focus and the other changes shutter speeds. A sliding bar above the viewfinder pushes a green filter into place in front of the lens.

The camera has an in-built Selenium exposure meter, adjustable for film speeds of 25–400 ASA. A needle in a window moves across a scale, according to the light available. As the shutter-speed dial is turned, a pointer connected to the meter also moves. When the pointer lines up with the needle, then the correct shutter speed has been set. The lens is fixed at f/3.5 and apertures are not adjustable.

Minox film is supplied in tiny double cassettes in which the film winds from one to the other as the body is opened and closed. They drop into the base of the body. The film

is still available in colour negative, colour slide and black-and-white versions.

The Minox B, as well as other Minox cameras, is distinguished from most miniatures by the large range of accessories available. These include a folding tripod, a copying stand, a binocular attachment to emulate telephoto effects, a neck chain with knots in it to indicate distances for close-up work, a range of different viewfinders, filters and flashguns. The tripod, copying stand and binocular attachments are fitted to the camera via special cradles, which also add a screw socket that lines up with the shutter release to accept a screw-in cable release.

The Minox B is perfect for the retro photographer who wants to work with a high-quality miniature camera.

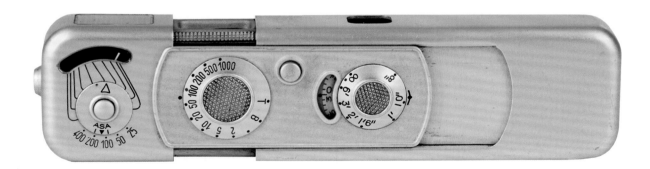

The Minox B, from the top, showing the only controls needed to operate the camera.

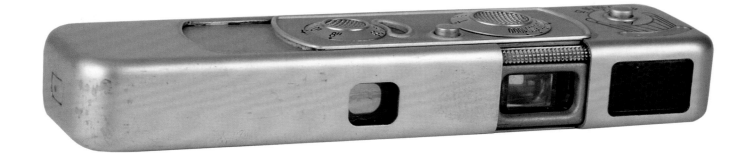

The Minox B open
and ready for shooting.

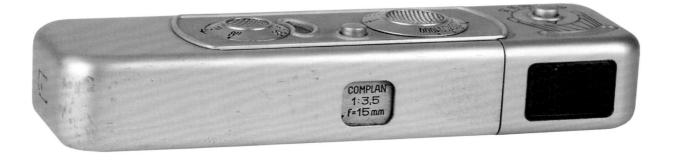

The Minox B in
its closed position.

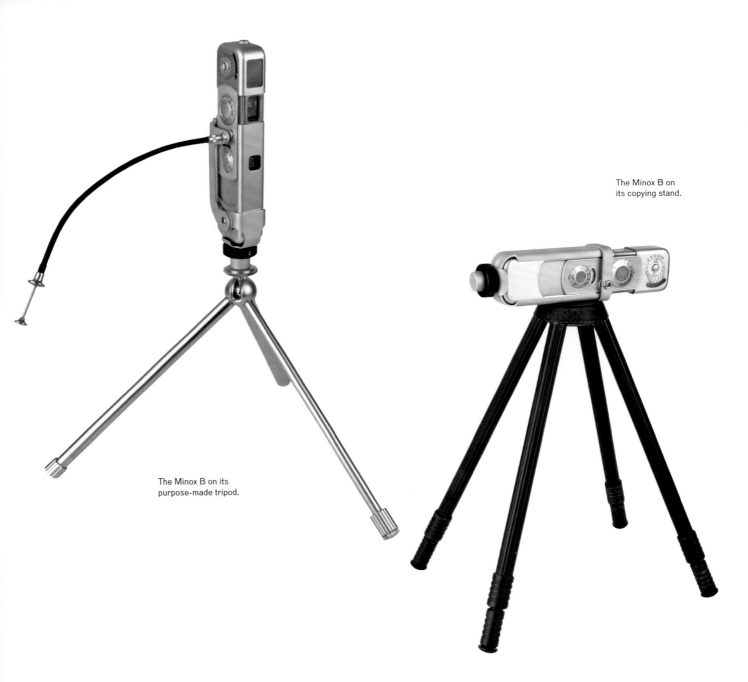

The Minox B on
its copying stand.

The Minox B on its
purpose-made tripod.

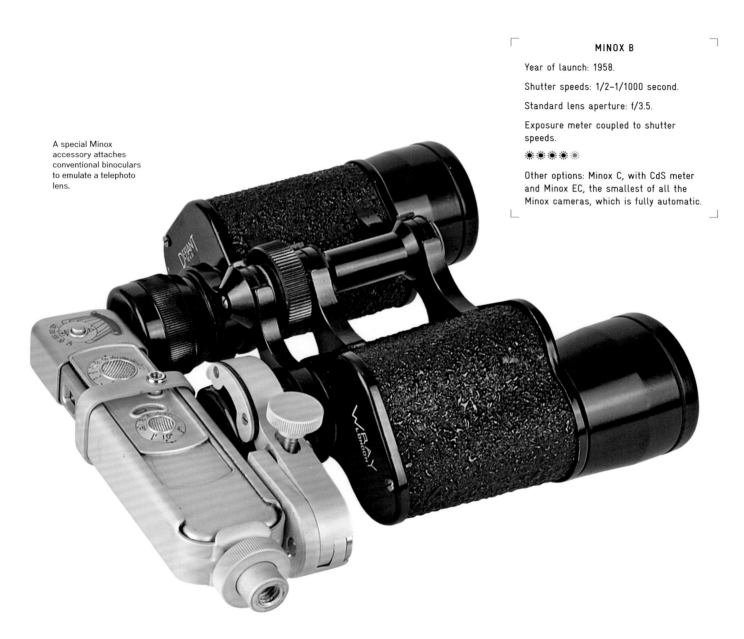

A special Minox accessory attaches conventional binoculars to emulate a telephoto lens.

MINOX B

Year of launch: 1958.

Shutter speeds: 1/2–1/1000 second.

Standard lens aperture: f/3.5.

Exposure meter coupled to shutter speeds.

☀ ☀ ☀ ☀ ☀

Other options: Minox C, with CdS meter and Minox EC, the smallest of all the Minox cameras, which is fully automatic.

Yashica Atoron

Yashica is a manufacturer better known for its 35 mm models and roll-film twin-lens reflexes. This model is similar to a Minox in size, shape and operation.

It also takes Minox film, which drops into the base when a flap is slid aside. A Selenium meter is linked to a single rotating dial that lines a pointer up with the meter's needle to select and set both shutter speed and aperture. Exposure Value (EV) numbers are the only indications of the setting.

Film is wound by pulling a tab out from the end of the body and releasing it. The shutter is fired by a button on top. A purpose-made flashgun for AG-1 bulbs attaches to the end of the body.

YASHICA ATORON

Year of launch: 1965.

Shutter speeds: 1/45–1/250 second.

Standard lens apertures: f/2.8–f/16.

Takes Minox film.

Other options: Yashica Atoron Electro with CdS meter launched in 1970; cameras also available in presentation boxes with filters and flashgun.

The camera with its purpose-made bulb flashgun.

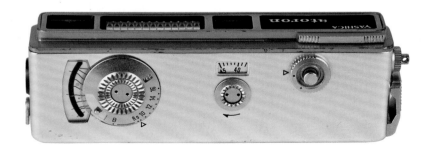

Leica M3 Classic Camera Collection

This miniature camera shows an interesting marriage between the Minox and Leitz names. It is a copy of the Leica M3, but scaled down to a third of its size to take Minox film, which is loaded through the base. The camera, and other miniature models styled on classic cameras, are still made in Japan.

The camera is a near-perfect miniature copy of the original, apart from a hump on the back, which is necessary because of the size and shape of a Minox film cassette.

As with the original Leica, a lever-wind requires two strokes to advance the film, and the shutter is fired by a button in the centre of the lever. All the other controls are inoperative. The shutter speed, lens aperture and focus are all fixed. Nevertheless, the camera is capable of remarkably good results.

LEICA M3 CLASSIC CAMERA COLLECTION

Year of launch: 1999.

Shutter speed: 1/250 second.

Standard lens aperture: f/5.6.

Takes Minox film.

✹✹✹✹✹

Other options: more miniature copies using Minox film include Contax I, Nikon F, Nikon SP, Rolleiflex 2.8F and Hasselblad.

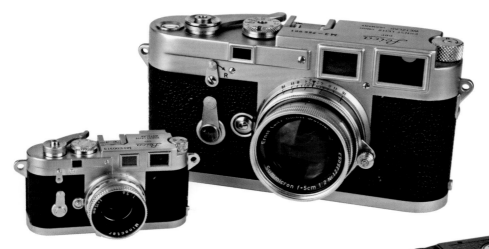

The miniature Leica M3 and the full-size camera that inspired it.

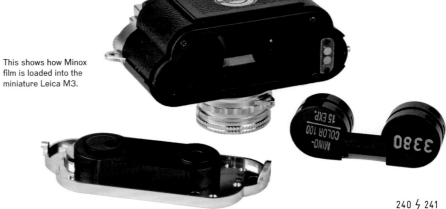

This shows how Minox film is loaded into the miniature Leica M3.

Ricoh 16

To be able to use a Ricoh 16 today, you will need to track down suitable film and pre-load it into the camera's own cassettes. The effort is worth it, though, because this is a fully specified camera that offers all the basic controls you would expect from a full-size 35 mm model.

A range of shutter speeds is selected by a knob on the top plate, apertures are set on a ring around the lens, which is interchangeable and focuses from 3 feet to infinity. Film-wind is by a lever and the shutter is released by a button beside it. The viewfinder is bright and seems disproportionally large for a camera small enough to be hidden in the palm of your hand.

RICOH 16

Year of launch: 1958.

Shutter speeds: 1/50–1/200 second.

Standard lens apertures: f/2.8–f/16.

Shoots 25 10 × 14 mm exposures.

☀☀☀☀☀

Another option: Golden Ricoh 16 with a gold-plated body – more collectable and therefore more expensive.

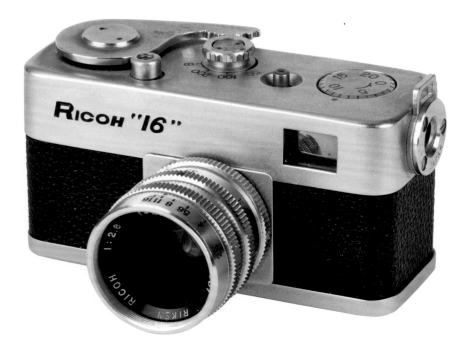

The Ricoh 16 is a fully specified camera in miniature.

Hapyucc

The name of this Russian camera comes from the way it appears to be written in Cyrillic lettering above the lens. It was also exported as the Narciss.

This is an eye-level single-lens reflex, made for 16 mm film, which today needs to be pre-loaded into the camera's cassette. The film is wound onto a take-up spool by a lever and rewound when all exposures have been made. Although only one standard lens was made for the Hapyucc, a special adapter is available that enables it to take 39 mm screw-fit lenses made at the time of the camera's launch for Zenith.

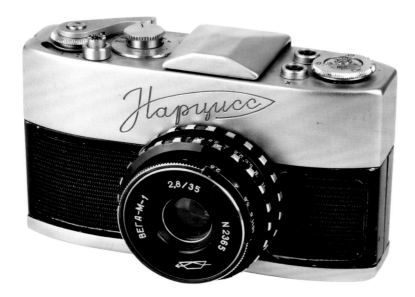

The Hapyucc is the only SLR made for 16 mm film.

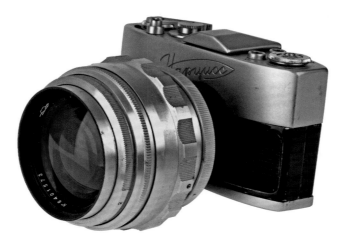

The camera equipped, via its special adapter, with a 85 mm f/2 Jupiter lens.

HAPYUCC

Year of launch: 1961.

Shutter speeds: 1/2–1/500 second.

Standard lens apertures: f/2.8–f/16.

Shoots 14 × 21 mm images on 16 mm film.

Sometimes found as part of a kit that contains a case, a lens cap, cassettes and lens adapters.

✹ ✹ ✹ ✹ ✹

Another option: a rare white version made for medical purposes.

Tessina

Although the Tessina is a miniature camera, it takes full-size 35 mm film. When the camera was launched, Tessina film in slim cassettes was available. Today, normal 35 mm film can be pre-loaded into the cassettes. If you can find the camera's purpose-made daylight film loader then this can be done without the need for a darkroom or a changing bag.

The Tessina is a twin-lens reflex with its two lenses side by side on the narrow edge of the body. Mirrors behind the lenses reflect their images down to the film, which runs at right angles along the base of the body and up to a ground-glass viewing screen on top. An exposure table sits beside the viewfinder. Unusually, a clockwork motor drive is used to advance the film.

Shutter speeds are set on a dial on the rear edge; apertures and focusing are set on dials on the top plate. A wrist strap can be found that enables the camera to be worn like a wristwatch.

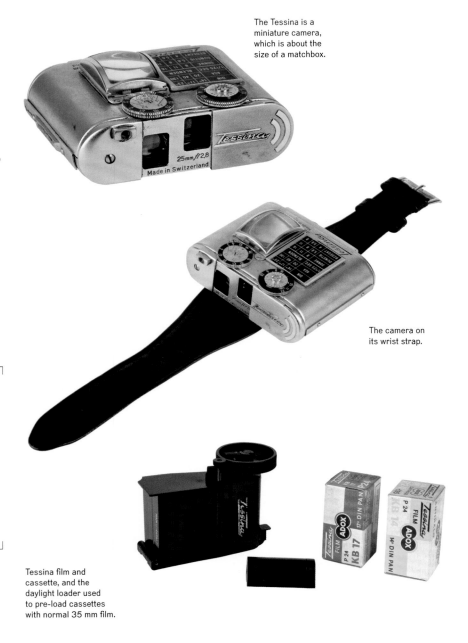

The Tessina is a miniature camera, which is about the size of a matchbox.

The camera on its wrist strap.

Tessina film and cassette, and the daylight loader used to pre-load cassettes with normal 35 mm film.

TESSINA

Year of launch: 1961.

Shutter speeds: 1/2–1/500 second.

Standard lens apertures: f/2.8–f/22.

Shoots 14 × 21 mm exposures on 35 mm film.

☀ ☀ ☀ ☀ ☀

Other options: usually seen in silver, the Tessina can also be found in black, red and gold.

Goldeck 16

The Goldeck looks more like a small 35 mm camera than one that takes 16 mm film. The film is in a cassette, wound onto a take-up spool and rewound when all the exposures have been made. The cassette can be pre-loaded with 16 mm in the usual way, but if you can find film for an Edixa 16 camera on the internet, then this comes in the same type of cassette and can be used in the Goldeck.

The film is advanced by an unusual plunger protruding from the top of the body and is released by a square button to the side. Shutter speeds are set on a thumbwheel protruding from the top plate; and apertures and focusing on rings around the lens.

The standard 20 mm lens is interchangeable and can be exchanged for a 50 mm telephoto.

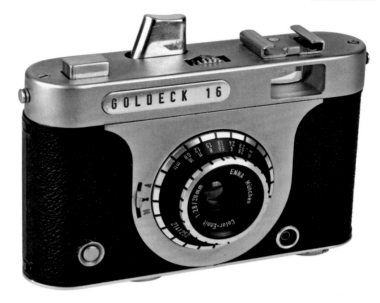

The Goldeck 16 with its standard lens.

The Goldeck 16, from above, with telephoto lens attached.

GOLDECK 16

Year of launch: 1959.

Shutter speeds: 1–1/300 second.

Standard lens apertures: f/2.8–f/16.

Accepts C-mount cine camera lenses.

✳✳✳✳✳

Another option: fixed-focus version with depth-of-field scale to show optimum focusing distances for each aperture.

Ensign Midgets

As with most other miniature cameras bought for use today, the first stumbling block in the use of an Ensign Midget is obtaining the film. The original was called Lukos E10, but this was actually 35 mm size, without perforations, mounted on backing paper. It is possible to cut down backing paper from a 120 film roll and use it to support modern 35 mm, but it must be attached in a darkroom or a changing bag. If you block off the red window on the rear of the camera, through which film numbers would normally be read, you can even use raw 35 mm in the camera, although it naturally has to be loaded and unloaded for development in the dark.

There are three basic models of the Midget, but the best is the Model 55. Folded, the camera sits comfortably in the palm of the hand. To unfold it, the lens panel is pulled forward on bellows and click stops in the correct position at the end of four metal struts. The front site of a viewfinder folds up from the front and the back site swivels into position on the back of the body. The camera also has a reflecting image viewfinder that swings out from behind the lens panel.

For such a small camera, the Midget is well specified with focusing from 3 feet to infinity, and shutter speeds and apertures set on small scales at the top and bottom of the lens. If you are using the original film, then the picture numbers are read in a red window on the back of the body as a key is turned on top. If you are using 35 mm, with or without backing paper, one and half turns of the key is about right to advance the film one frame at a time.

Two other versions of the camera can be found. The Model 33 is similar to the Model 55, although it has a fixed-focus lens and just two apertures designated as 'small' and 'large'. The model 22 also has a fixed-focus lens and fixed aperture, with shutter speeds designated only as 'I' and 'T' for 'Instantaneous' and 'Time'.

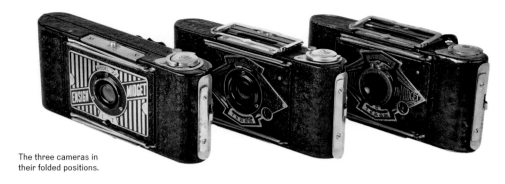

The three cameras in their folded positions.

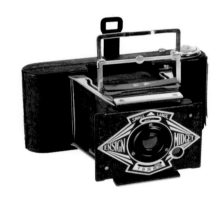

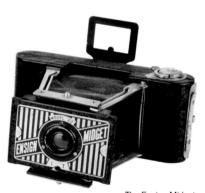

The Ensign Midget Model 33 (above left) and Ensign Midget Model 22 (above right).

The silver versions of the Ensign Midget Model 33 and Ensign Midget Model 55.

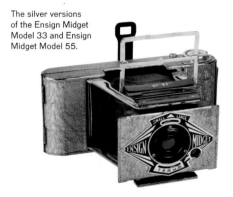

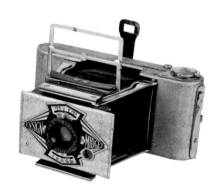

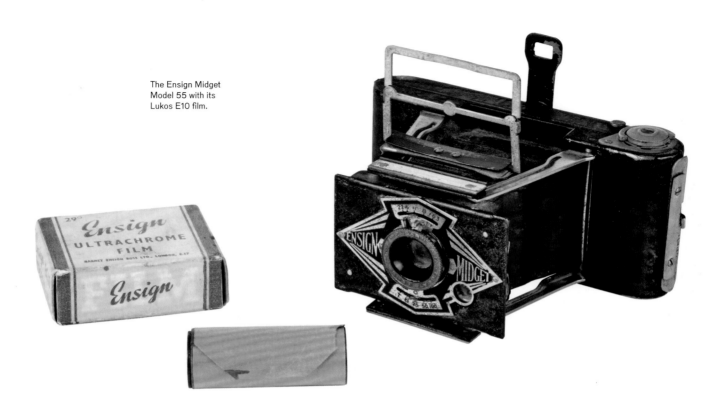

The Ensign Midget
Model 55 with its
Lukos E10 film.

ENSIGN MIDGET MODEL 55

Year of launch: 1934.

Shutter speeds: 1/25–1/100 second.

Standard lens apertures: f/6.3–f/22.

Shoots 30 × 40 mm images.

Other options: the Model 55 and Model
33 can also be found with silver bodies,
made to celebrate the silver jubilee of
King George V and Queen Mary in 1935.

Instant-Picture Cameras

There was an attempt to make an instant-picture camera, called the Dubroni, as far back as 1860. In the first half of the twentieth century street cameras were introduced. They were operated by photographers who specialized in shooting and processing on the spot so they could hand their subjects pictures of some kind within minutes of them being taken. The first truly viable instant-picture camera, which didn't need any chemicals, other than those contained in the film, to be developed, was launched in 1948. It was called the Polaroid Model 95.

The genius behind the camera was American physicist and inventor Edwin Land. Its design was much like a traditional folding camera of the past, but it was larger and equipped to take instant-picture film on twin rolls, dropped into each end of the body. The film incorporated pods of chemicals, which burst to spread a developer-cum-fixer solution across the sensitized film surface as a tab was pulled to slide the film between rollers. The process produced a monochrome negative followed by a positive, which was then removed from the back of the body. The camera is of interest to collectors, but the film is no longer available, so the camera, and others that used similar technology, is impractical for the retro photographer.

In 1963, Land went on to produce cameras for peel-apart pack film in which a negative and positive sandwich was pulled from the camera together after exposure, and then peeled apart to reveal a black-and-white or colour image. A major breakthrough came in 1972 with the introduction of SX-70 cameras and film, in which the print was automatically ejected from the camera after exposure to develop to full colour in about a minute. The 600 Series cameras and film launched in 1981 set a new style of camera and a new film which, at 600 ASA (ISO 600 in today's terminology), was four times faster than SX-70. The Image System that followed in 1986 improved usability, picture size and quality even more.

Today, Polaroid's peel-apart, SX-70, 600 Series and Image System film are no longer available, but an independent company has begun making its own versions, giving new life to old Polaroid cameras.

The same cannot be said of old Kodak instant cameras. Kodak entered the instant-picture market in 1977 with a process that was different from Polaroid's, but similar enough for Polaroid to go to court over patent infringement. The case was finally settled in 1985 when Kodak withdrew all its instant-picture cameras and film from the market. Today, Kodak instant cameras are unusable due to a complete lack of available film.

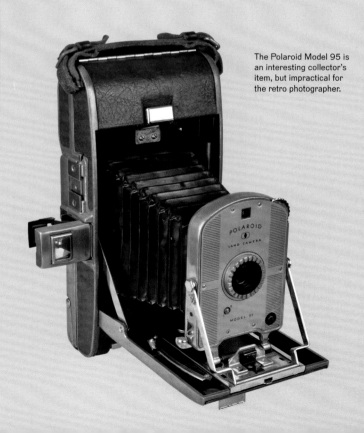

The Polaroid Model 95 is an interesting collector's item, but impractical for the retro photographer.

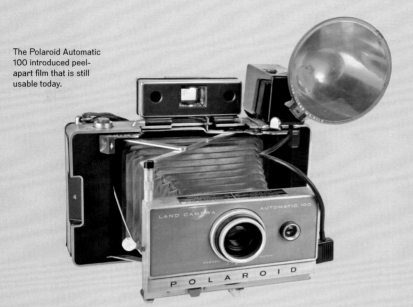

The Polaroid Automatic 100 introduced peel-apart film that is still usable today.

BUYERS' TIPS

Preferably choose Polaroid SX-70, 600 Series and Image System cameras.

Consider Polaroid peel-apart film cameras as a second choice.

Use the modern films being made today.

Old and outdated Polaroid peel-apart film can sometimes yield results, but avoid buying outdated Polaroid SX-70, 600 Series and Image System films, which deteriorate faster than normal film.

The batteries to operate SX-70, 600 Series and Image System cameras are in the film packs and are still charged after the last sheet of film has been used, so keep empty film packs with working batteries to test cameras you are considering buying.

Do not buy Kodak instant-picture cameras to use.

The Polaroid Autofocus 660 was one of the first to use 600 Series film.

Shooting Guide

Fuji still makes instant-picture cameras, but it is the older and rather more complex Polaroid cameras, resurrected with the introduction of modern instant films, which are attracting retro photographers.

The three most popular types of Polaroid instant camera, for which film is now available, are SX-70, 600 Series and Image System (also known as Spectra) cameras. Each takes its own kind of instant-print film – ten sheets to a pack in the old Polaroid packs, eight in the newer instant versions – and the films are not interchangeable across the camera types. The cameras are found in rigid and folding bodies. The latter require a certain knack to open them.

An SX-70 camera folded to a flat pack has a flattened viewfinder assembly mounted on top. The back of the viewfinder is gripped firmly and pulled up as the camera unfolds and clicks into position. To fold it again, a strut at the side that supports it in its open position is pushed backwards and the top and bottom of the body are pushed together.

The 600 Series cameras that fold flat like the SX-70 models are opened and closed in the same way. Others have flashguns on brackets that fold down over the camera lens when not in use. This is twisted up through 180 degrees until the flashgun points forward above the lens, where it clicks to a stop.

An Image (or Spectra) camera has a sliding catch on one side marked with a rear-pointing arrow. As this is pulled back, the camera self-erects into its shooting position. Pressing the catch again allows the camera to be refolded.

On all three camera types a catch is pressed on the side that drops down a trapdoor in the front. The film pack is pushed into the space behind and the trapdoor closed. This activates a mechanism that ejects a film-protecting card through a slot on the front of the camera. Thereafter, as each picture is taken, an instant picture is ejected through the same slot and self-develops outside the camera.

If any of the cameras hasn't been used for a while, there is a chance that the rollers that eject the film might be dirty or jam up, or the chemicals that develop the image might not spread evenly. If that happens, be prepared to waste the first exposures; the problem should resolve itself after a few shots.

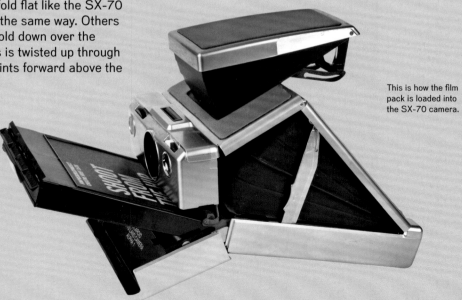

This is how the film pack is loaded into the SX-70 camera.

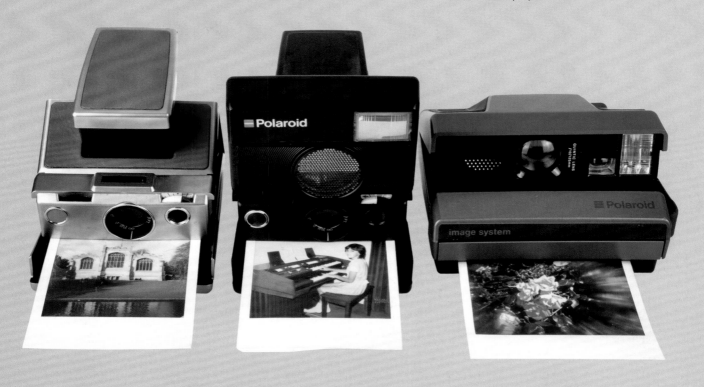

Here you can see how SX-70 Alfa 1, SLR 680 SE and Image System cameras eject their instant pictures. (The images are shown fully developed.)

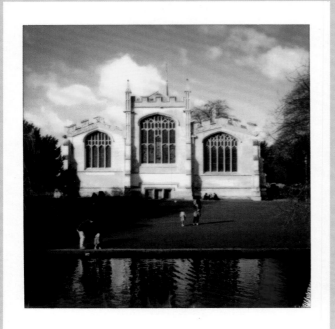
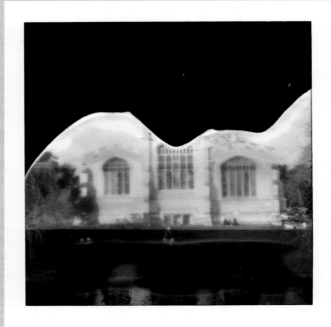

A correctly processed
SX-70 image (above
left). Above right you
can see what happens
when the chemicals don't
spread evenly during
the ejection process.

- Hold the camera in the palm of the left hand, using the right hand to steady it. The fingers of the right hand operate the focus control when manual and pressing the shutter release.

- The old Polaroid films self-developed in natural light in around a minute. The newer instant films take more like two minutes to start to develop and around 30 minutes to develop fully.

- Newer Polaroid films are more light-sensitive than the older type, and should be shielded from the light as soon as they are ejected.

- Turning the camera upside down immediately after exposure helps to shield the sensitive print.

- If the picture is too dark, turn the camera's lighten/darken control towards the light position. If the picture is too light, turn the lighten/darken control towards the dark section.

- Don't make a decision on lightening or darkening the next picture until the first one is fully developed.

The Image System camera with a multi-image filter in place, and instant pictures that were produced with this set-up.

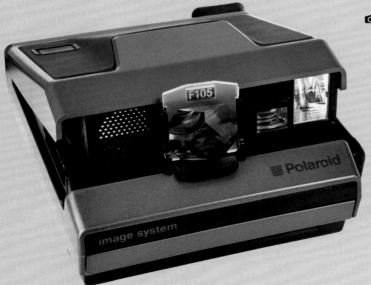

Polaroid SX-70 Alpha 1

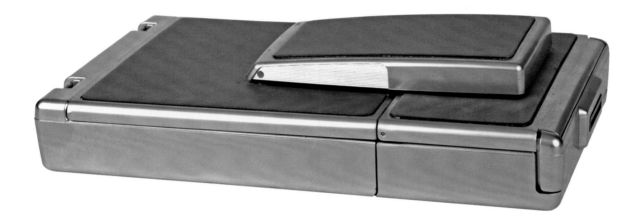

The Polaroid SX-70 Alpha 1 was one of the most complicated, unusual and revolutionary cameras of the 1970s. Launched five years after the birth of the SX-70 system in 1972, its instant picture was ejected from the camera immediately after exposure, self-developing in around a minute. Modern non-Polaroid SX-70 film takes longer to develop.

Although SX-70 was superseded by several superior instant-picture systems, it is the SX-70 cameras that draw retro photographers back time and time again. Of the many SX-70 models made, this one is the best.

It is not just an instant-picture camera, but also a folding camera and an SLR as well. Folded, the camera is long and flat, while unfolded it transforms into a triangular shape. The SX-70 film pack is inserted into the base

and a battery in the pack drives all the camera's electronic functions.

The camera is focused, with the aid of a split-image rangefinder in the viewfinder, using a thumbwheel that protrudes from the front panel. Another thumbwheel on the opposite side acts as a lighten/darken control to override the camera's programmed automation.

Before exposure, light travels through the lens to a mirror on the sloping back of the camera, down to another mirror lying on top of the film pack in the base, back again onto the first mirror inside the camera's back and then to a curved mirror in the viewfinder housing, from where it is viewed through the viewfinder eye-piece.

Making the exposure is as simple as focusing and pressing the shutter release, but what is happening inside the camera is far more complicated.

As the shutter release is pressed, the shutter closes and the mirror covering the film pack moves up to cover the mirror in the camera back. The shutter then opens and closes again to make the exposure. During this time light from the lens is reflected from yet another mirror now sitting at an angle in the camera back, and so down to the top sheet of film in the pack in the base of the camera.

As soon as the exposure is complete, an electric motor ejects the print from the camera, via a set of rollers, the optical system of mirrors returns to its starting positions and the shutter opens again to allow light to the viewfinder, ready for the next picture. Meanwhile, the instant picture is self-developing outside the camera.

Accessories, including a flashbar, a tripod mount, filters and a close-up kit, are available for this impressive camera.

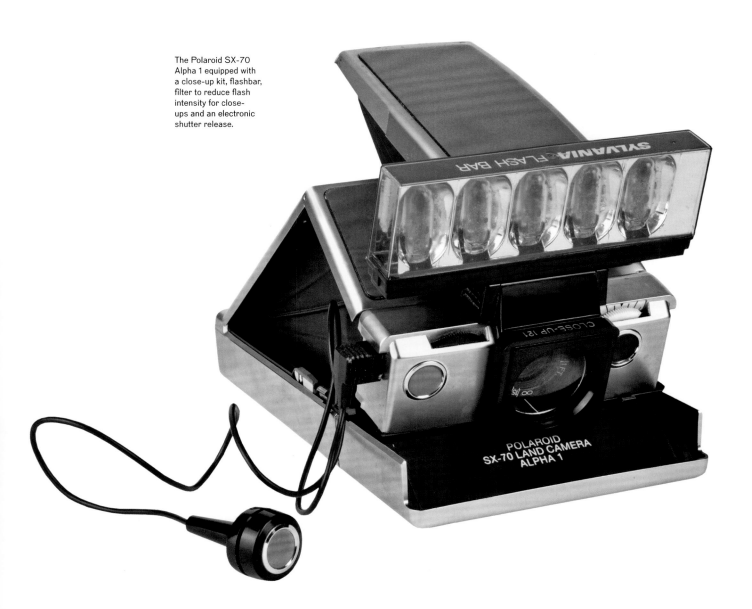

The Polaroid SX-70
Alpha 1 equipped with
a close-up kit, flashbar,
filter to reduce flash
intensity for close-
ups and an electronic
shutter release.

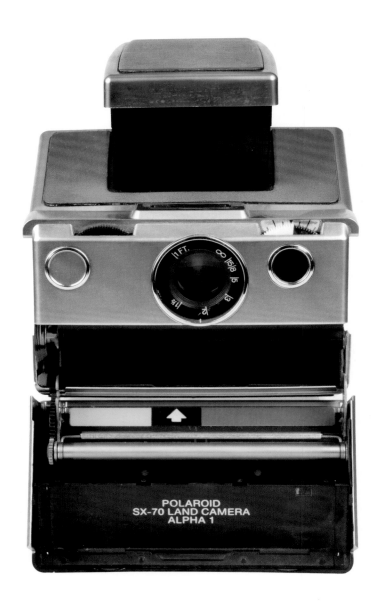

POLAROID SX-70 ALPHA 1

Year of launch: 1977.

Shutter speeds: 14–1/175 second.

Standard lens apertures: f/8–f/96.

Picture self-develops outside the camera.

SLR system for accurate viewfinding even with close-ups.

Shoots 77 × 80 mm pictures in 88 × 107 mm card mounts.

✸✸✸✸✸

Other SX-70 options: SX-70 Model 2, slightly stripped down and simplified; Model 3 without reflex viewfinder; various non-folding snapshot versions.

From the front, showing the only controls needed to shoot a picture and with the film door open: this is where the SX-70 film packs are inserted.

POLAROID
SX-70 LAND CAMERA
ALPHA 1

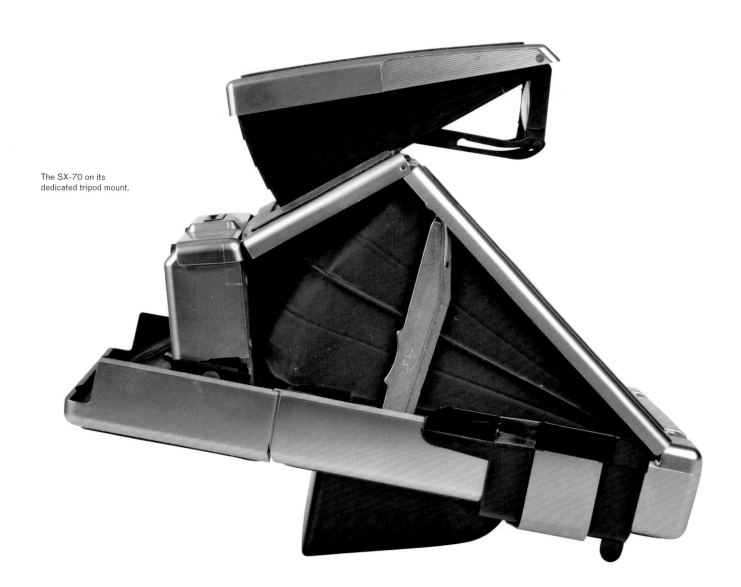

The SX-70 on its
dedicated tripod mount.

Polaroid SX-70 Sonar Autofocus

Polaroid is so well known for its instant-picture cameras that it is easy to overlook the other landmarks for which the company was responsible. The Sonar Autofocus is not only an instant camera for SX-70 film, but was also the world's first autofocus single-lens reflex.

The automatic focusing works differently from more conventional film camera systems. It comes courtesy of a circular unit mounted above the lens. As the shutter release is pressed, this device emits sound waves, which are inaudible to the human ear.

The required focus adjustment is calculated by the camera based on the time it takes for the sound to bounce off the subject and back to the camera's receptor. The distance is automatically set on the lens and the exposure made.

As with other SX-70 cameras, the print is ejected from the camera and develops in normal room lighting. Thumbwheels on either side of the lens provide, if needed, manual focus and a lighten/darken control to override the automatic exposure.

POLAROID SX-70 SONAR AUTOFOCUS

Year of launch: 1978.

Shutter speeds: 14–1/175 second.

Standard lens apertures: f/8–f/96.

Autofocus SLR based on a sound-wave system.

Shoots 77 × 80 mm pictures in 88 × 107 mm card mounts.

☀ ☀ ☀ ☀ ☀

Another option: Polaroid 5000 AutoFocus, which has similar technology, but a more streamlined design, and a detachable flashgun.

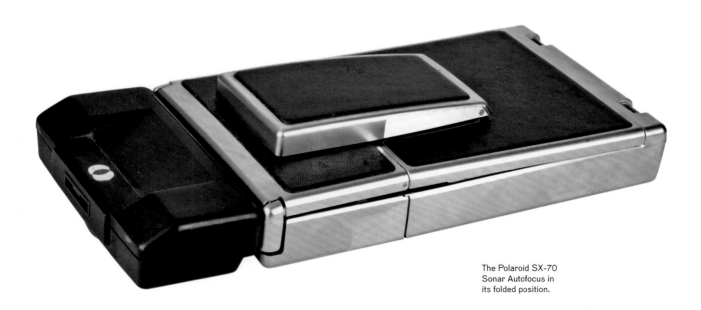

The Polaroid SX-70 Sonar Autofocus in its folded position.

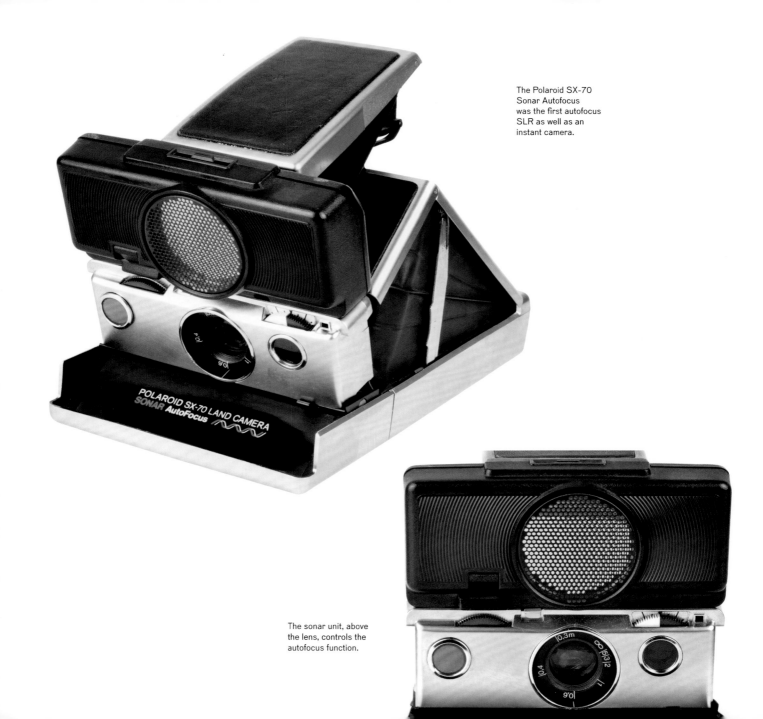

The Polaroid SX-70
Sonar Autofocus
was the first autofocus
SLR as well as an
instant camera.

The sonar unit, above
the lens, controls the
autofocus function.

Polaroid P Camera

Polaroid 600 Series cameras feature in-built electronic flashguns, which stand on brackets above the lens and fold down in front of it when not in use. The style of some is not particularly elegant, but the Polaroid P certainly is.

It is more stylish than most with rounded corners and is made in a high-gloss, silver-platinum finish. Exposure is automatic, but the lens is fixed focus for 1.2 metres (4 feet) to infinity. For closer subjects, a control on the front of the body slides a close-up lens in front the normal lens.

There is also a lighten/darken control beneath the lens. The flashgun fires automatically when light levels demand it, but it can be overridden by the photographer.

The stylish Polaroid P Camera.

POLAROID P CAMERA

Year of launch: 1997.

Shutter speeds: fully automated.

Standard lens apertures: fully automated.

Electronic functions driven by a battery in the film pack.

Shoots 77 × 80 mm pictures in 88 × 107 mm card mounts.

☀ ☀ ☀ ☀ ☀

Other options: a vast range of automatic exposure 600 Series cameras, both manual and autofocus.

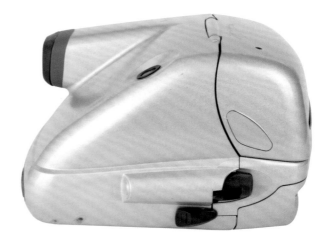

This shows how the flashgun folds down over the lens when not in use.

Polaroid SLR 680 SE

Of all the Polaroid 600 Series cameras, this is the one that is most sought after. Unlike the majority of 600 Series cameras, it is an SLR that folds like one of the older SX-70 models.

Internally, the mechanism for shooting a picture is much the same as that in SX-70 cameras, but the difference is that the SLR 680 produces instant colour prints on the faster, better-quality 600 Series film.

Autofocus is taken care of by the Polaroid sonar system and an electronic flashgun is built into a panel above the lens. Exposure is fully automatic, but can be overridden by a lighten/darken control beside the lens.

As with all other 600 Series cameras, the instant print is ejected immediately after exposure and develops in normal room lighting.

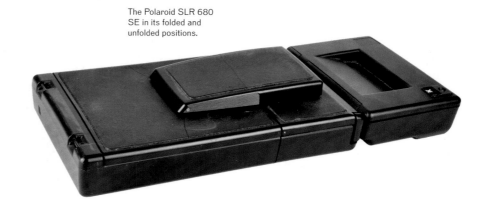

The Polaroid SLR 680 SE in its folded and unfolded positions.

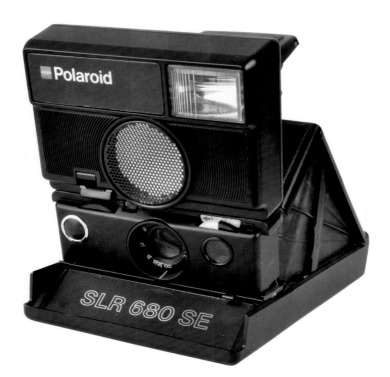

POLAROID SLR 680 SE

Year of launch: 1982.

Shutter speeds: fully automated.

Standard lens apertures: f/8–f/90.

All electronic functions driven by a battery in the film pack.

Shoots 77 × 80 mm pictures in 88 × 107 mm card mounts.

☀ ☀ ☀ ☀ ☀

Another option: SLR 690, updated version launched in 1996.

Polaroid ProPack

If you want to try using old and outdated Polaroid, or newer independently made, peel-apart films, the ProPack is the ideal camera for the job.

It is a folding model with an electronic shutter combined with a dual-aperture system, which is set by a control above the lens panel and designated in terms of ASA film speeds: 80 sets the lens at full aperture, while 3000 closes it down to its smallest. A lighten/darken override control is positioned beside the lens.

An optical viewfinder sits on top of the body. For flash photography, flashcubes can be fitted behind a small diffuser, but the base of the body also contains connections for an electronic flashgun. A digital timer on the camera back times development after the picture has been taken.

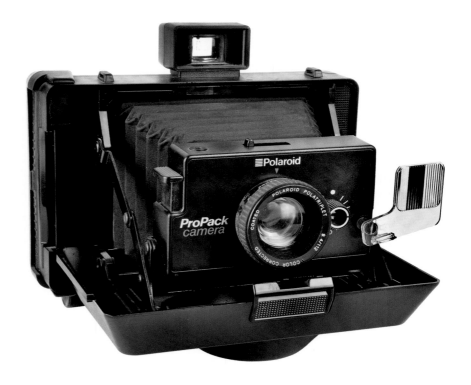

POLAROID PROPACK

Year of launch: 1988.

Shutter speeds: 10 seconds (approximately)–1/500 second.

Standard lens apertures: f/9.4 and f/58 (approximately).

Shoots colour or black-and-white images on peel-apart pack film.

Another option: Polaroid 600SE, a professional camera made in association with Mamiya as an instant version of the Mamiya Press camera.

The digital timer built into the camera back.

Polaroid Macro 5

It was designed primarily for medical or dental photography, but the Polaroid Macro 5 will appeal to any retro photographer who wants to shoot close-ups. It is an SLR that uses Polaroid's Image (or Spectra) film.

A large dial on the top presets one of five magnifications: 0.2×, 0.4×, 1.0×, 2.0× or 3.0×. Exposure is assisted by two electronic flashguns, one either side of the lens for shadowless lighting. An external flashgun can also be fitted via a conventional PC socket.

Twin light beams are emitted from windows at the top and bottom of the lens, and focus is adjusted by moving the camera backwards and forwards until the two beams overlap.

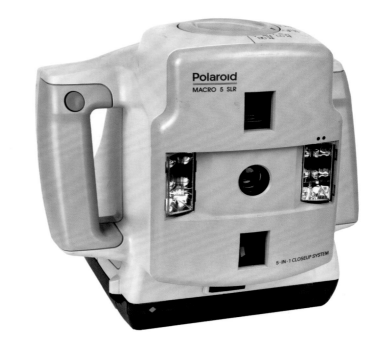

POLAROID MACRO 5

Year of launch: 1998.

Shutter speed: 1/50 second.

Standard lens apertures: f/20–f/100.

Shoots 75 × 90 mm pictures in 100 × 103 mm card mounts.

Focuses down to 8 cm.

☀ ☀ ☀ ☀ ☀

Another option: Macro 3, which is a similar camera with only three close-up settings.

The close-focusing control on the top of the camera body.

Polaroid Image System

Of the three main automatic print-ejecting Polaroid systems – SX-70, 600 Series and Image System – the Image System is the best. The instant prints it produces are larger and rectangular, rather than square.

The camera is a non-reflex, viewfinder type that folds to a large flat package and opens to a wedge shape. Exposure and focus are automatic and the camera has a small, in-built electronic flashgun that fires when light conditions demand it.

Special-effect filters are available that fit to the camera via a slot in a holder that clips over the lens. A system control panel on the camera back offers various manual overrides.

POLAROID IMAGE SYSTEM

Year of launch: 1986.

Shutter speeds: fully automatic.

Standard lens apertures: fully automatic.

Shoots 75 × 90 mm pictures in 100 × 103 mm card mounts.

Battery to drive electronic functions in film pack.

☀ ☀ ☀ ☀ ☀

Other options: known as the Spectra System outside the UK; upgraded as the Spectra Pro in 1990.

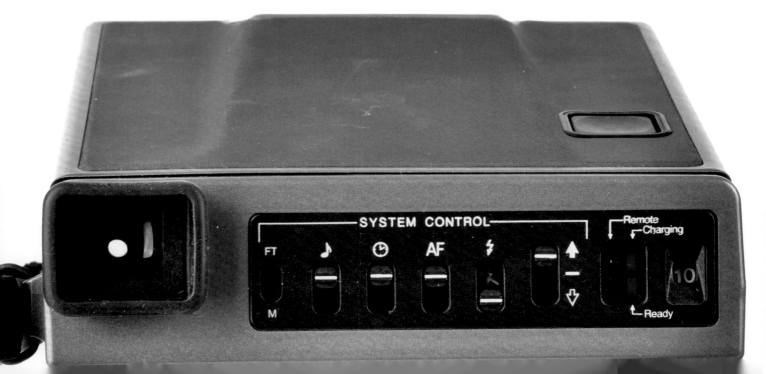

The viewfinder and system control panel on the rear of the camera.

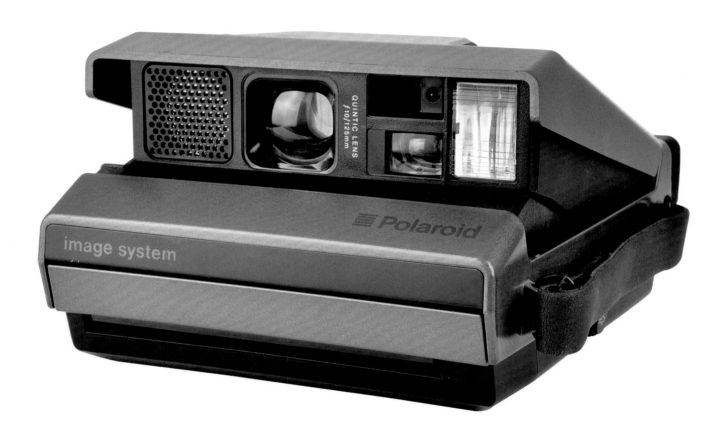

Graph-Check Sequence Camera Model 300

Not every instant camera was made by Polaroid. This one was made by the American Photogrammetry company, and was equipped with a Polaroid-made film-back to take 4 × 5 inch instant peel-apart film. For today's retro photographer, who is able to source the film, it is a fun camera to use.

As its name implies, it is made to take a sequence of pictures on a single sheet of film – eight exposures in all, which is why it has eight lenses. These are arranged in two rows of four, each with its own shutter. As the release is pressed, the shutters fire sequentially to build up a series of pictures, each one taken a fraction of second after the one before. One use suggested for the camera when it was launched was to help golfers improve their swings.

The interval between each exposure is controlled by a knob on the camera front, numbered one to nine. Sequences can be set to last from 1/10 second to four full seconds for the time taken to release all eight shutters. By setting the knob below its lowest setting, a sequence time of around ten seconds can be attained.

The lenses are fixed focus, but the depth of field extends from about 3½ feet to infinity. The shutter speed is fixed at 1/1000 second, but apertures can be adjusted to control exposure by a knob marked 'dull', 'normal' and 'bright'. The viewfinder is a simple wire-frame type that folds up from the top of the body.

Before making an exposure, the shutter must first be tensioned by pushing a sliding lever standing between the two lens rows towards and up to a second static lever. The shutter is released by another lever on the opposite side of the front of the body.

After exposure, the film sandwich is removed from the camera in the conventional Polaroid pack-film way and peeled apart to reveal the instant-picture sequence around 60 seconds later.

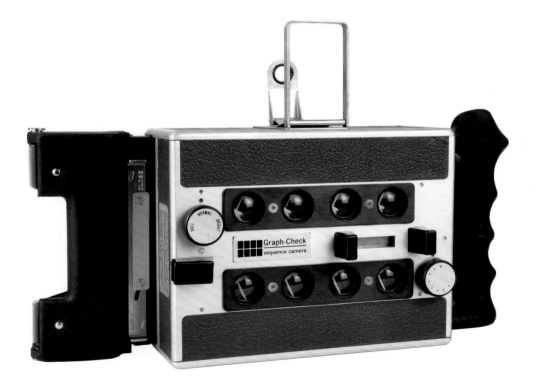

GRAPH-CHECK SEQUENCE
CAMERA MODEL 300

Year of launch: 1963.

Shutter speed: 1/1000 second.

Standard lens apertures: designated
by weather conditions.

Shoots a sequence of eight pictures for
each exposure.

☀ ☀ ☀ ☀ ☀

Another option: Model 400, which is
a similar camera with a fixed 1/250
second shutter speed.

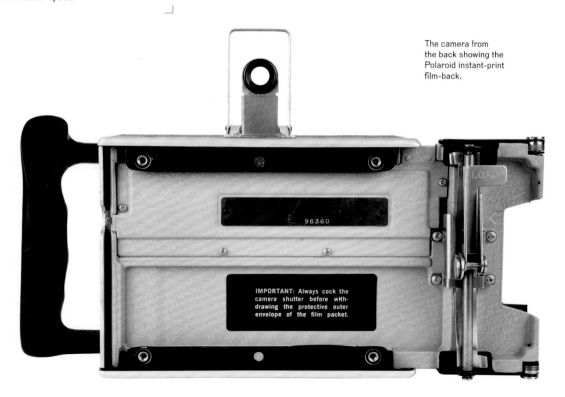

The camera from
the back showing the
Polaroid instant-print
film-back.

96360

IMPORTANT: Always cock the
camera shutter before with-
drawing the protective outer
envelope of the film packet.

Retro Accessories

Today, the extras are built into digital cameras so they do not require separate accessories in the way film cameras do. This section features some of the more popular accessories that can still be used to enhance retro camera pictures.

The effect of using a diffraction filter on a single light source. (Canon AE-1 35 mm SLR, Cokin filter)

Exposure Meters

Where it is not built into the camera, a separate exposure meter is useful, not to say essential. The usual operation method is to set the speed of the film you are using on the meter and then to point it towards the main subject and watch as a needle is deflected across a scale. The brighter the light, the higher the level of the deflection. The needle indicates a setting for a dial, from which shutter speeds and apertures are read. Meters with Selenium cells measure the light as it falls on the cell and do not require batteries, but the cells can become less accurate with age. Meters with Cadmium Sulphide (CdS) cells are more resilient, but take readings from the way light affects electronic resistance and therefore need batteries.

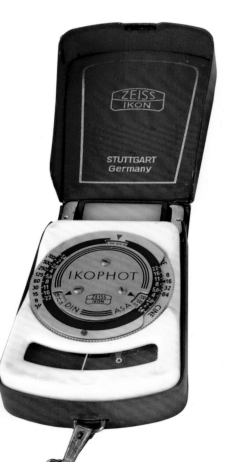

Exposure meters for retro photography: Zeiss Ikon Ikophot, Weston Master V, Leningrad 7, Sixtus and Sixon.

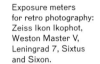
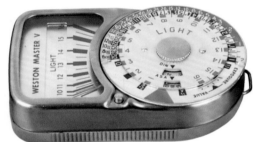
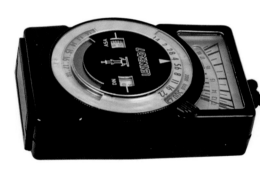
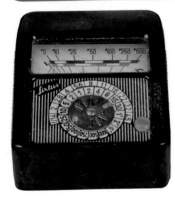
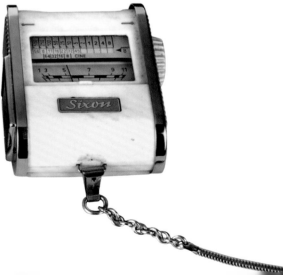

Rangefinders

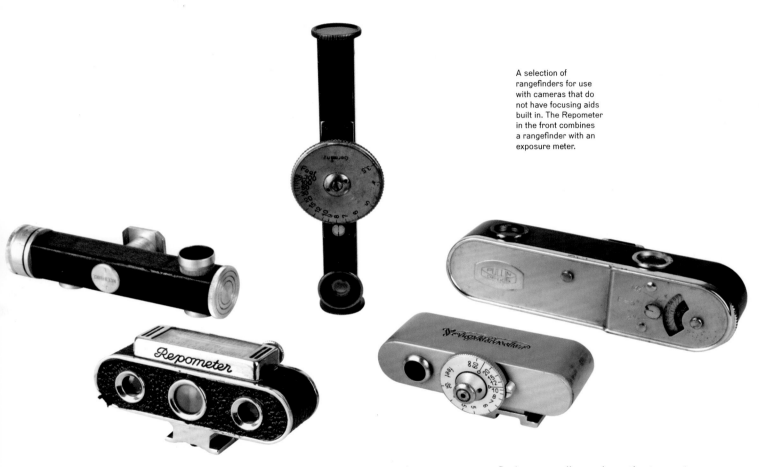

A selection of rangefinders for use with cameras that do not have focusing aids built in. The Repometer in the front combines a rangefinder with an exposure meter.

Accessory rangefinders usually work on the two-mirror, coincident image principle. The rangefinder is slotted into the camera's accessory shoe and then you can look through the window on its back, while turning a thumbwheel to bring the two images together. The distance is read from a scale around the edge of the thumbwheel and the indicated distance set manually on the camera lens.

Flashguns

If you have a choice, then an electronic flashgun, rather than the old-fashioned bulbs for which many retro cameras were made, is better. Older electronic flashguns give out a constant amount of light and exposure needs to be adjusted by changing the camera's aperture according to the flash-to-subject distance: large apertures for far distances and smaller apertures for close distances. The flashguns that were made nearer to the end of the film camera era moderate their own light at the moment of exposure, according to the aperture set on the camera and then indicated on the flashgun.

When using a flashgun, shutter speeds do not affect exposure. However, a leaf shutter can be set at any speed for flash photography; a focal-plane shutter must be set at a lower speed, usually 1/125, or 1/60 second, or slower.

Flashguns are connected to the camera either by a synchronizing cable, or by direct contact through a hot-shoe – a version of the old accessory shoe that incorporates electronic connections. If the camera has X and M synchronization, then select X for electronic flash.

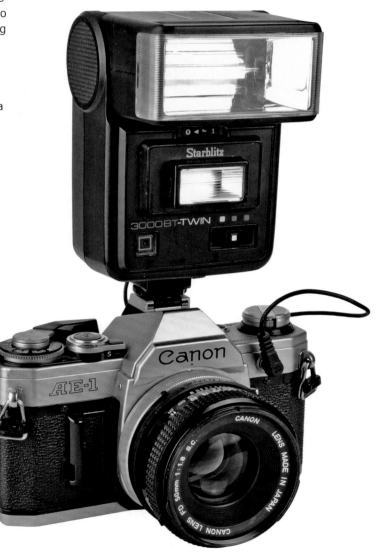

A Starblitz 3000BT-Twin flashgun fitted to a Canon AE-1 camera.

Tripods

A tripod is useful for keeping a camera steady, for any exposure, but especially when shooting at lower than the acceptable hand-held shutter speed. Go for the firmest tripod available and use a cable release to fire the shutter without touching the camera.

The long exposures associated with night photography make a tripod essential. The flare effect on the lights comes from the use of a special-effect filter on the camera lens. (Canon AE-1 35 mm SLR with a Hoya Starburst filter)

Filters

Filters are used in film photography for three purposes: to change the tones in a black-and-white photograph, to control colour temperature and for special effects. They are found in two styles: circular to screw to the thread on the front of a lens and square to fit into a holder that attaches to the lens.

In black-and-white photography, a filter lightens the tones of its own colour and darkens the tone of its complementary colour. (The complementary of yellow is blue, green is magenta and red is cyan.) The most common filters for this type of photography are yellow, green, orange and red. They are often used to enhance the sky in a landscape: fitting a yellow filter will darken a blue sky and make white clouds stand out more. The effect becomes more pronounced as orange and red filters are used.

At one time colour film was balanced for use in daylight or artificial light, and filters were used to convert one to the other. Since artificial light film is now difficult to find, the retro photographer is unlikely to need these filters.

Special-effect filters offer a vast range of effects: adding stars or rainbow spears to lights, selectively softening focus, multiplying the image, colouring the image overall or in parts, introducing subtle colour to selected parts of the image, darkening certain areas without colouration, creating a centre spot for colouring the outside area of an image, and more besides.

Red, blue and green filters can be used with colour film for a very interesting effect, providing the camera has a multiple-exposure function. The camera is placed on a tripod and the same scene is exposed on the same frame of film, through red, then green, and then blue filters. Since red, green and blue are the main constituents of white light, everything in the picture that remained static between exposures records naturally; anything that moved between exposures records in red, green or blue. The technique works most effectively on backlit sparkling water.

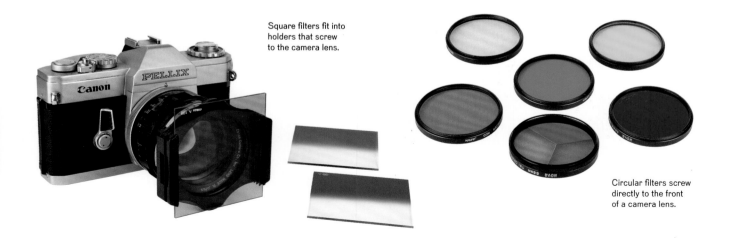

Square filters fit into holders that screw to the camera lens.

Circular filters screw directly to the front of a camera lens.

An orange filter used in black-and-white photography has darkened the blue of the sky, making the white clouds stand out more.

A special-effect filter can enhance an otherwise dull seascape. (Mamiya RB67 with Cokin tobacco filter)

Red, green and blue filters combined with multiple exposures give an interesting effect to backlit water. (Mamiya C3 TLR, Hoya filters)

The result of using a tri-colour filter plus a multi-image filter on a camera lens. (Canon AE-1 35 mm SLR, Hoya filters)

Centre-spot filters record the central part of the image correctly while adding a variety of effects to the outer edges. (Canon AE-1 35 mm SLR, Hoya filters)

Close-Up Attachments

The further a lens is positioned from the film, the closer it focuses. Once past the normal closest focusing point, the extra distance can be achieved by extension tubes or bellows fitted between the camera body and the lens. Tubes are rigid and come in different lengths, which give various degrees of magnification and can be combined. Bellows function in a similar way but are flexible.

For cameras without detachable lenses, close-up lenses allow closer than normal focusing distances. They are measured in dioptres and the higher the dioptre number, the closer the focus distance. Lenses of different dioptres can be combined, but the higher number should be used closest to the camera lens.

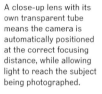

A close-up lens with its own transparent tube means the camera is automatically positioned at the correct focusing distance, while allowing light to reach the subject being photographed.

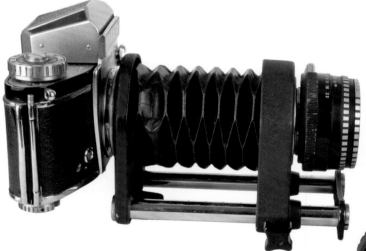

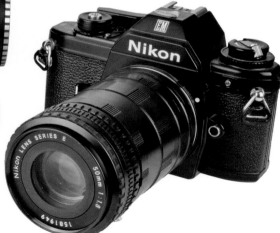

Extension tubes fitted to a Nikon EM and bellows fitted to an Exakta Varex IIb.

Focal-Length Adapters

A fish-eye attachment fitted to the standard lens of a Konica FS-1 camera.

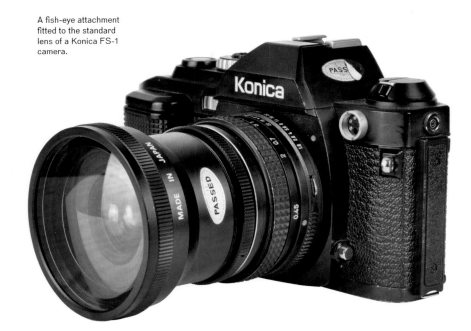

The super-wide, circular image that results from fitting a fish-eye attachment to a 28 mm lens on a 35 mm SLR.

Telephoto effects can be achieved by fitting teleconverters between the camera body and the lens. A 1.4× converter increases the focal length of a 50 mm lens to 70 mm, a 2× converter doubles the focal length to 100 mm. Be aware, however, that fitting teleconverters affects exposure. A 1.4× converter reduces the lens's maximum aperture by one stop (f/2.8 becomes f/4). A 2× converter reduces the lens's maximum aperture by two stops (f/2.8 becomes f/5.6).

Wide-angle effects can be achieved by screwing a fish-eye attachment to the front of the lens. The focal length of 50 mm lens on a 35 mmm camera is widened to approximately 15 mm; a 28 mm lens plus attachment gives a super-wide, circular view more like that obtained with an 8 mm fish-eye lens. Exposures are not affected.

Stereo Accessories

A stereo adapter is usually made to fit to the front of the standard lens of a 35 mm camera. It comprises two mirrors that record two images on a single sheet of film, each one from a slightly different perspective. It works in the same way as when two lenses operate on a more conventional stereo camera.

One of the best and most popular is the Zeiss Ikon Steritar, which is made to fit, via a special adapter, to the same manufacturer's Contaflex I and II single-lens reflexes. A metal mask fits to the front of the Steritar at right angles to the mirrors, helping to keep the two images separate in the viewfinder and on film.

Similar devices were purpose-made for Praktina and Exakta cameras, with the addition of special binocular viewfinders that fitted to the appropriate camera bodies in place of the traditional viewfinders.

A less-expensive version called the Stereax, with its own small waist-level viewfinder, can sometimes be found to fit non-reflex cameras.

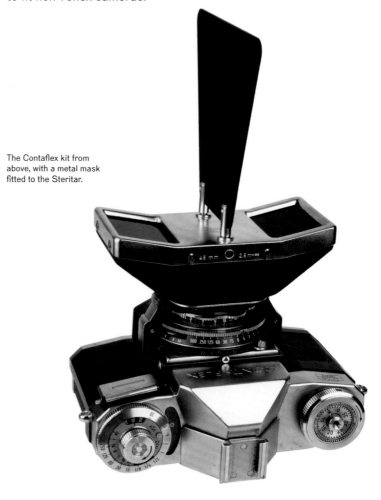

The Contaflex kit from above, with a metal mask fitted to the Steritar.

Praktina FX, fitted with its beam-splitter stereo device and special viewfinder.

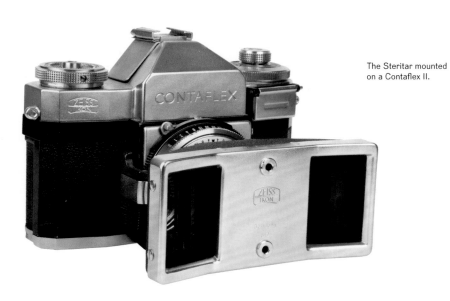

The Steritar mounted
on a Contaflex II.

The Stereax accessory
fitted to a non-reflex
Minolta Hi-Matic E
camera.

Further Information

Glossary

Accessory shoe: traditionally found on the top of a camera body for attaching accessories such as auxiliary viewfinders, rangefinders and flashguns.

Aperture: a variable gap, usually formed by an iris in front of, behind, or incorporated into a lens, to adjust the amount of light that reaches the film.

Aperture-priority: automatic exposure system where the photographer selects an aperture and the automation sets an appropriate shutter speed for correct exposure.

ASA: the American Standards Association is a scale that was once used to measure film speeds.

Autofocus: a method of automatically focusing a lens on a specific subject distance.

'B' setting: a shutter speed setting where the shutter opens when the shutter control is pressed and remains open until it is released.

Bayonet: a method of attaching a camera lens by inserting it into the body mount and twisting.

Bed: a flap or door in the body of a folding camera that is lowered to reveal the lens. It is then drawn out manually or automatically to a predetermined distance from the film.

Breech-lock: a method of attaching a lens to a camera, where the lens remains stationary while a collar around it is tightened.

Brief time: see 'B' setting.

Bright frame: frames etched into viewfinders to indicate the field of view of different focal lengths of lens.

Cable release: a flexible cable made to screw into the shutter button or another part of a body, enabling the shutter to be released without touching the camera.

Cassette: light-tight container for film, which slots into a camera; most popular in the 35 mm size.

Catadioptric lens: a telephoto lens that uses mirrors to fold the light path and so make the physical length smaller than that of a traditional telephoto or long focus lens.

CdS: Cadmium Sulphide, used in exposure meters to measure light intensity depending on how light on a cell affects electronic resistance.

Changing bag: light-tight bag with elasticized sleeves through which the arms can be pushed in normal lighting to perform light-sensitive functions without a darkroom.

Coincident image: when two images come together in a rangefinder to indicate subject distance.

Compact camera: a style of easy-to-use non-reflex 35 mm camera popular from the 1960s to the 1990s.

Daguerreotype: the first commercially successful method of photography, where a positive image was formed on a silver-plated copper base.

Dark slide: a slip of wood or metal that covers a plate or film, held in a holder in the back of the camera, pulled away prior to exposure and replaced straight afterwards.

Darkroom: a room devoid of light in which photographic processes such as developing, printing and film-loading are carried out.

Depth of field: the amount of an image that remains in focus in front of and behind the actual point of focus.

DIN: Deutsches Institut für Normung (German Institute for Standardization) was a scale once used in Europe to measure film speeds.

EV: see Exposure value.

Ever-ready case: a camera case that can be opened and the camera used without removal.

Exposure meter: a device for measuring light intensity and thereby calculating the required exposure.

Exposure value: a method of measuring and setting exposures that combines shutter speeds and apertures as single numbers.

Extinction meter: exposure-measuring device that relies on numbers or letters read against a graduated scale. Their visibility varies according to light levels.

Fish-eye image: an extra-wide image taken with a fish-eye lens.

Fish-eye lens: a lens with a very short focal length that produces a distorted image with a field of view of up to 180 degrees.

Flashbulb: a bulb, used once only, which produces a brilliant flash of light as an exposure is made.

Flashcube: four flashbulbs in a cube which is rotated between exposures.

Flashgun: a device fitted to, or sometimes incorporated into, a camera; used to fire flashbulbs or an electronic flash tube.

Flash synchronization: a way of connecting a flashgun to a camera so that it fires as the shutter opens.

F-numbers: the numbers assigned to different sizes of aperture.

Focal length: the distance between the centre of a lens and its sharply defined image when the subject is at infinity.

Focal-plane shutter: the exposure is controlled by the speed of movement of two blinds combined with the width of a slit between them.

Guide number: exposure guide for flash photography when using a flashgun with a constant light intensity, mostly from flashbulbs or early electronic flashguns. The camera to subject distance divided into the guide number gives the aperture for correct exposure.

Half frame: usually applied to 35 mm cameras; the picture size is 18 × 24 mm.

Hot shoe: an accessory shoe containing electrical connections to link a flashgun to the shutter release.

Hyperfocal distance: the closest distance at which the lens can be focused while keeping subjects sharp at infinity, at which point depth of field extends from infinity back to half the set hyperfocal distance.

Instant return mirror: reflex mirror inside a single-lens reflex that returns to its viewing position immediately after exposure.

Iris: metal blades incorporated into a lens, designed to open and close to form the apertures.

ISO: the International Organization for Standardization is a method of measuring film speeds.

Lateral reversal: a viewfinder image which, while remaining correctly orientated top to bottom, is reversed left to right so that objects on the left of the picture area appear on the right of the viewfinder, and vice versa.

Leaf shutter: a shutter that relies on thin leaves of metal, which move to open and close, to allow a specific amount of light through the lens to the film.

LED: see light-emitting diode.

Lens: one piece of curved glass, or several pieces arranged in groups, to focus an image onto the film.

Light-emitting diode: tiny, long-lasting bulbs of different colours, which are used as indicators for exposure measurement, delayed action devices, etc.

Macro photograph: the image size on the film is up to and including the same size as the subject.

Match-needle metering: method of exposure measurement where a needle is matched to another needle or viewfinder guide mark to indicate apertures and/or shutter speeds.

Medium format: film formats of between 4.5 × 6 cm and 6 × 9 cm.

Meter-assisted exposure: exposure measurement from an in-built meter that is not coupled to the camera's shutter speed or aperture controls.

Microprism: small prisms arranged in a circle in a camera viewfinder, which exaggerates image blur when not in focus.

Mirror lens: see catadioptric lens.

Movements: the movement of a camera lens relative to the film, primarily up and down and side to side, but sometimes also with tilting and swinging actions.

M synchronization: form of flash synchronization where the flashgun is fired slightly before the shutter opens. Used mostly with bulb flashguns which require a minute amount of time for the bulb to emit its maximum intensity.

Parallax: difference between the view seen by the camera lens and that taken by a separate viewfinder.

Pellicle mirror: a semi-silvered mirror used in some single-lens reflexes to allow light though to the film, while also reflecting a percentage to the viewfinder.

Program exposure: automatic exposure system that sets both shutter speeds and apertures.

Rangefinder: a device for measuring the distance between the camera and the subject.

Red window: it is found in the back of roll-film cameras and is used to read numbers on the film's backing paper to determine the places to which the film must be wound for each exposure.

Rise and fall: movement of a camera lens up and down.

Roll film: film wound onto rolls with backing paper that shows numbers for each exposure.

Selenium: used in exposure meters to generate a minute electrical current to deflect the meter's needle.

Self-erecting front: used in a folding camera so that the lens automatically clicks into its shooting position, as the camera is unfolded.

Semi-silvered mirror: see pellicle mirror.

Shutter-priority: an automatic exposure system where the photographer chooses the shutter speed and the camera's automation selects and sets the appropriate aperture for correct exposure.

Shutter speeds: the length of time a shutter remains open during exposure, measured in full seconds and fractions of a second.

Single-lens reflex: a camera that uses a mirror system to enable the viewfinder to look through the camera lens prior to exposure.

SLR: see single-lens reflex.

Snapshot: a picture taken quickly, usually with a simple camera and most often referring to pictures taken by amateur photographers.

Split image: two parts of an image that come together to make a whole and thus indicate subject distance in certain types of rangefinder.

Sprocket holes: the holes each side of a roll of film, usually 35 mm, used to engage with a sprocket in the camera to advance the film.

Standard lens: one which takes in a field of view similar to that seen by the human eye.

Stop-down metering: a method of reading exposures through the lens only when the lens is stopped down to the chosen aperture required for correct exposure.

Struts: metal supports in folding cameras that hold the lens a specific distance from the film.

'T' setting: an exposure setting that opens the shutter as the release is pressed and keeps it open until it is pressed again.

Telephoto: a lens that magnifies the image, giving the appearance of bringing far subjects closer to the camera.

Through-the-lens metering: system where the metering cell takes its reading through the lens prior to exposure.

TLR: see twin-lens reflex.

Transparency: positive image on a sheet of developed film, also known as a colour slide.

Tripod bush: socket on the base of a camera into which the tripod is screwed.

TTL: see through-the-lens metering.

Twin-lens reflex: a camera with two lenses, in which one takes the picture, while the other reflects its image at right angles to a viewing screen on top of the camera.

Viewfinder: a device for previewing the picture before exposure.

Wet-plate photography: an early form of photography in which the plates were prepared immediately prior to exposure, used in the camera while still wet and developed immediately after.

Wide-angle lens: lens that takes in a wider view of the subject than that seen with the human eye.

X synchronization: form of synchronization for flash, in which the flashgun is fired at the precise moment the shutter opens. Used mostly with electronic flashguns.

Zone focusing: method of focusing a lens by use of symbols rather than measured distances.

Zoom lens: a lens whose focal length can be varied to give different magnifications, while keeping the subject in focus.

Index

Index

Acknowledgments

I am hugely grateful to five camera-collecting colleagues for pictures and the loan of cameras that were photographed to help illustrate this book.

Thanks to John Rushton for pictures of his Kodak Cirkut panoramic camera and to Fred Friedman for his Meagher picture of the Murrey & Heath Binocular Stereo Camera.

Thanks also to Don Baldwin, Vic Rumak and Bob White, who kindly loaned the following cameras for illustrative purposes: Mecaflex (lizard-skin version), Periflex I (pig-skin version), Hasselblad 500CM, Pentax 6×7, Bronica ETRS, Bessa II, Rolleiflex 2.8F, Mamiyaflex accessory lenses, Noblex 135, Noblex Pro 6/150 and Globuscope.

Other than the above mentioned, all cameras are from the author's private collection, and photography is by the author.